W9-AVY-369

Annual Report Design

Annual Report Design

A Guide to the Annual Report Process for Graphic Designers and Corporate Communicators

Jerry Herring

Watson-Guptill Publications
New York

Produced by Jerry and Sandy Herring, Graphic Design Press
Design by Jerry Herring
Edited by Janet Frick
Design and production assistance by Susan Lemcke,
Steve Freeman, Ellen McCormick, and Tom McNeff
Intern assistance by Russ Wall

Copyright © 1990 Jerry Herring

First published in 1990 in New York by
Watson-Guptill Publications,
a division of Billboard Publications, Inc.,
1515 Broadway, New York, New York 10036

Library of Congress Cataloging-in-Publication Data

Herring, Jerry.
 Annual report design: a guide to the annual report process for
graphic designers and corporate communicators /
by Jerry Herring.
 p. cm.
 ISBN 0-8230-0231-4
 1. Corporation reports—Publishing. 2. Printing,
Practical—Layout. 3. Corporations—Publishing. 4. Business
report writing. 5. Book design. I. Title.
Z286.C68H47 1990 89-24948
686-dc20 CIP

All rights reserved. No part of this publication may be
reproduced or used in any form by any means—graphic,
electronic, or mechanical, including photocopying, recording,
taping, or information storage and retrieval systems—without
written permission of the publisher.

Quotes on pages 12 and 15 Copyright © 1986 by The New
York Times Company. Reprinted by permission.

Manufactured in Singapore

First printing, 1990

1 2 3 4 5 6 7 8 9 10/94 93 92 91 90

Acknowledgments
A book like this takes more time than you would ever guess—
time away from family, away from friends and away from my
regular clients. For their time and patience, I want to thank my
wife, Sandy, and my sons Stephen and Matthew, who sacrificed
the most by putting up with the constant trips to the office to
"work on the book."
 Thanks to Glorya Hale, for initially insisting that I write this
book, and to Mary Suffudy for agreeing to publish it and to
Janet Frick for her fastidious editing. And thanks to the people
who contributed their ideas and support: Ted Swift, Paul Hatler,
Mason Morfit and Hardie Davis.
 And special thanks to the people who work alongside me,
whose extra efforts helped the project through: Susan Lemcke,
Steve Freeman, Ellen McCormick and Tom McNeff.

Contents

Preface

What is this book all about?

It is a road map to the annual report and the process of producing one. It is, I feel, a valuable tool for designers and corporate communicators alike.

What this book is not, however, is a pronouncement on what a *good* annual report is. Or the exact way to produce a *good* report. Successful reports are those that answer the needs of the individual company, that express management's messages while clearly expressing the financial condition of the company.

Every year countless designers, writers and corporate executives are introduced to the process of creating the annual fiscal report for a corporation. These annual reports are the most important publishing venture for many companies, and the projects come with a variety of expectations, assumptions and needs—not to mention variations in budgets and tastes. Having seen and read annual reports before is little preparation for the extreme pressures involved in creating a report.

Two things are givens to start with. Every public company must report to its shareholders, and it must do so within a specified time period. These are the rules under which the corporation must operate.

Given the demands of an immovable deadline and a complicated task of gathering information and images for the annual report, the term "drop dead date" was surely coined for the annual report deadline.

To help you through the process of producing an annual report, this book offers help with the following questions:

Which companies are required to produce annual reports?

Who in these companies is responsible for the report?

When are annual reports produced?

What *must* to be included in a report?

What elements make up these reports?

Are there rules that govern a report's makeup?

What steps are included in the process of creating an annual report?

What have others experienced?

Beyond these basic questions, you will find insight into the areas of text preparation, photography, illustration, charts and maps and even the terms that people banter around during the process.

Introduction

There is a mystique to annual reports, and for good reason. They are not only the most important document for most companies, they are also in many cases the most expensive. It is a project that has the direct involvement of the CEO, while involving literally scores of people in the company, some of whose jobs or status in the company may depend on how well they perform on this project.

Reports today need to communicate to a variety of audiences: shareholders, brokers, stock analysts, lending institutions, employees, customers, prospective employees, the business and public presses and government officials. With such multiple audiences, there are quite naturally a number of agendas and expectations for the report, depending on whom in the company one talks to.

Whose Book Is This, Anyway?

In most cases the annual report is, quite simply, the CEO's book. Just as most corporations reflect the personality and direction of the person at the top, so the annual report reflects the chief executive officer's outlook, philosophy and vision—and aesthetic taste.

The annual report is a very personal project for most CEOs. It is a reflection on them personally, and they care a great deal about how they are presented to their peers, their shareholders and their many publics. Think about it: Their picture is displayed, they sign their name to the text, their successes and failures are the subject of the report. Yet, even with all this riding on the report, many CEOs are shielded from much of the process by their own organization.

"Because of the CEO's pivotal role, it is virtually impossible for a designer to create an effective annual report without first finding out what's on the CEO's mind," says Richard Lewis, chairman of Corporate Annual Reports Inc., a leading producer of annual reports for major American corporations. "The designer has to spend time with the CEO or be extremely well briefed by someone close to him. Without that kind of input, a designer falls into a 'bottom-up' trap—dealing several rungs down the corporate ladder while trying to guess which topics and themes the CEO considers most important for inclusion in the report."

Involve Top Management Early in the Process

I once worked on an annual report for the holding company of a large bank. The writer and I were at the corporate offices going over the final mechanicals when the director of investor relations, our client, informed

"... worldwide annual report production has become a $5.1 billion industry, according to a recent study. More than 11,000 corporate annual reports are produced in the United States today—not to mention thousands of annuals published by government agencies, nonprofits and other private institutions."
from the catalog for "A Historical Review of Annual Report Design," Cooper-Hewitt Museum

It is the responsibility of the designer and the contact person at the company to make sure that their agenda is that of the top management, and that concepts and directions of the report are approved early on by top management. Without this understanding, much of the early effort may be a waste of time.

us that the CEO didn't like what we had done. We were two days away from delivering the final mechanicals to the printer. The photographs were completed; all the text was typeset and in mechanical form. We were in shock.

In the next two days the report was rewritten, stock photographs were obtained to represent the areas of business that the CEO wanted to talk about and new mechanicals were submitted to the printer. The report was produced on time, although no one was really pleased with the result. The report lacked the quality of the original version, the CEO wasn't totally pleased with the final result, and on top of all that, the cost of the report was well over budget because of rush charges. The company had just paid more than it had budgeted and received less than what it wanted.

This was a clear yet painful lesson about the value of including top management early in the annual report process. But there was one more lesson to be learned here: the lesson of "whose book is this, anyway?" When the writer began resisting the changes that had been sent down by management, the officer took him aside and gently informed him, "This is *our* annual report. When *you* are in charge of a public corporation, then you will have the opportunity to produce *your* annual report."

The Who, Why and When of the Annual Report

Who produces an annual report? Every American publicly held corporation must report to its shareholders on an annual basis. Private companies need not do so, but many do. A publicly held corporation is one that has shareholders, people who have bought stock in the company. The buying and selling of this stock is governed by the Securities and Exchange Commission (SEC). It is the SEC that requires the company to report its financial status on a timely basis. The exact timing depends on the stock exchange where the company's shares are traded (see Delivery Dates, page 19).

There are over 10,000 U.S. corporations required to issue annual reports. The actual number constantly changes as new public corporations are formed and existing ones go out of business or are merged into other companies. According to some sources, as many as 50,000 reports are actually produced in the United States. Besides the public companies, many nonprofit organizations are required to issue annual reports. In addition to these organizations, public agencies, universities, research organizations—even airports—issue annual reports. Some companies that you might suspect would issue an annual report may not, however. When multiple companies are part of a holding company, for instance, only the holding or parent company need produce a report.

What Constitutes a Good Annual Report?

There are a number of ways to judge an annual report. How pleased management is with the report is one way; how the audiences respond is another. There are quite a few annual report competitions, some based on the "look," or graphics, and others based on the "readability," or words. Award shows should be taken with a critical eye toward the competition's purpose. Many graphic design competitions reward the "style" of the book, with many of the jurors of these competitions never reading a word of the text. The purpose of these shows is to unveil new trends in graphics, as opposed to judging what a good or successful annual report is. There may be some excellent annual reports in a graphics exhibition, but there may also be reports that were sadly unsuccessful at achieving their purpose.

Some competitions are run by analysts, whose considerations may have little to do with either design or readability. I was in a room with an analyst and saw him rip off the front section of an annual report and file the financial section in a binder. The front of the report, or the narrative, went into the wastebasket without even a cursory look. "Why?" I asked. "Because I can find out everything I need to know about the company without wasting my time on the slick view of what they *think* the company is. The financials tell me exactly what the company is, and where it is really going."

Sid Cato, whose national newsletter on annual reports has made major waves in many corporate offices, judges the annual report on these criteria:

1) Is the report's front cover demanding of readership? Has the report utilized readership-enhancing devices—intriguing cover statement and, on inside pages, textual call-outs, boldface lead-ins, action subheads or bulleted paragraphs? Does it contain an open, inviting layout, ask for readership throughout and have an action-filled contents listing?

2) Is the writing sprightly, and does the text pretty much eschew gobbledygook? How does the text score on readability?

3) Does the report truly aim to inform the reader fully?

4) Does it shed light on the company's competition, market position and market share? Also, does it provide a breakdown of operations, results and prospects?

5) Have its producers used a photograph of the organization's head person, and does that photo lead off the shareholder letter?

6) Has management assumed responsibility, alongside the auditors, for the financials?

7) Does the report contain biographical data on officers and directors?

8) Has it broken any new ground—in other words, is the report other than run-of-the-mill?

9) Does it have a discernible point of view, or a clearly stated, tautly executed theme?

10) Does it communicate a favorable image or identity of the company?
11) Is financial disclosure more than simply what's customary or required by the Securities and Exchange Commission? And are graphs fully captioned?
12) Does it earn any points for rhetorical commitment? Read: honesty! Is there any other way?
13) Is there CEO involvement, actual or perceived, in the shareholder letter?
14) Does the report deserve more points for the CEO (a) presenting a revelatory view of the company as well as (b) providing insight into where it's headed?
15) The yecch factor: Did we like the report?

© 1989 Sid Cato's Newsletter on Annual Reports. Reprinted with permission.

Why So Much Pressure?

"It's like physical exercise," Bennett Robinson of Corporate Graphics told *The New York Times*, "At the start of the season I tell my people to take their vitamins."

Since many companies have the same year end, December 31, the suppliers that produce the annual reports are scrambling about during the same period, competing for the same resources. Many top-notch design firms produce 5 to 10 reports in a season; a few of the larger firms can produce as many as 35 to 40. Photographers and illustrators have only so much time to give during annual report season, and many of the good ones are booked far in advance. Typesetters are notoriously overworked during the months of January, February and March. Large printers will allocate press time in advance, and waiting too long to order the paper for the annual report is courting disaster.

When indecision or delays on the part of management are added to this mix, overtime and rush charges begin to appear. Annual reports are expensive to begin with, but it is not uncommon to see companies begin to "throw money at a problem" late in a report schedule. Reshooting photographs, changing text again and again or readjusting the financials—often after typesetting—can create a sense of panic and cause a financial disaster.

To help corporate communicators and CEOs head off problems during the final stages of an annual report, Corporate Annual Reports' Richard Lewis outlines the following advice in his firm's style guide:

A Message to the CEO: How You Can Prevent Annual Report Disaster

The annual report project can get dangerously out of hand in the final, crucial weeks. The result: soaring costs, gross waste of executive time, frayed nerves and a mediocre annual report.

"Any one who enjoys sausage, or annual reports, should never watch either being made."
framed saying on the wall of an investor relations officer

The chief executive officer—more than any other person—can prevent this from happening. Here are some of the ways.

Pick a Strong Project Manager.

The most effective way of holding down costs is to put a trusted lieutenant in charge of the annual report project and then back him or her to the hilt.

Actively involve yourself in the early planning stages, when the concept and the design approach are decided. Make your opinions and preferences known at this point. Later, when you see a mock-up of the annual report, order only those changes that are essential.

Review the First Draft Carefully.

Many executives don't take the first draft seriously. As a result, they are often compelled to order many changes in text as the report is about to go to press.

You should make your opinions known early, before the copy is typeset, and then let the professional writers do a polished, coherent job.

Have the entire report, including the financial section, reviewed for style consistency by the project manager or the designated editor before mechanical boards are made by your design studio.

Suppress the Nitpickers.

In the final weeks of preparation, lawyers, directors, division vice presidents and others who did not participate in the conceptual thinking become involved with the annual report. Circulate the text to these people only after you have read it and it reflects your revisions. Inform them that they are expected to focus only on factual matters. If you allow them to suggest creative changes, you risk wasting an enormous amount of executive time.

Watch out, too, for "style experts" who want to change the language just to assert themselves, whimsically substituting *approximately* for *about* or *this* for *that*. This kind of fiddling is enormously costly, especially if the annual report is already typeset.

Avoid Panicking.

A common occurrence in companies just before press time is that a wave of panic sweeps through the staff, resulting in urgent pleas for drastic changes in text and design. Keep your cool. The judgments you made in the planning stage will stand up much better than the changes you consider under the pressures of the final deadline.

© 1987 Corporate Annual Reports Inc. Reprinted with permission.

The Press Check: The Final Translation of the Original Concept

After months of meetings, photography shoots across the country, late-night copy revisions and weeks of separations and proofs, the moment of truth is at hand. The project is on press. This is where the report lives up to everyone's expectations or becomes the largest elephant you have ever

tried to put your arms around.

The annual report business is full of war stories, and many of them revolve around the printer. In an age of advancing technology, printers are still putting ink on paper the same way they have for hundreds of years. They have better equipment, to be sure, but the process is the same.

There are as many things that can go wrong as you can think of, and if you ask another designer, he or she will tell you a few more. That is why it is imperative for the designer, and if possible the corporate communicator, to be on press. The purpose of the press check is not to tell the printer how to do his job, but to give guidance as to what is acceptable, and to find alternatives when nothing seems to work.

Why are there problems in the first place? Basically, every step of the annual report process is a translation from the step preceding it. When you are in a meeting discussing the photography, your mind's eye sees only what is possible. When the photographer points the camera, the real world floods in through the particular lens in place, electric poles and all. Later, as you review the film, you are no longer seeing the scene as you imagined it. The real world has been translated from the three-dimensional space you were standing in to a slide, a flat image on celluloid.

Often the designer will have photoprints made of the slides to put in place to show management what the spread in the report will look like. This represents another translation, because the print will lose some of the clarity and color saturation of the original slide. The client may be a little disappointed in the color of the image, at which time the designer will be heard saying, "Don't worry, the original is much better than what you are looking at. It will print okay."

But wait, the translations of that image are far from over. When the slide is sent to be separated for printing, a laser scanner will separate the image into four images, each one a single color—red, yellow, blue and black. When these are printed in small dots on the page, your eye will blend the dots together to make a colorful image. Although this is a wonderful process, the color and clarity are less than what was on the color slide. To make matters more complicated, what you review to approve the separation—to make sure the colors are in the right shades and values—is a proof that will be made out of plastic or film. The proofs, called matchprints or Cromalins, are very close to the printed image, but are made on equipment totally different from a printing press, and they are not ink dots on paper. The designer shows them to the client for approval, then goes to press and tries to match what has been approved.

On press, the final translation takes place. There are plenty of variables, from different printing presses to the expertise of the person running the equipment. The surface of the paper will make a difference, and so will the humidity in the air, the pressure of the printing rollers on the paper, the correctness of the exposure on the printing plates, the registration of the four colors and on and on.

A printing form, the sheet of paper that goes through the press, may have as many as eight to sixteen pages of the report on one side of it. As the form goes through the press, the ink that is being put on the paper by the press can be adjusted, say more red on this side of the page or less blue on that area. One of the more frustrating realities is that the images that you looked at as individual slides, and individual proofs, are now lined up next to and across from one another on the printing press. One image may need a little more yellow to make the trees really snap out, but when you add yellow, the CEO's face turns orange. You are now in a position to make the tough decisions, and it is for this reason the that designer and the corporate representative are at the press.

Is the Annual Report Worth the Cost?

There are annual reports that cost $35,000 and reports that cost that much for the type alone. "Depending on the size, complexity and number of copies," reports *The New York Times*, "a report can cost a company $250,000 to $750,000." Are they worth the expense? Yes, no and maybe.

For many small companies, the question of cost is a quandary. I sat in a meeting as a company's top managers approved $40,000 to produce their report—a modest sum in the overall annual report picture—and then realized they were about to spend $100 a shareholder for the report. For some closely held companies, or companies whose stock is held by a few large investors or institutions, the cost of producing a limited number of reports can seem outrageous. Yet, seen as an expense to woo more large investors, boost the stock price or influence a few large customers, the cost becomes more understandable. The problem is that it costs about the same to produce 10,000 reports as to produce 5,000 reports. The costs of design, writing and photography, along with the printing start-up costs, make small runs very expensive on a per-unit basis.

The Evolving Annual Report

Although reporting to the shareholders has been required by the SEC since its Exchange Act of 1934, the report as we know it today began in the 1950s. The 1959 Litton Industries report, designed by Californian Robert Miles Runyan, set the stage for the report as an "image" piece for the company as well as a financial document. Before this report, photographs may have been included with the financials, but they were primarily to document facilities or plants. The Litton annual introduced dramatic, conceptual photographs to the annual report world.

Today, the changes in annual reports revolve primarily around technical advances in communication, typesetting and printing. The advent of facsimile transmissions coupled with overnight delivery services and abundant flight opportunities to every conceivable location have literally

brought the entire world to the pages of today's reports. And while the technologies of creating reports have changed, so have the attitudes of top-level managers, who are now very sophisticated in communication skills. Top management now exerts a great deal of control over their reports, aware of the influence they now have.

The "Designer's Book"

"You could say the annual report is the world's worst design problem, because it seems to always be the same kind of job," comments Arnold Saks, one of the country's more well-known annual report designers. "But it's not really, because if you look at each individual company, you find out what it is that they want to project. There really are different stories to tell." Telling the company's story is still the basic charge of the designer, yet that mission can be left behind in an effort to create "award-winning" reports.

Graphic design award shows have brought a higher level of awareness to the annual report field, while at the same time creating a quest among graphic designers to create reports that constantly challenge the basic form of the financial report. The awards focusing on the annual report field have helped push designers to produce some highly unusual reports, some superb reports, and some very bad diversions.

The "designer's book" has emerged, a kind of report that seems to be intended for the designer's peers as opposed to the investment community: reports that are aimed at winning awards, as opposed to winning over shareholders.

"I always cringe when the client asks me to design an award-winning report," comments a leading graphic designer, who has won more than his share of awards. "Any report with four pages and a cover can win some award, somewhere. The hard job is to create a really good report that the client is pleased with, that then goes on to win awards. You have to complete the assignment first, using all the tools you have as a designer to make the pages grab you, inform you, entertain you, and finally, influence you. That's a lot. If you do all of that, you *should* get an award."

The designer's role is a difficult one, because he or she *should* be trying to promote a higher level of aesthetics while at the same time being sensitive to the needs of the client. In a sense, the designer needs to lead and follow at the same time. I have yet to find a CEO who didn't know more about his company than I did, and I have yet to find one who knew more than I about how to communicate using the printed page. Knowing each other's boundaries and strengths should help the designer and CEO know when to lead and when to follow.

Supplemental Reports

For many design firms, the relationship with the company continues on through the year, as the company produces quarterly reports and in some cases statistical reports.

Quarterly reports, although part of the new year, often take their look or layout from the last annual report. They are seen as a continuation of the results of the last annual report, and an update on the figures reported there. A quarterly report may carry the results and speeches from the annual meeting, or a totally freestanding report may do so.

Another financial report that the company may send out is the supplemental statistical report, an extensive review of the company's trends, sales records and industry comparisons. This report is generally not sent to the shareholders unless they specifically request it. Its purpose is to go to the financial analysts, who scrutinize the firm and report to investors on the company's future. The analysts require a wealth of information, more than most companies would care to put into their annual reports.

Alternative Annuals?

There are several options for the company when it comes to reporting to the shareholder. The required 10-K form, a dry financial document that is sent to shareholders as part of the proxy, can suffice for an annual report. The 10-K is generally quite long, and is printed on very lightweight stock.

A variation on the normal annual report is the "10-K wrap," a slick cover that is printed and bound to the 10-K. It is little more that an outside cover with the officers and general corporate information listed on the inside covers. Another variation using the 10-K has some companies substituting the 10-K for the financial section of their report, binding in the lightweight stock into the back of the report. Although the 10-K has far more pages than a normal financial section, the cheaper paper and typesetting savings more than compensate for the difference.

The summary report, introduced in 1986, allows the company to include its financial statements in the proxy to the shareholders, and print a smaller report summarizing the financials. This report is less expensive to produce. However, it has been criticized since it separates the "story" of the company from the normal, extensive financials.

The emergence of video and computers has brought on speculation that annual reports may someday be produced electronically rather than on paper. Today there are companies using video and electronic information, but mainly as supplements to the printed reports. Nothing indicates that this will change in the foreseeable future.

The steps of producing an annual report are presented here in a simplified form. Many of the activities outlined overlap in actuality. The time required for each phase is estimated, and can vary drastically from report to report, based on the number of pages, images and reports printed. All reports must work toward a press date that will allow for delivery by the required deadline (see Delivery Dates on facing page).

Initial Meetings
Interviews

Initial meetings involving CEO, management, designer and writer. Setting of theme, budgets and schedule.

Begin three to four months before company's year-end.

Text Outline
Report Layout

Layouts and text outlines are presented with finalized budgets and schedules. Begin production.

This phase can take two to six weeks.

Final Text
Photography
Illustration

Text, location photographs or illustrations and portraits are produced.

Time for this phase is determined by days available between starting time and printer's due date for beginning of printing, less typesetting and production time.

Typesetting

Setting of text and financials in type.

This phase can take two to six days, but it will most likely be executed in partial phases. Corrections are additional.

Mechanical Production
Charts and Maps

Production of boards, putting type, photographs and charts in place for printer.

This phase can take one to two weeks.

Separations
Stripping

Color photographs or illustrations, charts, maps and other graphics are prepared for printing.

This phase can take two to three weeks.

Proofs

Text, charts and color photographs or illustrations are proofed.

Allow two to three weeks for proofing, corrections and reproofing.

Printing

Report is printed, bound and delivered to mailing house for mailing to shareholders.

Press time can take one week for smaller books and web runs, two weeks for larger sheetfed runs. Binding will take from 2 to 10 days.

The Production Process

The actual production of an annual report is a process that can take from three months, at the very least, to one year at the most. The average production time is six months, and eight to nine months is not out of the ordinary. Why the discrepancies? Size of company is one answer; the ability to make long-range plans is another.

Timing: The Beginning of the Thought Process

Many smart corporate communicators begin planning the next annual report shortly after the party celebrating the completion of the current report. The advantage to this method is that the team responsible for the report has the opportunity to document the company throughout the year, and will not be forced into trying to shoot all the photographs at the year-end. For instance, discussing a concept that calls for an array of outdoor, summer foliage images may cause real problems if the meeting is taking place in the Northeast in November. The disadvantage to beginning the process so early is that the year has not evolved enough to talk about. Changes in management's thinking, changes in sales or production, changes in the makeup of the company—buying or selling parts of the company—may have quite a dramatic impact on the tone or direction of the report.

The key dates for the production are these: the date the financials are ready to be released to the designer, and the date the reports must mail to the shareholders. The first date, the financial release, determines when the financial section of the book can begin to be typeset, when charts can be produced, and when the text can reflect the actual figures. Before this date, the creative process can be in full swing—text written, photographs taken, and so on—because management knows the results of the year *in general*. With the release of the financials, the text can now reflect the *actual* numbers.

The second critical date, the day the reports must ship to the shareholders, is a date from which the designer must work backward in determining a printing and mechanical production schedule for the reports. The mailing date is determined by the stock exchange where the company's stock is traded. Missing this deadline requires a petition for an extension and is tantamount to signaling sloppy management or serious trouble at the company. Companies hate to take this step unless there is a major and compelling reason, such as a merger or imminent litigation.

Delivery Dates

The following are the delivery requirements of the annual report to the shareholders, based on where the securities are listed or traded.

NYSE
15 days before annual meeting; not later than 90 days after close of the fiscal year.

AMEX
10 days before annual meeting; not later than 120 days after close of the fiscal year.

OTC
No delivery of annual report to shareholders is necessary unless there is an annual meeting for which proxies are being solicited. State laws governing corporate activities should be checked to determine how many days before the annual meeting the annual report must be delivered.

From Doremus & Company

Assembling the Company Team

People likely to be involved in a company's annual report include: the chief executive officer (CEO), chairman, president, group or department vice presidents, investor relations officer, public relations or corporate relations officer, chief financial officer, comptroller and chief legal counsel.

While we stress over and over again the importance of the CEO's involvement in the report, the fact is that another person or group of people will be responsible for the day-to-day production of the report. The lead person responsible for the report varies from one company to another. Time was when the report was the product of the company comptroller, or the chief financial officer or the vice president in charge of finance. In some companies this is still the case. More often than not, the current lead for the report will have the title of vice president—corporate relations, or vice president—investor relations. In some companies, a management group may review the report as well. This group will be made up of the president and the chief financial, legal, manufacturing and marketing officers.

Beyond the lead person, group vice presidents will be consulted, and division managers will have input as well.

Large companies may have someone on staff who will write the report, as well as additional people for research, keystroking, and so on.

Selecting a Design Firm

Selecting the design firm sets the annual report process into motion. Whether the report is the company's first, or whether a design firm is being hired to replace an existing firm, the process of selecting a firm will say a lot about the company that is doing the choosing.

A company is seeking a partner as well as a supplier. This is a relationship that will be based on trust, and one that will be tried by budget and time constraints. Here is how I feel a company should go about finding a design firm.

How the Company Should Conduct a Search.
1) *Make a list of possible design firms.* Ask other companies and business associates for referrals. Make a list of possible design firms and call or mail a request for a preliminary presentation. Ask for a resume or profile, a list of references, 5 to 10 printed samples (annual reports or brochures). State in this request any items that may disqualify the design firm, or any items that the firm may need to be aware of (such as not wanting a design firm that is currently producing a competitor's report. As a courtesy, send the firm the company's last two reports.

2) *Interview.* From the response, select three to four firms to interview. More than this number will be a waste of time. If possible, interview the prospects at their offices, and ask for a tour. Whether the firm has 3 employees or 30, the feel of the office is important.

The selection of a design firm should be based on criteria beyond the firm's experience and portfolio. Annual report experience is important, in some cases absolutely necessary. But you, the client, are about to select a

person or a group of persons to spend a great deal of time with over the next six to nine months. (Make sure you meet the actual people who will work on the project, not just the firm's principals.) Choose someone you have confidence in, and someone you feel comfortable with. If the person seems abrasive in the initial meeting, just wait until you are on a week-long photo shoot together at remote, wintry location.

3) *Do not hold a competition.* It is of no value. One of the most important phases of any report is the input of top management in the initial planning meetings. In these meetings the designer and writer have the opportunity to ask questions, suggest ideas and respond to the information at hand. Likewise, management has the opportunity to bounce ideas off the designer, refining the concepts or narrowing the focus of the report. In a competition, all this is missing. The designer will receive a typed outline or statement, and from there the designer is guessing. And when the presentation to the client is made, the designer will be relying on salesmanship to get the project, as opposed to working toward a viable approach to the report.

How the Design Firm Should Respond.

1) *Do your homework.* Before interviewing with a prospective annual report client, find out what the company is all about. Ask for the last two to three annual reports; ask for a facilities brochure, if one exists. Get a feel for the company's history, its products, its territories and its management. See how the company has expressed itself in the past. Ask a broker for information on the company. (These research papers will give an opinion on the company, stating the company's strengths and weaknesses.)

2) *Present your work.* At the presentation, show work that you feel will relate to the project at hand. Show annual reports, of course, but also include brochures or other samples that may have some relationship to the company's business.

3) *Present yourself.* Ask questions. Then ask more questions. Your ability to create a flow of information is one of the talents that the prospective client is looking for. Listen and respond to the information that is coming to you. Given the opportunity, most people enjoy talking about their business. Let the client do as much of the talking as possible, and you are on your way to a better understanding of the people you may be working with.

Promise only what you can deliver. You are starting a relationship that you hope will last for years. Be clear about who will serve the account and how much time the principals will devote to the project. (Don't be afraid to decline the project if the company does not seem to be a good fit for your firm.)

Finally, discuss general financial structures without getting too particular. (The actual quote will come later.)

Hire professionals and let them do their job.

The starting point for most reports is a concept or planning meeting. The input of the company (1) and a preliminary schedule (2) are necessary elements to begin the discussions that will lead to rough layouts (3). Previous materials the company has produced (4) are also helpful in determining the content the report may include.

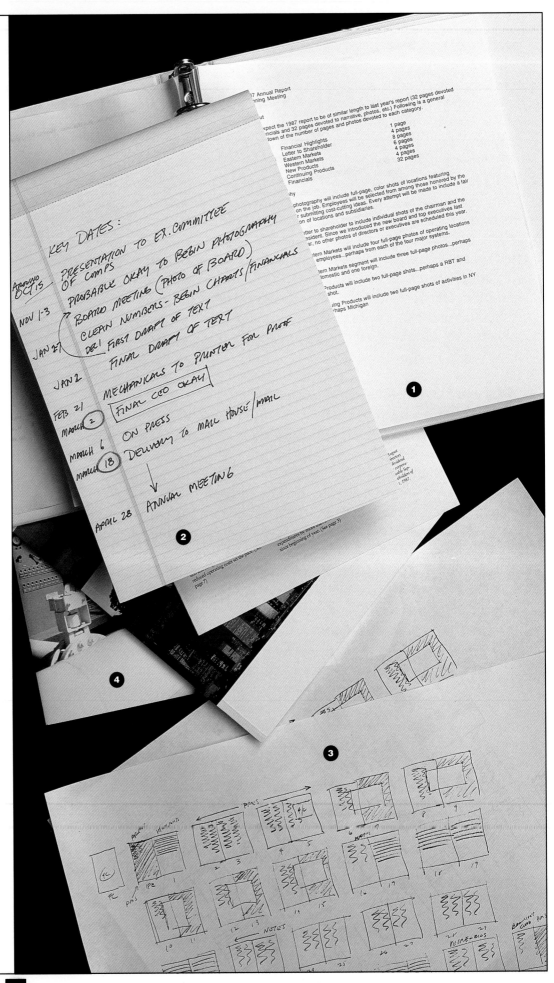

The Initial Concept Meeting: Planning the Report

The initial planning/concept meeting should take place with all the key players involved: the people responsible within the company, the designer and the writer. If the CEO is not involved in the initial meeting, he or she should be consulted in a follow-up meeting.

The purpose of this meeting or meetings is to gather information and begin to establish a concept or theme, a plan and a schedule.

The corporate representative should have a fix on what is on the CEO's mind, how the company is doing, how the company wants to project itself to its many communities and what will be the "hot topics" for the coming year. He or she should also have a fix on the budget, and a sense of history about the company and its past reports.

The designer should come with an open mind and a notepad. The designer's main goal at the initial meeting(s) is to come away with real hard information, the kind of information that should be incorporated into the report and will guide the initial theme and layout approach. To get this information, the designer needs to ask questions, listen, ask more questions and take notes. The designer should also bring a sense of timing for the many tasks at hand. Discussions of how long the photography might take, or the time needed by the typographer, will have a bearing on what is possible for the project.

The concept or theme. The concept or theme of a report is its story line, the thread that is woven through the report to help the reader come away with the major message or messages that the company is trying to convey. A simple, concise statement can help everyone approach the report from the same direction, such as "Our employees are our greatest assets," or "New technologies," or "Building a better America." Such a theme can be the starting point for a unifying visual concept, demonstrated in the initial layouts, that will also guide the writers.

The plan. "Plan everything," says Bart Crosby of Crosby Associates, Chicago. "Plan time to plan. Develop a comprehensive schedule that details all activities and tasks and indicates the person(s) responsible for them." The plan the team develops should be a road map for the report: Who is responsible for what tasks, and when the key dates are.

Using the mailing date as the final deadline, the schedule should work backward. Pencil in the time the printer will need to print, bind and deliver the reports. This gives you the deadline for final materials to be delivered to the printer. Pencil in the date the financials will be released by the auditors. This will give you the date the financial typesetting can begin. Then pencil in the date the color separator needs the photographs to ensure that the color work can be done in time for the printer's beginning date. Then put in the key approval dates, such as the CEO and the management committee. Now there is a skeleton for the remaining dates, working back to the date that the initial meeting is taking place.

The initial presentation to the company by the designer will generally include thumbnail layouts (1) to give page allocations and a sense of the report's flow; page mock-ups (2) for the style of the photographs or illustrations, the style and size of the type, and the color of bars, rules, maps or charts; and a paper dummy (3) made up of the exact paper with the exact number of pages for the client to feel the weight and texture of the paper, as well as its color or finish.

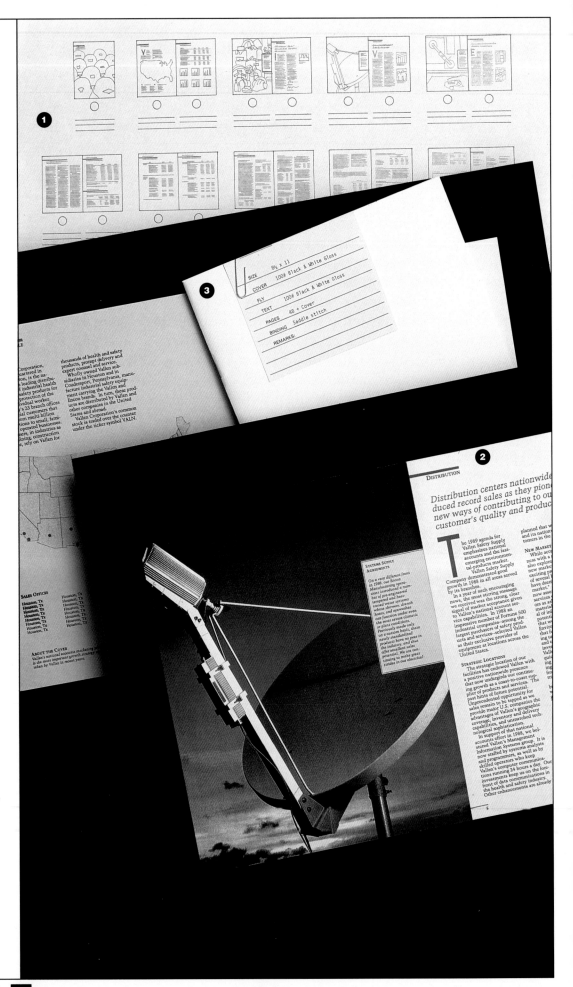

Initial Layouts

Armed with the initial input from management, the designer is ready to begin making the rough skeleton of the report. The writer may draw up an outline for use in the initial layouts, or may wait for the designer to pencil out the concept in thumbnail form. The thumbnail is a page-by-page layout of the entire report, in small enough scale so the entire report can be viewed as one entity, making the content of the pages and their pacing clear.

The techniques that designers use to present their layouts vary from designer to designer. Some presentations are very loose, with rough sketches and a "talk-through" by the designer. Some designers are good at painting a verbal picture of what to expect, and use a minimum of visuals. Most designers use a combination of thumbnails and representative pages, or "comps." Some show thumbnails initially, possibly more than one approach, and follow up that presentation with a more comprehensive one after a thumbnail has been approved.

I prefer to show a half-scale thumbnail layout along with comprehensive mock-ups of the cover and several spreads. With this method, the client has an overall view of the report, with several spreads that give an exact feel for its design.

Other firms prefer to show a very comprehensive dummy to begin with. "We do very complex dummies of all the report's pages using scrap that illustrates our point of view," says Arnold Saks of the New York design firm Arnold Saks Associates. "We get the client to sign off on the dummy at the beginning; then the photographer uses it to go by on the shoot. If ever there is a problem, we say, 'Let's look at the dummy'."

Whatever the approach, the client, designer and writer should all agree on the layout or dummy before the actual text and photography or illustration for the report begins production. This is the plan for the report, visualized. If confusion appears later in the process, the dummy will serve as a map or guide for the report.

Production Cost Quotes

The layout and quoting process should be considered together. The designer should have a general budget in mind to help guide the preliminary layouts. Once the thumbnail is finished, the quoting process should begin. The costs of all the elements should be estimated: design and production, writing, photography or illustration, retouching, typography, printing prep, printing and delivery. A detailed list of specifications for the printer (or group of competing printers) should be drawn up. The printer needs to know the report's print quantity, trim size, number of pages, paper stocks, color subjects and extra inks or varnishing requirements—as well as the client's binding preference and schedule demands.

To the uninitiated, photography may seem like a very simple practice: Point the camera, and in a sixtieth of a second the photograph is made. In reality, a typical photograph for an annual report, such as this photograph (1) by Mason Morfit from the 1987 Intermedics report, may take one to four hours to set up.

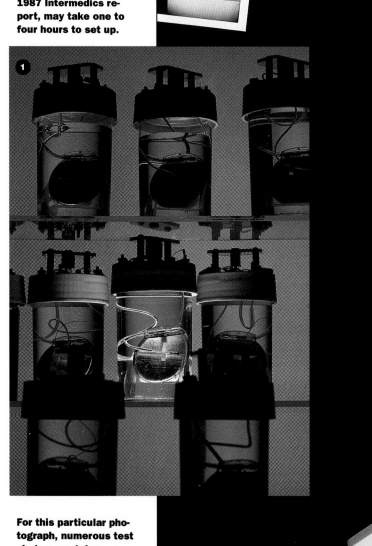

For this particular photograph, numerous test shots were taken on Polaroid film (2) before the final film was shot. Then four rolls of 35 mm film (3) were shot with only the slightest variation in lighting, exposure, or positioning. The result was 144 exposures that produced one final image.

Photography

One of the most compelling aspects of any report is its photography. The look and feel of the company, its products and people, more often than not are communicated through this medium.

There are several important considerations: which photographer to use, whether to use more than one, whether to buy stock or original photographs, the cost of location photography, rights and usage issues, model releases and compensation.

Typically, the decisions on whether to use stock or original photographs—and one or more photographers—are based on the illustration demands of the report. If the report calls for a variety of generic locations around the world, stock photographs would be more efficient and economical. If the report calls for photographs of specific factories around the world, original photography will be required, but individual photographers in separate locations may be chosen. By and large, one photographer for an annual report is the preferred route, as one eye will create the evenness and clarity in the images that one voice will in the text.

If the budget will allow, the designer should accompany the photographer on location. The designer will concentrate on subject matter and appropriateness of the images, while the photographer is free to concentrate on the light and composition. When photos are taken at a company location, or the location of a company's client, a representative of the company should accompany the photographer and designer.

Rights and Usage.

One area of great confusion to many first-time annual report producers is the concept of photographic rights ownership. Simply stated, when purchasing photography the company is buying the right to use the image, not to own the actual, physical photograph.

This concept is part of the Copyright Act of 1976, and it states that the creator of an image, in this case a photographer creating an image on each piece of exposed film, is the owner of the copyright to this work, and will remain the owner until that right is transferred to another party.

Many businesses are confused by this, thinking that when they pay a photographer a day rate, film and processing charges and travel expenses, this makes the images theirs to own. This is not the law. The company is buying the right to reproduce these images for a specified purpose, and the photographs must then be returned to the photographer.

There are many variations on this arrangement. The photographer can agree up front that the images will belong to the company, or that only the images used in the report will belong to the company, or that the images may be used for one year in company publications, and so on. The important thing to remember here is what the law is, and that anyone buying photography should have a clear understanding with the photographer *before* any work begins, so that there will be no misunderstandings

For some annual reports, stock—or existing—photography is appropriate. There are numerous stock photography agencies that will send existing photographs to a designer or company to use in an annual report. These agencies typically charge a research fee and delivery costs up front. The fees for using the photographs are based on the reproduction size of the photograph and the report's quantity.

after the fact. (See page 131 for photographic rights transfer form.)

Suggestions for On-Location Photography.
1) When it comes to a photo session, don't assume anything.
2) Don't wait until the last minute. Many companies don't begin planning their annual report until the fall, and this can cause real problems for photography. Locations that may have looked great in the spring or summer may not be so photogenic in the fall or winter. "I've gone to the store and bought hundreds of plants," says California photographer Mason Morfit, "just so I can simulate a summer feel in the middle of the winter."
3) Make all the arrangements ahead of time, personally if possible.
4) Confirm the arrangements in writing.
5) Double-check all itineraries. If you are taking the trip, go through the itinerary personally and make sure that all forms of needed transportation are in place. It may not occur to a secretary that a rental car will be needed, for instance, or that it should be a station wagon. Arriving at a remote location late at night with seven or eight large metal cases full of photography equipment is no time to find out that a vehicle was not planned for.
6) Make sure all necessary approvals are in place, and in writing. Just because you are working for the investor relations officer of a company doesn't mean that the head of the research lab will allow you to photograph that facility.
7) Take all the necessary paperwork along with you on the photo trip. One person may give you permission but may be out of town when you arrive to take the photo. The people in charge may not know about the session, and may not allow you to proceed without numerous calls and a lot of wasted time. Have photo releases with you. (See page 130 for a copy of a standard release.)
8) Never allow a photographer to go unassisted to a client of the company that is producing the report. Photography can be very intrusive, and there are many opportunities for misunderstandings and hurt feelings. No photograph is worth ill will on the part of your client's client.
9) Remember, you are a guest. A photography session at a plant or office is a disruptive occasion. Most people's experience of a photograph is that you point the camera and push the button. People may approve a photo session in a producing area of the plant, unaware that actually setting up lights, moving articles into place and posing the workers may in fact take hours.

The Executive Portrait.
There is probably no area of the annual report that will put the designer in more jeopardy of losing the client than directing the executive portrait or portraits. The portraits of top management will be closely scrutinized by the executives, their secretaries and wives or husbands. The pressure to please this group can be made very difficult for a variety of reasons, not

the least of which is that executives, like the rest of us, are highly critical of photographs of themselves.

It is awkward for most executives to be photographed; it is something that doesn't happen every day.

Here are some of the problems you may encounter:

1) The executive may come with a preconceived idea of what he or she wants to look like. Someone has said, "Look serious," or "You look so much better when your teeth don't show." It was well-meaning advice, but it will make the person more self-conscious and less directable.

2) Executives are busy people and often haven't allowed the kind of time it may take to execute a good photograph. If the session starts to exceed the time the executive has allotted, he or she may become edgy or irritated, or may up and leave.

3) The executive may not have been aware of some special situation, such as being photographed with a prop, outside or in a different location.

4) The executive may show up with wrinkled clothing or a five o'clock shadow.

5) Two executives may need to be photographed together, yet have differences of height, personality, and even skin tone—one may have pale, yellowish skin, while the other is overly ruddy in complexion.

Suggestions for Executive Photography.

1) Reconfirm the photo session with the executive's secretary. Make sure the person is aware of the place, time, time needed and any demands that will be made (such as the fact that the photo will be taken in the middle of a factory floor.)

2) Scout the location of the portrait ahead of time. Whether the photo will be taken in the studio, the office or another location, be aware of any problems and circumstances in advance.

3) Set up the photo with a stand-in. Set the lighting, the props (chairs and so on) and the crop.

4) If possible, take the photograph first thing in the morning, when the person is fresh, before the beard has grown or the makeup faded.

5) Be ready to take the photo in a hurry. By preparing for the portrait ahead of time, you can ensure that the executive's time will be well used.

6) Keep everyone else away from the scene of the photograph. Secretaries, other executives or workers should be kept out of the area to eliminate distractions. If possible, schedule the photographs on a weekend, when the office will be your own.

7) Talk to the person. Put him or her at ease. But be aware enough of the company's business not to say anything that may be upsetting. If there have been layoffs, or a drop in earnings or sales, certain small talk may rub the person the wrong way. You are trying to relax the executive long enough to take a good photograph, so keep working while you carry on a conversation.

8) Be prepared to respond to the person's ideas, such as "I want to be photographed in my shirt sleeves" or "How about if I stand instead of sit?"

Every illustrator has a different way of working. However, many follow the basic method used by James McMullan to produce a series of illustrations for Southwestern Bell: McMullan photographed models (1) in general poses that he had in mind for the final illustration and used these as his source for the initial sketches (2) that were shown to the designer and client for approval. If changes were indicated, they were made in the sketch phase with slight adjustments to the existing drawings or with totally new and different drawings before the final work (3) was executed. Instead of taking their own photographs, some illustrators may use existing photographs or live models for their original sources.

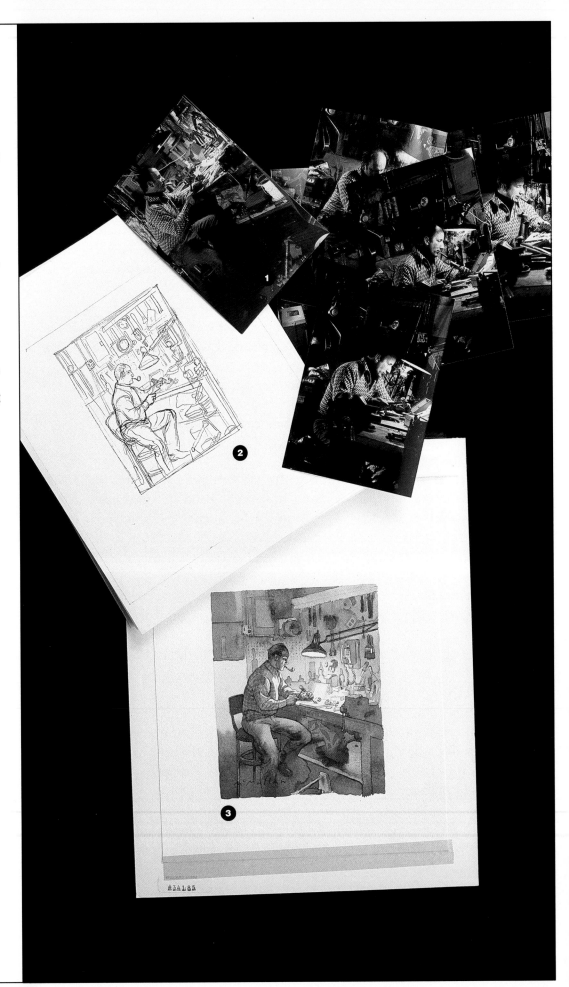

Illustration

Using illustration in an annual report is an art in itself.

When used well, illustration has the ability to excite the imagination, convey difficult concepts or entertain us. It can be provocative or soothing, cartoonish or serious. What it should not try to be, in my opinion, is a substitute for photography: a representational drawing when a photograph is just not handy.

There are inherent problems in working with illustration for a report. Something is about to be created that doesn't exist, that can't be totally judged until it does exist. The artist will be chosen on the basis of a portfolio, then asked to apply those skills and styles to the project at hand. The process is time-consuming and based on differing expectations. "I might start with a rough pencil, to work out the basic elements," states noted illustrator James McMullan. "The client will see this, then I'll do a color sketch. This may in fact be the finish. If the client doesn't like a part or an area of the sketch, I would really prefer to start over. You can't just 'fix' the drawing. It is something very different when you try."

Choosing the right artist for the assignment is the first task, because a designer will generally have a style or visual approach in mind when forming a concept for the report. Each illustrator works differently. Some will readily work from a designer's sketch; others will decline the project if they are not a part of the conceiving of the drawings. Still others will decline if they are not totally in control of the concept.

How a finished illustration is arrived at also varies from illustrator to illustrator, but in general, the stages are as follows:

1) *Reference material.* Illustrations very rarely spring from the raw imagination of an artist. They are generally based on "reference" (which may be live models or objects, existing photographs, photographs taken by the artist of specific locations or objects) or on "scrap"—those pieces of magazine or newspaper clippings that the artist collects over time for further referral. Scrap may be people in different poses, objects such as chairs or rugs, scenes such as landscapes or industrial settings . . . or even the client's product catalog.

2) *The sketch or tissue.* Using the collected reference material, the artist will create a rough sketch that can be submitted for approval. Any problems should be addressed at this stage, because corrections to the final art range from difficult to impossible. The sketch is usually executed in pencil. A color study may also be produced, which is a rough rendering in color that can capture the mood or feeling of the illustration.

3) *Finished art.* The final art will be ready to be separated for printing. As with photography, the right to own this work resides with the artist, unless prior arrangements have been made. The client is buying the right to reproduce the illustration for a one-time use, and the art will be returned to the artist after the report is printed.

Bar chart.
Bar charts are best used for comparing quantities. Each bar represents a quantity, which can be compared to another bar on the same scale. Trends can be compared using time and quantities (left), or an overall trend can be explained using the various elements making up the trend (right).

Grain Exports
In millions of bushels

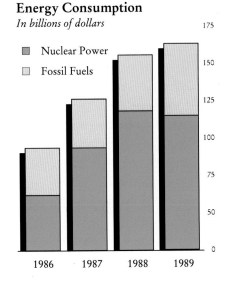

Energy Consumption
In billions of dollars

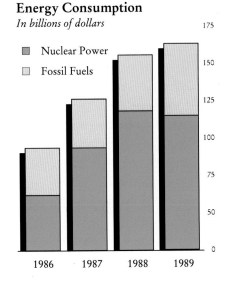

Pie Chart.
Pie charts are best used to compare percentages, or the elements making up one entity (left). Using the same information, one or more areas can be highlighted by pulling out that piece of the pie (right).

Annual Grain Exports
In millions of bushels

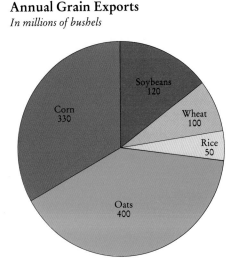

Annual Grain Exports

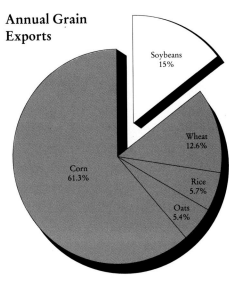

Fever Chart.
Fever charts are best suited to showing comparisions of amounts over a period of time, or trends. When information is plotted across a scale, all the points are connected by a line, and the trend can be easily recognized (left). When the lines do not overlap, areas of tone can be added to create masses (right), which helps readability when more than two items are being compared.

Annual Sales
In millions of dollars

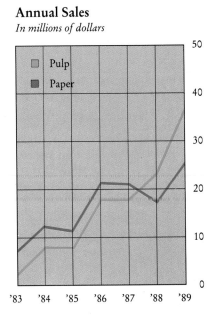

Annual Sales
In millions of dollars

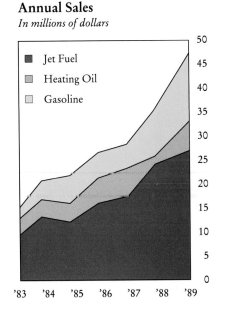

Charts

One would be hard-pressed to find many annual reports without charts. They are a major staple of the medium and have become the tool of choice for describing financial results and trends in a brief, dramatic form.

With the advent of desktop publishing, charts are now easier to produce by anyone near a computer, and they have become common ingredients of even the most mundane interoffice report.

The central challenge to the annual report designer is to create charts that are visually appealing while clearly communicating the information at hand. Charts have the potential to communicate large amounts of facts and figures in a quickly read graphic, but they also have the potential to befuddle, mislead or even misinform.

When preparing charts for an annual report, the corporate communicator and designer should question the central message to be expressed, then choose a chart form that helps the reader grasp the information. Most designers have computers that allow them to sketch out charts quickly to see how the relative values compare, and then work with the scale to make the charts appear the clearest.

Numbers don't lie, we are told, but they can leave out a great deal of meaning. Making a chart appear dramatic to highlight the information should be the goal of the designer, as long as the company's credibility is not put in jeopardy by manipulating the chart to add drama that is not inherently there.

Many charts are produced that look attractive yet are almost unreadable because the designer has taken extreme liberties with the form. Richard Saul Wurman chastises designers for this in *Information Anxiety*: "The low premium on clarity is due in part to graphic designers who operate more as cosmeticians—putting mascara instead of meaning on information. . . ."

Misleading charts can also be the result of companies pressuring the designer to be creative with the chart. For the annual report of a large bank, I once produced a series of charts that compared the results of the institution to the industry average. The results of the bank *were* better than the average, but only by very small percentages. To make the charts look better, the bars were bled off the bottom of the page, creating a base to the chart that was far higher than zero. The effect was to magnify the spread between the bank's performance and the industry average. (If the charts had been shown at that large scale with the base going down to zero, they would not have fit onto the 8½ x 11" page; they would have been nearly 2 feet long!) The information was in place for the reader to discern the true meaning of the charts, yet the impact was misleading.

Reports that have successfully used charts as major illustrations are exhibited on pages 102 and 103.

"The purpose of making a chart is to clarify or make visible the facts that otherwise would be buried in a mass of written material, lists, balance sheets, or reports."

Nigel Holmes,
Time *Magazine*

On this page are three styles of maps.

A very simple line style (top) is useful for location maps, where the number and type of facilities are important, and the geographical location can be approximate. A topographically rendered map (middle) can add a feel for the area that is being defined; generalized information, such as the pipeline system shown, can be overlaid. A stylized drawing (bottom) can relay ideas that do not need to be exactly defined, such as a sales region that may cover a certain broad area of the country.

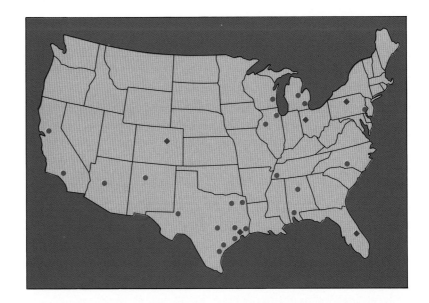

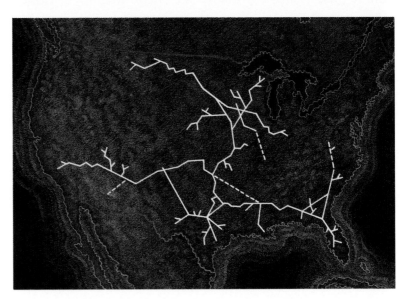

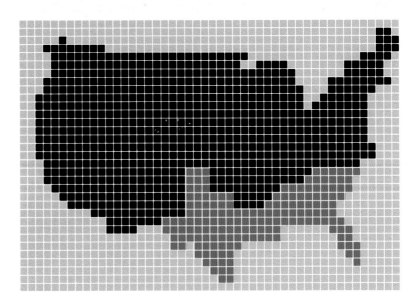

Maps

Many of the rules that apply to charts also apply to making maps. Like charts, maps graphically portray information and have the potential to enlighten or befuddle, or just take up space.

Before setting out to illustrate a map, the designer and corporate communicator should ask themselves, "What do we want someone to learn from this?" It is a simple enough start, but often skipped.

Designers will routinely map out a company's locations or sales areas when a typographical listing would be as effective. What will excite the reader about such a display? Has it grown in the past year? Should the former sales offices be compared to the current number? Has there been a geographical shift? What is the reader to infer from the map? If 10 offices have hundreds of employees and several have just a few, is a group of same-size dots misleading?

Chronic problems with map design are:

Too much art. Excessive stylization can be a hazard to communicating information. Trying to make a map "pretty" can draw the viewer away from the information, instead of into it. Choosing a style that fights the information can backfire as well. Very angular maps can be effective in some circumstances, for instance, yet may be totally inappropriate if the actual terrain is important. Peripheral items, such as decorative borders or deep drop shadows, can also distract from the point. Using such "borrowed interest" should make the designer stop and consider what is the purpose at hand—is it to make a pleasing illustration or give the reader a set of useful facts?

Wrong scale. The area that is being mapped should be carefully thought out. We have all seen maps of the United States that had most of the information in the upper right corner or within 100 miles of Chicago. A full map of the United States may not be needed.

Too many layers. There are times when we are presented with one map when three would do nicely. Piling layer after layer of information on a map can be confusing, to say the least. Valuable information will be lost because of the conflicts caused by some information being portrayed in lines or rules, while other items are represented by symbols and still others by areas of color.

Inadequate legends. It doesn't help to lay out a mass of information and then not help the readers understand what they are looking at. Legends should help the reader find items quickly, with nonconflicting colors and shapes.

What then makes a good map? Clarity. If the message is clear, the map will have its own beauty. In a variation on the theme of form follows function, in map design, style should follow understanding.

"Maps aren't mirrors of reality: they are a means of understanding it. To accomplish this, mapmakers can reduce, distill, exaggerate, or abstract reality. Their mission is to capture the salient aspects of a particular reality that would enable someone to understand it"

from Information Anxiety *by Richard Saul Wurman*

An example of a compli-
cated photo composite
using multiple images
merged with the aid of
a computer. The final
image (large) is from
the 1988 Premark Inter-
national report, and is
made up of 12 indi-
vidual photographs.

Retouching, Image Enhancement and Creating Computer Images

Reality has a hard time keeping up with our perceptions. This is very true of photography, where we imagine a dramatic image in our mind, but find the actual location to be cluttered with traffic signs, damaged trees and lights missing. We travel thousands of miles to find that the street in front of our photo subject is under repair, or the truck carrying our product has a large dent in it.

Computer retouching and computer color separation have added new possibilities to the design process, and these advances are very prevalent in the annual report field. There are three basic areas of activity: fixing images that have flaws, enhancing areas of an existing image and creating new images using the computer's capabilities.

Fixing flaws. Retouching is an accepted practice to repair flaws in a photograph that, once repaired, leave the meaning of the photograph unchanged. For example, a man's five o'clock shadow in a portrait, telephone wires in a landscape, or stains or unsightly blemishes on machinery in an industrial scene are common flaws that can be repaired with the computer, and leave us with the impression that nothing has been changed.

Enhancing. Enhancing an area of a photograph is less drastic than conventional retouching, or fixing. In this process, an area may be lightened, or the color may be made more intense or brighter. Typical applications may include adding color to a sky that is overexposed in an otherwise good photograph or brightening the paint color on a vehicle. Changing the skin tone on individuals in a group photograph is often practiced to make the tones more compatible, where before one person may have looked too yellow and someone else too red.

Creating images. Photographs are fed into a computer with an imaging system which divides them into a grid of thousands of squares, or pixels. Each pixel holds the information of the color within the individual square, and this information can be altered or moved. The computer has the ability to combine multiple images, altering the color and perspective of the images until they appear as one. Common examples of multiple images: replacing a smog filled sky with one that is a clear blue or adding an executive to a group photograph that he or she was unable to be a part of. New applications use photographs as part of multi-image "photo illustrations," where many photographs or parts of photographs are merged together in an illustration style.

A clear dilemma arises: When does a computer-enhanced or -generated image help our understanding of a company or product, and when is it deceptive? A factory that has been idealized beyond anyone's expectation may be deceptive; taking a few parking signs out may not be. It is a call that needs to be made constantly, as technology allows us to create an unlimited array of images that are now being accepted as "real."

A typical example of solving a problem through retouching: the photograph of the AT&T building (top) was taken when the window-washing apparatus was extended. The retoucher duplicated the transparency (below), masking out the item to be removed in the duplicating process. The duplicate transparency then had a clear area on it where the window-washing apparatus was, which the retoucher filled in with tone to match the sky.

The typesetting process begins with the text, supplied to the designer in hard copy (1) and/or on a disc (2). With a computer layout system, the text is arranged in pages using the original keystrokes supplied on the disc. A laser copy is printed (3), which is used for proofing. As the text is edited, additional laser prints are made (4) that reflect the changes. At the top of each page in a set of laser prints is the time and date of its printout. This ensures that everyone involved has the most current update. When the final changes are made, the information is loaded on a disc (5) and sent to a service bureau to be set on photographic paper. The high-quality reproducible galleys (6) are used to make the mechanicals that will be sent to the printer.

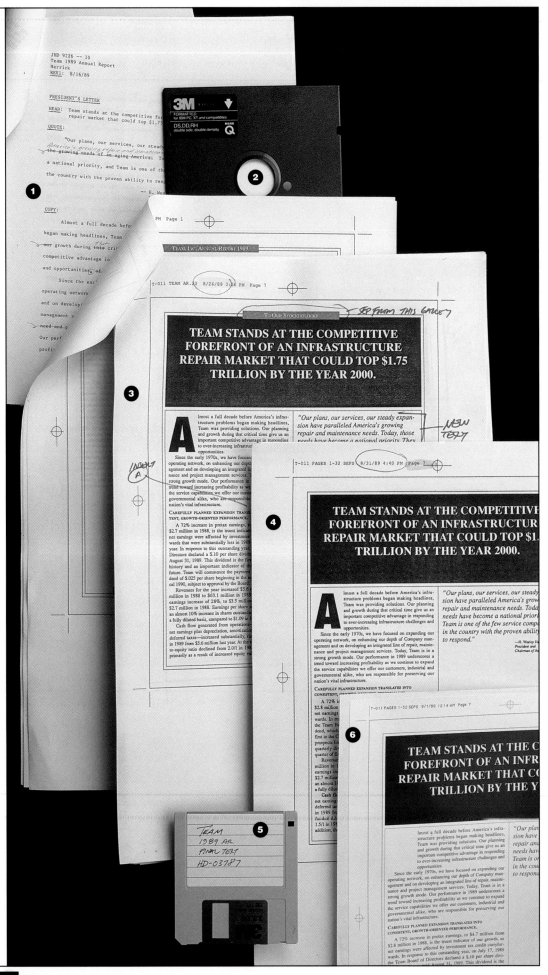

Typesetting

In the last 20 years, typesetting has made major advances, from individual characters cast in lead and arranged in "slugs" to make lines of type on a page, to computers with multiple typefaces available at a single command. Where once type was set by a printer or typesetter, now there are multiple options available.

Traditional typesetting. Using a typesetting supplier, the designer can send the text to the typesetter in the form of typewritten pages, or on a computer disc. The advantage of sending a disc is that the keystrokes will not have to be duplicated, cutting out part of the cost of typesetting, and reducing the amount of human error that can occur. (See page 140 for help in preparing word-processed copy for the typesetter.) The typesetter will take the typewritten pages or disc, and, following the designer's instructions, produce galleys that consist of running columns of type, in the correct type size, face and column width. Or the galleys can be paginated, with the typeset columns in place on the page as they will appear in the final report.

The setting of the financial section can be produced as stated above. However, the addition of multiple tabs for columns of figures can make it difficult for a typesetter to "read" the client's disc.

Electronic typesetting. Many design firms, and some companies, now have typesetting and pagination systems. Using these computer systems, the design firm will take a disc from the client (or receive the keystroked text over the phone lines using a modem), enter the text into the system, and produce pages that are formatted to appear like the final report. The pages will be printed out using a laser printer. These pages are not of reproduction quality, but are used for proofing. Once the proofing is completed, the pages are sent (by modem or disc) to a typesetting supplier and printed out in reproducible pages.

The advantage to this approach is that the designer gains more hands-on control of the pages by putting rules, headlines, captions and so on in place. Corrections can be made easily, and problems with text running too long or too short can be dealt with immediately.

The disadvantages to this approach are that most designers are not as proficient as typesetters are in the areas of accuracy, speed and proofing. And these computer systems are not as sophisticated as the typesetter's equipment, which narrows the designer's ability to generate as good a product. However, this is an area in which the technologies are rapidly advancing, and new equipment, programs and expertise are appearing regularly.

Type specification. The SEC has guidelines that refer to type size in a report, and these are spelled out on page 145. Page 141 describes type proofing. Also refer to page 153 for a description of type size (point) and page 152 for type spacing (leading).

"The desktop computer is centralizing our responsibilities to become more directly involved in all aspects of the final product. From concept to finish we are being forced to become better writers, editors, proofreaders, typesetters and programers as well as keep our traditional roles as designers, illustrators, and printing experts."
Douglas May writing in the AIGA- Texas Newsletter.

When the mechanical (1) is ready for the printer, it should have the reproducible type galleys in place in page spreads. Printing instructions are marked on a tissue overlay (2). The photographs are photocopied to size and attached to the mechanical, in position and cropped.

Mechanicals

The process of preparing the report for the printer is called mechanical production. During this step mechanical boards or "pasteups" are prepared for each page spread of the report.

Each page is arranged precisely the way the printer will prepare the printing plates. The designer pastes the type into place on light cardboard mechanical boards, indicates the exact placement and size of all photographs and illustrations and attaches any overlays for charts or maps. A transparent tissue paper is then taped over these materials. Certain instructions to the printer, and final corrections to the copy, can be written onto this tissue without damaging the mechanical below.

Type. The type is put in place on the page, using the final reproduction-quality print from the typographer. This may come to the designer in columns that the designer will cut up and paste into place, or it may come in a totally arranged page. In the latter form, the type is said to be paginated and all the type on the page is in place, including captions and page numbers.

Photographs or illustrations. Photocopies or prints of the photographs or illustrations are put on the mechanicals to show the exact size and placement.

Charts and maps. Photocopies or notations of the chart or map art are put on the mechanicals, indicating size and position. Or the actual chart or map art may be placed on the mechanical, with the acetate overlays for type, legends, color bars, and so on taped to the mechanical.

Color instructions. On the margins of the mechanical board or on the tissue overlay, specific instructions dictate the color to be used for the type, for charts and for background areas, if desired.

Colors may be indicated by specifying the ink color to be used, such as "black" or "process blue," or by giving the screen combinations of the process colors to make up shades. For instance, the designer might write "80% red, 100% yellow" to specify a particular shade of red. Or the designer may place a color swatch on the mechanical and ask the printer to match this color using screens of the process colors.

Special ink colors may be indicated by using a swatch from a color system such as the PANTONE MATCHING SYSTEM®*, or by just giving the color's number, such as "PANTONE 417," which is a warm gray color.

Paper specification. The paper to be used should be indicated on the mechanical. If more than one kind of paper will be used, the mechanical should show where in the report the paper will change.

General instructions. The general instructions on the mechanical will include inks or varnishes to be used, or special instructions about problem areas, such as fit or images that cross the gutter (center) of the report. A date should be included, so that when corrections are made, the last date will indicate how current the mechanical is.

*Pantone, Inc.'s check-standard trademark for color reproduction and color reproduction materials.

Proofs used by the color separator and printer include: Cromalins or matchprints (1) of the photographs. Proofs are cropped to the exact size to be used in the final report. Small imperfections in the proof are circled. Larger corrections, such as making colors lighter or darker, less red or more blue, require new proofs. When the designer uses screen combinations in charts, maps or rules, small sample proofs of the combinations (2) are made before the screens are stripped together with the type and a final Cromalin proof (3) is produced. A blueline proof is made to indicate the placement of all elements in the report. The proof is bound as the report will be (4) and/or can be viewed flat with lines ruled for the trim (5). A flat color key of each press form will show the entire report with all the elements in place and in color (6), although the quality of the color will not be as good as the individual Cromalin proofs.

Separations, Proofs and Approvals

A milestone in the production of an annual report is the date when final mechanicals are delivered to the printer, thus signifying the beginning of the printing process. In actuality, many of the materials that will be printed are submitted long in advance. Photographs and illustrations, and in some cases maps and charts, must be delivered to the printer weeks in advance to begin the color preparation.

Color separations. To transform color photographs or illustrations to the printed page, color separations are made of the images. The images are separated into four colors that, when printed, will be blended by our eyes into the full color spectrum.

The image is translated from a photograph (generally a slide) to a set of four images that have been screened into dots. The designer wants the color-separated image to look as much like the original photograph as possible, while understanding that it will never be exactly the same. Judgment calls are made, with the designer and client agreeing to the proof that is the closest to the original photograph.

The proofs of the separations are called matchprints or Cromalins, which are plastic representations of the images made to specified sizes. Using these proofs, the designer and the client determine whether the color is too red or too dark, for instance. Areas of the proofs are marked up for the separator to work on, to improve the color or contrast. The separator then makes new proofs, and will continue to do so until a proof is signed off on. As the proofing process advances, the proofs should be dated and kept for referral. There are times when an earlier, rejected proof will become acceptable because no later proof comes any closer to the original photograph.

Blueline proofs. Bluelines (or brownlines or silver prints) are the proofs supplied by the printer to proof the type, and show the photographs and charts in place. These are one color-proofs, so photographs, illustrations or other color material will not appear in full color. The blueline will be folded and stapled together just like the finished report. It is a very good idea to also ask for a flat proof, one that shows how the form will be printed. It is much easier on the flat form to pick up problems of alignment, such as page numbers. A flat proof is also helpful for seeing what images will print next to each other on the printer's form.

Chart and map proofs. Charts and maps may be proofed using either a color key or a matchprint or Cromalin system. The printer uses a camera to translate the images to film, and strips in the screens that will make up the specified colors. These images will be proofed individually.

Approvals. The printer does not begin the printing process until each set of proofs is approved and signed. Each proof supplied has a signature card that the designer and/or the client signs, specifying that the proof is not acceptable and a new proof must be supplied, or is okay with changes, or, finally, is okay to print.

The two basic forms of printing differ in how paper is fed into the printing press. In the sheetfed process (top), individual sheets of paper are fed into the press, printing one side at a time. To print the reverse side, the paper is sent through the press again. A typical sheet is large enough to print eight pages of a report, although this can vary. The web process (middle) feeds paper through the press in a continuous sheet from a roll, printing both sides of the sheet at the same time. The paper is cut and folded into 16-page signatures at the end of the press.

A saddle-stitched report (1) is made up of folded sheets with two staples in the spine, while a double-saddle-stitched report (2) uses four staples to stitch two booklets into one cover. A perfect-bound report (3) has individual sheets side-stapled, sewn or glued together and then glued into a cover.

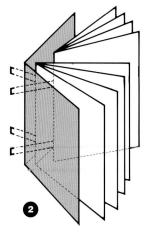

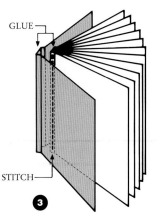

GLUE

STITCH

❶ ❷ ❸

Printing

The printing process is on one hand a very simple process, and on the other, a mysterious odyssey. There is hardly enough space here for a printing education; however, there are three key concepts that the novice needs to understand that will directly affect the annual report from the beginning. (This is aimed for the most part at the corporate communicator, because any designer who is approaching his or her first annual report without an average understanding of the printing process is in more trouble than I care to think about.)

Sheetfed versus web printing. The selection of the *kind* of printing press that the report will be printed on is a direct reflection of the number of copies to be printed, and to a lesser extent, the number of pages in the report. Not all printers have both capabilities; smaller to medium-size printers generally have only sheetfed presses.

Sheetfed presses feed flat sheets of paper through the press, one at a time. The press can print four, five or six colors at a time, on one side of the paper. To print the other side of the paper, the stack of printed sheets is inverted and run through the press again, this time with a different set of plates. The average sheetfed press will print a sheet with 16 pages on it. These sheets are then folded into signatures. The stack of signatures is then collated with the cover and stapled or glued together to form the report.

Web presses use a roll of continuous paper, and print at a very high rate of speed. The press prints a "form" that may be 8 or 16 pages. These pages come off of the press printed on both sides of the paper and folded together into one signature. The binding is the same as in sheetfed printing. Web presses can print from four to eight colors at a time.

Colors. As mentioned earlier, color printing is made up of four process colors: red, blue, yellow and black. The black ink is also used to print the type. The press may print other "colors," such as a special premixed color for type or a background, or a glossy varnish over the photographs.

Binding. There are three primary binding choices: stapled, double-stapled or perfect-bound.

Stapling is the most common way to bind a report, and is done by simply putting two staples through the spine. Reports with many pages should not be stapled, because they will shingle badly and bow at the spine. (Make a paper dummy to determine which binding to use.) Double stapling is used when two forms are bound together, such as the narrative pages on one paper and the financials on other. Then a total of four staples will be used.

Perfect binding uses glue to hold the pages to the cover, and has a boxed or squared-off spine. Perfect binding is used for reports consisting of many pages or multiple papers. Reports of fewer than 32 pages should not be perfect-bound, as a general rule. Perfect-binding a report with too few pages will severely test the spine's ability to last.

Generally speaking, sheetfed printing is of a higher quality than web, because of the speed at which webs print. However, for the average viewer the difference is not discernible. Most of the magazines we read, for instance, are printed on high-speed web presses.

The advantage of a stapled report is that it will open more easily and lie flatter. Perfect-bound reports have the advantage of consistent page size. In a stapled report of 24 or more pages, each page will be progressively narrower as the report approaches the middle. This is called shingling and is the result of folded paper.

At the press check the sheets being printed are checked against the Cromalins or match-prints for color (1), and the blueline (2) to make sure all the type is where it should be and to approve the color. After the client and/or designer signs the okay sheet (3), the full press run can begin.

On Press

The press check is the final act of control the designer has over the product that he or she has been working on for the past six to seven months. The press checks are the last chance to make corrections, and for this reason a company representative should be on hand. The types of changes that are made on press, aside from color adjustments, should be viewed as "disasters" if they were not made. An errant comma may not justify the time and expense of changing the printing plates; however, a wrong figure or a misspelled name does qualify.

Everything should be in order when the printer has been given the authority to print. "I don't think there is any better way to have a successful end to a beautiful book than very good preparation," states Corporate Graphic's Bennett Robinson. "Don't go on press unless all your proofs and Cromalins are in just perfect condition, exactly the way you want them. I know there are some who feel that 'we'll fix it at the printer.' However, you should not leave any of the creative part to the end."

On press, there are two major considerations. First, the report should be looked at one last time for accuracy. Second, the quality of the printing should be controlled.

A Short List of What to Look For on a Press Check.
1) Check all text corrections against the latest blueline proof.
2) Read the text on the printed sheet, checking to see whether any copy is missing or any errors appear.
3) Check to make sure that the type is clean and unbroken, and that there are no small pieces of trash printing on the sheet.
4) Make sure the four colors are in register. This is a starting point, because the color cannot be truly accurate if the colors are not registered. Hold a loupe, or magnifying glass, to the sheet. If the colors are not in register, one or more of the colors will "hang out," creating a very small line of color along the side of the image, such as a thin blue line.
5) Check the density of the ink. The press should be able to print many different forms consistently and will have a problem doing so if too much or not enough ink is being put down on the paper. Look at the text. If it is being printed in black, does it match the mechanical, the typeset type? If it does not, chances are the next form will be different, causing the text to fade or get darker as you thumb through the report. Keep a copy of the approved form to check future forms with, constantly being aware of how the different forms match up.
6) Check for "hickeys" and other imperfections in the images. Bits of dust and trash from the paper attach themselves to the printing rollers, causing little white spots or holes in the color.
7) Aside from checking the images against the proofs, do you like the color? Keeping in mind that the printed sheet will never look 100% like the proofs, are you pleased with how the images look? Common sense

"The phone rings. I check the clock radio with one eye open to see that it is 4:00 a.m. No, I'm not a doctor due to deliver a baby, and no, I am not going fishing . . . I'm a designer and I am due on press. Graphic designers go on press 24 hours a day, and this morning it is my turn to see how the ink is hitting the paper."
Robert Warkulwiz writing in the AIGA Philadelphia Views

"My theory is that printers do not actually have day shifts."
Jackie Wilson, Public Affairs, Lyondell Petrochemical Company

and your own judgment have to take over on press.

8) Make sure you are checking the printing in a good light. Most printers have corrected lights over the viewing stand, to look at the printing in the very best conditions. As a test, take a sheet into the next office and look at it under fluorescent light. That is probably where the CEO will look at it. Do the portraits still look good in this light? An image that may look marginally dark under the printer's corrected light may become unacceptable under fluorescents.

9) Be very aware of "gutter jumps," those pictures that spread from one page to another. It is critical that the sheet be cut apart and the two sides butted together to make sure the color is matching from page to page.

10) Put together binding samples as the project progresses on press, checking for lineup of photos, type and rules. Double-check the gutter jumps and color matchups with these samples. Also look for unwanted marks, such as trim or register marks that may not be getting trimmed off. In a large press sheet these are not obvious, but they will be very apparent in a trimmed copy.

11) Are the images "ghosting?" That is, is one image causing a band of lightness or darkness to go across another image? There is no one answer for this, but the printer can adjust for it.

12) If there is a fifth color, say a bar of color across the top of the page or special headlines in another color, make sure that it matches the color swatch. Ask the printer to check the fifth color with the densitometer. Check to make sure that the density is even across the entire sheet. It may look even to your eye; however, it could be several percentage points off, creating problems of matching when the reports are bound together.

13) If the press that is printing the report is a web press, the form will come off the press folded into a signature. The folding should be scrutinized, because once the reports are printed and folded on the web, nothing can be done in the bindery to change any alignment problems. If the report contains more than one signature, compare all the signatures to make sure they align properly. (Page numbers should not jump around, for example.

Once the form is up to the standards that the designer, company representative and printer are happy with, the printer will ask you to sign the sheet. This is the printer's record that you have approved this form. Should there be a discrepancy later on, your signed approval takes the liability off the printer's shoulders. The designer and the company representative should take sample sheets away at the same time for their reference, and it is a good idea to have the printer sign these copies. Once the designer has left the print shop, the printer may spend two to twenty hours printing the one form. There will be constant adjustments along the way to make sure that the printing matches the approved sheet.

Final Check

Before allowing the printed sheets to be cut and bound, have the printer prepare several bound samples to show management. These samples will be a preview of the finished report that will be delivered shortly, and they are the last "disaster check" available. If there is a problem, the alternatives to the designer are more acceptable than if the entire report has been cut and bound.

Say there is a broken character in a critical place in the book, such as the financial highlights on page 1. The printer can make a plate that will fill in the character, and run the sheet back through the press. I know this works because, unfortunately, I have had to do it.

If the problem is greater, say a problem in a photograph that no one knew about before, it is possible to reprint that one form, or a part of the form. This is expensive, to be sure, but if the report has 40 pages and the problem can be resolved by reprinting only 4, or 8 or 16, the problem has been reduced from an entire reprint.

Robert Miles Runyan tells the story about how he found that the wrong date had been printed on the cover of an annual report that had a print run of 40,000 copies. He was able to devise a creative solution to the problem by die-cutting the covers to view the correct date on the next page. Had the book already been bound, a complete reprint would have been needed.

Delivery

The end of the project for the designer is overseeing the delivery of the final product—the boxes and boxes of reports—to their final destination. This is no time to be taking a breather. Many months of time and effort—and many thousands of dollars—are about to be put in trucks and carted across town or across the country.

The designer and the corporate communicator should draw up a delivery schedule well in advance of the delivery due date. A list of delivery addresses should be made that includes the bank or registered agent, the mailing house and the corporate store house. Another list should be made up of departments or individuals who need copies immediately. Still another list should be made up of VIPs who will have one or two copies hand-delivered to their offices. These lists should include names of the people who will sign for the reports, their addresses and phone numbers, and the delivery method and carrier to be used. The printer and/or binder should have their delivery instructions well ahead of time.

Once the lists are in place, the reports finished and the deliveries begun, the designer should check to make sure the deliveries have actually been made, and on time. The names of the people who signed for the deliveries should be verified. Everything okay? Now break out the champagne.

Front Cover

The cover is the reader's introduction to the report, the first hint of what will follow. But more importantly, it is a billboard for the company. It will lie on desks and coffee tables across the country, promoting the company's corporate image. It should reflect the business or the attitude of the company. Whether a strong photographic image or an elegant type treatment on textured paper, the cover must set up the reader for the report and the company at the same time.

The only elements that need be on the cover are the name of the company and the year of the report. However, creative solutions may override even these bare essentials.

ENRON CORP

1987 Annual Report

The Report Elements

All annual reports are made up of the same basic elements. The challenge to the designer is to take the rigid structure of financial reporting and make the individual report come alive for the reader, creating a document that illustrates the company, that entertains and informs at the same time.

An annual report is first and foremost a financial document. Accountants are responsible for a majority of any report, and the structure they give to the information must be respected in the report's design. The structure of an annual report is also the product of tradition. Annual reports have evolved over the years, and people have come to expect the information to be organized in certain ways.

For these reasons, this section of the book details the major sections or areas of a typical report. The purpose here is to illustrate the subject and order of these elements, as opposed to illustrating design approaches. The examples shown in this section were chosen for their simplicity, to best describe the content of the various elements of a report.

Certain areas of a report are dictated by the SEC. These are pointed out on the following pages. A more extensive outline of what the SEC requires in a report is reproduced on pages 144–146.

Corporate Profile

On the inside front cover or opening spread, a brief description of the company should appear. The purpose of this profile is to allow the reader to learn what the company is about without having to read pages of text. The profile should summarize the company's primary business or businesses, its products or territories and any historical aspects that may be relevant.

Contents

A table of contents helps the reader locate the various areas of the report. This is particularly important in reports over 24 pages long.

Cover Caption

Captions are one of the more read elements in a report. If the content of the cover photograph or any inside illustration is not immediately self-evident, it should be captioned.
Beyond this purpose, the cover caption can also be used to set up the theme of the report.

Contents

On the Cover

Coming up with new, more innovative and cost effective ways to accomplish what may have become routine is just one way Enron employees contribute to the corporate goal of becoming the lowest cost transporter and supplier of natural gas in the industry.

Corporate Profile

Enron Corp. is an integrated natural gas company with revenues approaching $6 billion and assets of almost $8 billion. Its core businesses include the sale and transportation of natural gas to markets throughout the United States; the exploration for and production of crude oil and natural gas; the purchase, production, transportation, distribution and marketing of natural gas liquids, crude oil and refined petroleum products; and the production and sale of cogenerated electricity and steam.

Headquartered in Houston, Texas, Enron was formed in 1985 through the combination of InterNorth, Inc. and Houston Natural Gas Corporation. Since that time, the company has focused its operating commitment on its core businesses and has aggressively positioned itself to take advantage of its major asset: a 38,000-mile gas pipeline system that links all major producing areas in North America with three of the country's fastest growing markets—Texas, Florida and California. Enron also markets gas outside its traditional sales areas through its affiliated marketing operations.

The company and its subsidiaries operate the largest integrated natural gas pipeline system in the nation, selling and transporting an average of 6.4 billion cubic feet per day, which represents approximately 15 percent of all gas delivered to U.S. consumers in 1987. Major pipelines operated by Enron include Houston Pipe Line Company, Northern Natural Gas Company, Transwestern Pipeline Company, Florida Gas Transmission Company and Northern Border Pipeline Company.

Its exploration and production unit, Enron Oil & Gas Company, currently ranks as the third largest independent oil and gas company in the nation in terms of equivalent domestic energy reserves. It has total reserves of 1.7 trillion cubic feet equivalent, 85 percent of which is natural gas and 94 percent is domestic.

Enron's liquid fuels organization extracts, markets and transports natural gas liquids, crude oil and refined products in the Western Hemisphere, throughout Europe and in Japan. It is among the top six worldwide marketers of liquids. Principal companies include Enron Gas Processing Company, Enron Gas Liquids Marketing Company, Enron Liquids Pipeline Company, Enron Oil Trading & Transportation Company and Enron International, Inc.

Through partnerships in cogeneration facilities, Enron's affiliate, Enron Cogeneration Company, has become one of the largest independent U.S. producers of cogenerated electricity. Enron Cogeneration's project participation includes equity funding, contract negotiations, third-party financing and fuel procurement.

Financial Highlights

Enron Corp. and Subsidiaries

(Millions of Dollars, except per share amounts)	Year Ended December 31,				
	1987	1986	1985	1984	1983
Operating Revenues	**$5,916**	$ 7,453	$ 9,458	$6,743	$4,252
Income (Loss) From					
Continuing Operations	**$ 70.6**	$(107.9)	$ 115.4	$229.5	$222.4
Income (Loss) From					
Discontinued Operations	**$ (65.0)**	$ 185.5	$ 23.3	$ 35.0	$ (3.8)
Extraordinary Charge	**$ —**	$ —	$(218.0)	$ —	$ —
Net Income (Loss)	**$ 5.6**	$ 77.6	$ (79.3)	$264.5	$218.6
Earnings (Loss) Per Common Share					
From Continuing Operations					
Primary	**$.58**	$ (3.53)	$ 1.51	$ 4.08	$ 4.54
Fully Diluted	**$.58**	$ (3.53)	$ 1.51	$ 3.91	$ 4.42
Net Income (Loss) Per					
Common Share					
Primary	**$ (.86)**	$.66	$ (2.89)	$ 4.87	$ 4.45
Fully Diluted	**$ (.86)**	$.66	$ (2.89)	$ 4.58	$ 4.34
Dividends Paid Per Common Share	**$ 2.48**	$ 2.48	$ 2.48	$ 2.40	$ 2.22
Book Value Per Share	**$21.44**	$ 22.87	$ 27.73	$32.31	$31.00
Return on Average					
Stockholders' Equity*	**7.9%**	N/A	8.9%	15.4%	14.8%
Return on Average					
Invested Capital**	**10.3%**	5.9%	9.4%	10.4%	12.0%
Capital Expenditures	**$184.5**	$ 208.2	$ 557.3	$630.6	$241.9
Operating Cash Flow From					
Continuing Operations	**$563.0**	$ 432.7	$ 607.2	$547.5	$501.3
NYSE Price Range					
High	**$ 53½**	$ 50⅝	$ 54⅝	$ 42½	$ 41
Low	**$ 31**	$ 33¾	$ 39	$ 32¾	$ 24⅛
Close December 31	**$ 39⅛**	$ 39½	$ 45	$ 42¼	$ 39½

*Based upon income from continuing operations before extraordinary charge.

**Based upon income from continuing operations before interest and related charges.

Assets by Line of Business
(December 31, 1987)

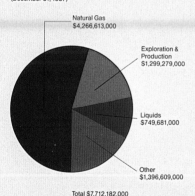

Natural Gas
$4,266,613,000

Exploration &
Production
$1,299,279,000

Liquids
$749,681,000

Other
$1,396,609,000

Total $7,712,182,000

1

Financial Highlights

This table is the capsulized version of the company's financial position: how the company performed for the year and how that year compared to the year or years past. The financial highlights are expected to be found on the opening spread, or second best, next to the letter to the shareholders. The style of this table varies according to the company's desire to put its best foot forward. Charts or graphs may be used to add information on this page or draw more attention to specific statistics contained in the highlights.

Letter to
Shareholders

The letter to shareholders (or stockholders) is the first editorial of the report, and it gives the CEO's (the chairman's and/or president's) view of the company, how it did and why, and how the company promises to do in the future. The letter should be written in the first person and should reflect the personal touch of the CEO. The letter allows the CEO to cover areas other than performance and financial issues, such as his philosophical reflections about the industry or his thanks to the employees. The name and title of the CEO should appear along with a signature. Analysts and shareholders alike expect to see a current photograph of the CEO. (If more than one person signs the letter, both should be pictured.) The date on the letter does not indicate the company's year-end, but rather reflects the day the CEO signs off on the content, usually just days before press time. Any major changes in the company's status, such as a merger or acquisition, should be reflected in the letter even though the activity was not a part of the past fiscal year.

maintenance costs per thousand cubic feet of gas delivered on our pipeline system have been reduced by almost one-fourth. Our goal is to continue to drive the unit costs down, to keep expanding our markets and to shape the environment which influences our profitability.

John M. Seidl

Outlook

Although 1987's financial results were neither what we had desired nor a banner year, they still were reasonable when viewed in an environment of sluggish industry conditions and the unforeseen oil trading loss. However, higher natural gas prices and a colder, more normal winter have started 1988 on a positive note, leading us to expect stronger results from our continuing operations in the future.

To take full advantage of the improved natural gas environment on the horizon, we recognize the need to remain committed to our top priority in 1988—reducing Enron's debt, both in absolute terms and as a percentage of total capitalization. We continue to make progress toward that goal. From its peak in the third quarter of 1985, Enron's total debt was reduced from $4.8 billion to a level of $4.0 billion by year end 1987.

We expect to make additional progress this year in strengthening the balance sheet through a number of transactions already under way. The addition of a strong partner to our cogeneration operations should bring in about $90 million, and changes in the income tax accounting standards on deferred taxes will have the effect of increasing stockholders' equity by more than $400 million in the first quarter. These changes alone will help Enron reduce debt to total capitalization by six percentage points.

We also expect to improve significantly our financial ratios and structure, and increase shareholder value through the sale of up to 20 percent of Enron Oil & Gas Company stock. Although our plans were delayed in 1987 because of stock market conditions, we remain committed to our original strategy and expect to proceed when the stock market improves.

In summary, there is ample reason to believe that the worst is over for the energy industry. The improvement in natural gas markets should ensure that 1988 will be a better year than 1987. Over the next few years, the entire energy sector should show strong growth. This would be even more likely if natural gas becomes the centerpiece of a national energy policy to reduce the nation's dependence on foreign oil.

The rapid growth in oil imports has severe national security implications and the increasing cost of oil imports has become troublesome as well. Petroleum imports rose to 40 percent of domestic consumption in 1987 and continue to increase. The cost of oil imports was estimated at $50 billion in 1987, up 35 percent from a year earlier and one of the primary

6

reasons that reduction of our country's trade deficit has become so difficult.

It is imperative for the United States to set a course that ultimately will stabilize and reduce oil imports. We think the centerpiece of such a policy should be increased use of natural gas, one of our nation's most abundant energy resources. It is a clean resource and one that rather quickly can be substituted for oil, thus reducing U.S. dependence on imported oil.

Additional Thoughts

During 1987, the company made two key personnel changes to further strengthen what already is considered to be one of the strongest management teams in the industry.

In September, Forrest Hoglund joined the company as chairman and chief executive officer of Enron Oil & Gas Company. Previously, Forrest was president and chief executive officer of Texas Oil & Gas Company, where he established one of the most successful track records within the industry over a 10-year period.

Effective in January 1988, Jack Tompkins became senior vice president and chief financial officer. Jack, a Certified Public Accountant and previously a partner with Arthur Andersen & Co., brings 15 years of experience with natural gas pipeline, exploration and production and liquid fuels businesses.

Kenneth L. Lay

The company also added highly regarded experience to its Board of Directors with the election of Robert Mosbacher in December 1987. Bob, chairman and chief executive officer of Mosbacher Energy, brings additional sound judgment and insight to an already outstanding board.

In closing, we want to take this opportunity to thank our shareholders, customers and employees for your continued support and confidence during these difficult times. Enron's management and Board of Directors are confident that this loyalty and commitment will be rewarded over time.

John M. Seidl
President and
Chief Operating Officer

Kenneth L. Lay
Chairman and
Chief Executive Officer

March 4, 1988

7

Special Sections

Aside from the normal report structure, some companies add special sections that explain the company further. These sections may be placed in any area of the book, although in most cases they are found just before or just after the letter to shareholders. These sections do not need to recur from year to year.

Shown here are three examples. The Year in Review from the 1979 Johnson & Johnson report (top left) listed major events in bold type followed by a more detailed explanation. The 1987 Kraft report (top right) showed product groups. And the Norton Company Business Profiles, from the 1988 report (bottom), gave the reader an outline of the company's products, markets, market position, market outlook and the highlights in these areas for the year.

Business Profiles

Norton Company, with more than 100 years' experience in materials engineering, is the world's leading manufacturer of abrasives, and produces technologically advanced ceramics, plastics, and products used in chemical processing. Through joint ventures, we are a leading supplier of performance drilling products and services for the energy industry.

Norton employs 16,100 people worldwide; we have 113 manufacturing plants throughout the United States and in 25 other countries.

Products

Bonded Abrasives

More than 250,000 types and sizes of grinding wheels, most custom-designed and engineered for specific applications. Natural and synthetic abrasive grains bonded into solid form, usually wheels but also other shapes.

Coated Abrasives

More than 38,000 types of coated abrasives (sandpaper) with a variety of abrasive grains and backings. Manufactured by adhering natural and synthetic grains to paper, cloth, fiber or synthetic backing. Made into belts, disks, rolls, sheets.

Superabrasives

Diamond and cubic boron nitride (CBN) grinding wheels. Diamond tools for precision grinding. Diamond powders and slurries for superfine finishing. Construction products include concrete cutting machines, laser welded blades, saw blades and core bits.

Advanced Ceramics

Fine ceramic powders and abrasive grains, specialty materials for abrasive and nonabrasive applications, structural refractories, refractory cements, igniters, bearings, wear-resistant products, semiconductor kiln furniture, armor for the military.

Performance Plastics

Specialty plastic products: fluid systems; foams, films and laminates; electromagnetic windows (radomes) for aerospace and defense; high-performance polymeric materials machined, molded or formed into tight tolerance parts and self-lubricated bearings.

Chemical Process Products

Random tower packing, structured tower packing and fractionation trays for separation. NOX (nitrogen oxide) removal, catalyst and catalyst carriers, heat transfer enhancement technology and radial elements. *Selexol* process for acid gas treatment.

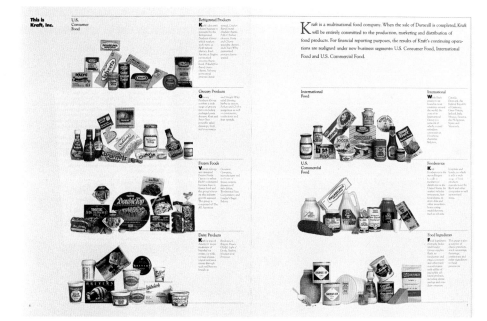

This is Kraft, Inc.

Kraft is a multinational food company. When the sale of Duracell is completed, Kraft will be entirely committed to the production, marketing and distribution of food products. For financial reporting purposes, the results of Kraft's continuing operations are realigned under new business segments: U.S. Consumer Food, International Food and U.S. Commercial Food.

Markets	Competitive Position	'88 Highlights	Outlook
Essential when metals, glass, ceramics or plastics are cut, shaped or finished. Major markets: metalworking, automotive, aerospace. Most U.S. and Brazilian sales through industrial distributors; European sales through industrial and direct distribution.	World's leading manufacturer. Many regional competitors. Leader in North America. Global competitors include Tyrolit and Noritake. Full-line supplier. Strengths in materials, technology, marketing contribute to continuing market share increases.	World plant specialization for lowest production cost. World plants near capacity. Acquired Micromold Italia S.p.A., world class supplier of superfinishing products. Launched *Norton SG* Seeded Gel wheels in North America and Europe.	Globalization of market accelerating as customer base shifts to developing countries. Low-cost wheels imported into all markets from Norton source plants. Cost position crucial. Growth through increased market penetration, distribution methods, new markets.
Necessary for grinding, sanding and polishing in metalworking, woodworking, automotive, glass and electronics industries. Also sold to consumer and automotive repair markets.	Share leading position in global market with 3M. Strong number two in U.S. market behind 3M. Market leader in Canada, Brazil, Australia. Norton has gained market share through acquisitions. Strengths are technical, materials and marketing expertise.	Growth in market share in all geographic markets. Launched new initiatives with major capital investments in process technology in the United States.	Market growth follows durable goods production. Shift in customer base to low-cost developing countries. Cost position and successful penetration of growth market segments is crucial. Consumer and automotive repair markets are long-term growth segments.
Superabrasive wheels and tools sold to carbide, glass, ceramic, electronics and aerospace manufacturers. Superabrasive construction products used in building and highway construction and repair, to cut and polish natural stone, and for cutting refractory material in factories.	Among the world's top three superabrasive producers. In construction products, an industry leader in fragmented global market. Improved customer service and increased participation in U.S. construction markets. Active worldwide sourcing.	Acquisition of Penhall Diamond Products Company. Record volume and profit gains in construction products due to cost control, strong European demand and increased presence in Europe, Japan and the United States. Increased global use of diamond and CBN micron products.	Strong growth potential due to increased demand for closer tolerances and more efficient abrasives. Expenditures for highway construction and maintenance, building renovation and industrialization in developing countries have favorable impact on worldwide demand.
Semiconductors, automotive market, ceramics, process heating, metal melting, military armor, home appliances, electronics for substrates, ceramic materials for grinding wheels and coated abrasives.	Many competitors in various segments of the global market. U.S. leader in ceramic materials technology. Leading supplier of silicon carbide and *Norzon* abrasive grain. Strengths in application know-how and custom design.	Broke ground for *Norton SG* Seeded Gel materials plant. Cerbec joint venture with The Torrington Company to produce and market bearings. Opened new alumina zirconia plant in Canada. Ceratronics joint venture with Toshiba Corporation to market specialty substrates.	Opportunities are ultra-fine powders, ceramic and hybrid ceramic bearings, wear products like pump and valve components and cutting tools, electronic substrates, engine components and military applications. Cost effectiveness and overcoming technical barriers are critical.
Used in aircraft, appliance, automotive, biotechnology, chemical, construction, food and beverage, electrical/electronic, environmental, laboratory, medical, pharmaceutical, semiconductor processing and transportation industries.	A leadership position in selected segments of the performance plastics market including flexible tubing for laboratory applications and sealants for automotive and construction industries. A world leader in fluoropolymer processing.	New product introductions for automotive industry. Sales offices opened in Far East and Europe. Reorganized to better meet customer needs. Worldwide business teams formed: Composites; Foams, Films Laminates; Fluid Systems; and Precision Products.	Customer base expanding due to globalization of markets and manufacturing. Growth potential due to increasing need for highly engineered, higher temperature components and composites in specific segments, and the increase in high performance plastics replacing metal.
Used in chemical and petrochemical processing, cogeneration and power generation, natural gas and landfill gas processing.	A world leader in random tower packing and liquid distribution technology. Largest worldwide producer of ethylene oxide catalyst carriers.	Acquired heat transfer enhancement technology. Implemented manufacturing agreement in Korea. Issued a license to market structured packing technology in Brazil.	Cycles in heat and mass transfer depend on capital and maintenance spending in the hydrocarbon processing industry, currently in a strong building mode. Legislation for air pollution control affects demand for NOX abatement catalyst.

5

Review of Operations

This area of the report discusses the particular makeup of the company. It is a review of all the operations of the company and is therefore structured along the lines of the company. Single-business companies, such as a hotel chain, may break up the section with types of services or varying locations. A corporation made up of multiple companies may devote a page or spread to each operating company or group of companies. A company with multiple products, such as a processed-foods manufacturer, may organize the pages around these products. Or the report may center on the major direction the company is moving, and treat the operating sections in the letter to shareholders or a simple table.

The reader is looking for the financial performance of the company's parts, as well as a feeling for the company's future earning ability. The photographs or illustrations should help relay this story and build confidence in the company's stock. Smaller companies, for instance, often show assets in the photographs, promoting the image of worth and stability to the reader.

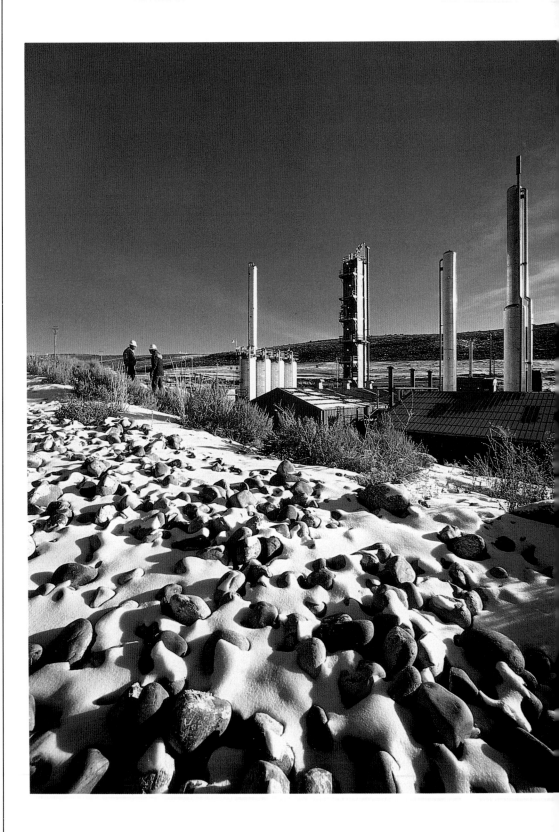

> **"In this new world of challenges, our performance will set us apart from the competition."**

The reorganization and consolidation of Enron's liquid fuels unit, which was initiated in 1986, began to have a positive impact on results during 1987. With cost cutting measures in place, management was able to take advantage of increased crude oil and natural gas liquids marketing margins to report earnings before adjustments of $51.8 million compared to a loss a year ago. Earnings after a $50.7 million charge, taken in the fourth quarter to cover pending settlements of two long-standing lawsuits, were $1.1 million compared to last year's loss of $300,000.

Improved Performance

A significant portion of the overall improvement in the liquid fuels organization can be attributed to management's critical review of all businesses, the elimination of unprofitable operations and the concentration on those businesses that have proven to be the most successful.

Enron Gas Processing (EGP) reported a 17 percent increase in volumes in 1987 due primarily to significant production increases in its Bushton, Kansas, ethane facility. Improved product prices, the elimination of unprofitable operations and timely maintenance and upgrading of facilities also contributed to performance.

To develop new business opportunities, EGP is exploring the possibilities of processing refinery fuel gases in partnership with others. Preliminary plans call for joint-venture construction of gas processing plants adjacent to chemical and refinery facilities like those along the Houston Ship Channel. Negotiations continue with several potential participants.

During the year, Enron consolidated its domestic and international liquids marketing organizations to achieve operational savings and efficiencies. The combination helped Enron Gas Liquids Marketing (EGLM) report a significant improvement in earnings. With the help of an experienced staff, EGLM expects to expand its international marketing effort. Early in 1988, EGLM added a new customer, who is a significant factor in the total Italian liquid fuels market.

Abnormally warm weather in early 1987 throughout its service area, coupled with reduced volumes during the crop drying season and the loss of a major customer who closed its syngas plant, resulted in reduced earnings for Enron Liquids Pipeline (ELP). The inauguration of an aggressive

Two Enron employees, Vern Langford (left), operations and maintenance supervisor, and Harry Wickstrom, get an overall view of Enron Gas Processing's Painter Plant, a nitrogen rejection facility near Evanston, Wyoming. Nitrogen injected into the oil and gas field to improve recovery must be removed from the gas stream before it can be transported through Enron's pipeline network. Gas from this area can flow into the Northern Natural Gas pipeline through Trailblazer Pipeline, an Enron affiliate.

Enron Liquid Fuels—
Percentage of Net Operating Income

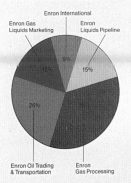

Enron International
Enron Gas Liquids Marketing
Enron Liquids Pipeline
9%
15%
15%
26%
Enron Oil Trading & Transportation
Enron Gas Processing

25

Financial Section

The financial section of a report may begin with another table of contents to help the reader use this section. Often there is a change in paper stock at this part of the report, especially if the report has a large quantity of pages. Another technique used to signify the financial section is to print a light color or a screen of a color on the sheet, giving the financial section a subdued feel.

Financial Review

Contents

**Management's Discussion and Analysis of
Financial Condition and Results of Operations**

Results of Operations

The following review of operations of Enron Corp. (the
Corporation) by major income statement caption for the
three-year period ended December 31, 1987, should be
read in conjunction with the accompanying consolidated
financial statements and supplemental financial data.
The acquisitions of Houston Natural Gas Corporation
(HNG), effective June 1, 1985, and the Falco companies
on July 1, 1984, contributed to the material changes
during 1986 and 1985 discussed below.

Operating Revenues. Operating revenues decreased
$1,538 million (21%) and $2,004 million (21%) during
1987 and 1986, respectively, while such revenues
increased $2,714 million (40%) in 1985, in each case as
compared to the prior year. The following table reflects
the revenue changes (in millions) experienced by each
segment of the Corporation's continuing operations.

	Increase (Decrease) From Prior Year		
	1987	**1986**	**1985**
Natural gas	$ (714)	$ (184)	$1,591
Exploration and production	(55)	(181)	50
Liquid fuels	(783)	(1,710)	1,161
Other	(5)	(6)	12
Intercompany sales	19	77	(100)
	$(1,538)	$(2,004)	$2,714

Natural gas. Revenues from natural gas operations
decreased during 1987 and 1986 primarily as a result
of reduced sales rates partially offset by increased
transportation volumes reflecting the implementation of
Federal Energy Regulatory Commission (FERC) Order
No. 436 by Northern Natural Gas Company and Trans-
western Pipeline Company. The declines in sales rates
reflect continued competition from alternate fuels and
increased spot market activity. Adding to the decline in
1986 were reduced sales volumes and rate reductions
associated with lower purchased gas costs. The inclu-
sion of HNG's operations limited the decreases in 1986,
and accounted for the increase in the previous year.
Without HNG's operations, natural gas revenues would
have decreased in 1985, due to declines in sales to pipe-
line customers and rate reductions placed into effect
during 1984 and 1985.

Exploration and production. During 1987, exploration and
production revenues declined as a result of the continu-
ing decline in natural gas sales volumes and prices, off-
set in part by a slight improvement in crude oil prices as
compared to 1986. During 1986 and 1985, revenues
were adversely affected by the collapse of crude oil and
natural gas prices as well as the cancellation of explora-
tion and production agreements in Peru during August
1985. However, the effects of increased production
related to the acquisition of HNG partially offset
decreases in 1986, and resulted in a net increase in 1985.

Liquid fuels. Revenues reported by the liquid fuels opera-
tions decreased during 1987 as a result of reduced liq-
uids marketing volumes, partly offset by increased
prices. Lower product prices combined with reduced
marketing volumes were the primary reasons for the rev-
enue decline during 1986. The addition of the Falco
companies' crude oil gathering, transporting and mar-
keting operations, as well as expansion of existing crude
oil and refined fuels gathering and liquids marketing
operations, were the main reasons revenues increased
in 1985.

Costs and Expenses. The cost of gas sold declined dur-
ing 1987 and 1986, reflecting reduced natural gas
prices. The 1986 decrease also reflects reduced pur-
chase volumes, partly offset by a $32 million year-end
write-down of natural gas inventory and the inclusion of
HNG's operations. The inclusion of HNG's natural gas
operations were primarily responsible for the higher
cost of gas sold in 1985. Lower prices and sales volumes
for the other natural gas operations partially offset the
1985 increase.

The cost of other products sold was lower in 1987 due
primarily to a reduction in marketing activities by the liq-
uid fuels operations. The decline in 1986 resulted from a
combination of lower liquids prices and reduced market-
ing activities in response to depressed market condi-
tions. An expansion of the same activities in 1985 was
responsible for increased costs in those years.

Operating expenses declined during 1987 primarily
as a result of cost reduction programs undertaken in
1986 and 1985. These programs included severance,
early retirement and relocation costs associated with
restructuring the Corporation's business units and clos-
ing the Omaha corporate offices. The Corporation
intends to seek recovery of those costs which are appli-
cable to its FERC regulated operations in future rate fil-
ings. Recovery of such costs would increase future
earnings; however, such recovery cannot be assured.
Increased operating expenses in 1986 and 1985 primar-
ily resulted from the inclusion of HNG's operating
expenses and the restructuring costs discussed above.
The 1986 increase was somewhat offset by the effects
of cost reduction efforts. In addition, nonrecurring
charges pertaining to the write-down of certain non-
productive assets affected results in 1985.

Oil and gas exploration expenses increased during
1987 primarily as a result of two major exploratory dry
holes. The decrease during 1986 was a result of a
reduced level of exploration activities as compared to the
prior year. The increase in 1985 was attributable to the
increase in exploratory drilling and reevaluation or
release of significant undeveloped properties. The 1985
expenses also included the impact of HNG's exploration
and production operations for the seven months ended
December 31, 1985.

31

**This page (or pages)
carries management's
overview of the compa-
ny's financial condition
and is a preview to the
financials to come. The
SEC requires this sec-
tion. It is not a part of
the audited financials,
however.**

Auditors' Report

The accounting firm that audits the company's financials makes a statement to be included in the report. The auditors' report must appear, and it must begin or follow the audited section of the report. The accounting firm will supply a signature, sometimes well in advance, sometimes just before the report is to be printed. The auditors wield a certain amount of authority over the financial section, and will review the galleys, mechanicals and proofs. The accounting firm may also send a representative to the press check as the report is being printed.

Statement of Management's Responsibility

This is the statement that the management of the company takes responsibility for the preparation and presentation of the financials. It is usually signed by the chief financial officer. This statement should be placed on the same page as, the page preceding or the page following the auditors' report.

Independent Auditors' Report

To the Stockholders
and Board of Directors of Enron Corp.:

We have examined the consolidated balance sheet of Enron Corp. (a Delaware corporation) and subsidiaries as of December 31, 1987 and 1986, and the related consolidated statements of income, cash flows and changes in stockholders' equity accounts for each of the three years in the period ended December 31, 1987. Our examinations were made in accordance with generally accepted auditing standards and, accordingly, included such tests of the accounting records and such other auditing procedures as we considered necessary in the circumstances. We did not examine the 1985 financial statements of Houston Natural Gas Corporation, a wholly-owned subsidiary, which statements reflect assets and operating revenues of 47% and 19%, respectively, of the related consolidated totals. These statements were examined by other auditors whose report has been furnished to us. Our opinion, insofar as it relates to amounts included for those entities, is based solely on the report of the other auditors except for retroactive adjustments with respect to Houston Natural Gas Corporation for the change in accounting for oil and gas operations to the successful efforts method in 1986.

In our opinion, based on our examinations and the report of the other auditors referred to above, the consolidated financial statements referred to above present fairly the financial position of Enron Corp. and subsidiaries as of December 31, 1987 and 1986, and the results of operations, cash flows and changes in stockholders' equity for each of the three years in the period ended December 31, 1987, in conformity with generally accepted accounting principles applied on a consistent basis.

Arthur Andersen & Co.

Arthur Andersen & Co.
Houston, Texas
February 19, 1988

Management's Responsibility for Financial Reporting

The following financial statements of Enron Corp. and subsidiaries were prepared by the management which is responsible for their integrity and objectivity. The statements have been prepared in conformity with generally accepted accounting principles appropriate in the circumstances and necessarily include some amounts that are based on the best estimates and judgments of management.

The system of internal controls of Enron Corp. and its subsidiaries is designed to provide reasonable assurance as to the reliability of financial records and the protection of assets. This system is augmented by written policies and guidelines, a strong program of internal audit and the careful selection and training of qualified personnel.

Arthur Andersen & Co. was engaged to examine the financial statements of Enron Corp. and its subsidiaries and issue reports thereon. Their examinations included a review of the Corporation's accounting systems, procedures and internal controls and tests and other auditing procedures sufficient to provide reasonable assurance that the financial statements are fairly presented. The Independent Auditors' Report appears to the left.

The adequacy of Enron Corp. and its subsidiaries' financial controls and the accounting principles employed in financial reporting are under the general oversight of the Audit Committee of the Board of Directors. No member of this committee is an officer or full-time employee of the Corporation. The independent auditors and the internal auditors have direct access to the Audit Committee, and they meet with the committee from time to time to discuss accounting, auditing and financial reporting matters.

Jack I. Tompkins

Jack I. Tompkins
Senior Vice President
and Chief Financial Officer

34

Statement of Consolidated Income

Enron Corp. and Subsidiaries

(In Thousands, Except Per Share Amounts)	Year Ended December 31,		
	1987	1986	1985
Revenues	**$5,915,766**	$7,453,338	$9,457,539
Costs and Expenses			
Cost of gas sold	**2,119,745**	2,693,576	2,886,894
Cost of other products sold	**2,077,166**	2,871,228	4,452,621
Operating expenses	**888,986**	1,109,843	1,089,778
Oil and gas exploration expenses	**41,411**	23,473	92,864
Depreciation, depletion and amortization	**306,553**	406,937	349,222
Taxes, other than income taxes	**77,516**	89,511	90,304
	5,511,377	7,194,568	8,961,683
Operating Income	**404,389**	258,770	495,856
Other Income and Deductions			
Equity in Earnings of Unconsolidated Subsidiaries	**50,573**	51,241	45,217
Interest Income	**39,310**	27,557	15,946
Other—net	**74,910**	(108,707)	(18,640)
Income Before Interest Expense and Income Taxes	**569,182**	228,861	538,379
Interest Expense—net	**483,993**	431,426	319,860
Income (Loss) From Continuing Operations			
Before Income Taxes and Extraordinary Charge	**85,189**	(202,565)	218,519
Taxes on Income	**14,592**	(94,684)	103,098
Income (Loss) From Continuing Operations			
Before Extraordinary Charge	**70,597**	(107,881)	115,421
Income (Loss) From Discontinued Operations	**(64,950)**	185,444	23,312
Income Before Extraordinary Charge	**5,647**	77,563	138,733
Extraordinary Charge	**—**	—	218,000
Net Income (Loss)	**5,647**	77,563	(79,267)
Preferred Stock Dividends	**44,605**	48,312	48,554
Earnings (Loss) on Common Stock	**$ (38,958)**	$ 29,251	$ (127,821)
Earnings (Loss) Per Share of Common Stock			
Continuing Operations	**$.58**	$ (3.53)	$ 1.51
Discontinued Operations	**(1.44)**	4.19	.53
Extraordinary Charge	**—**	—	(4.93)
	$ (.86)	$.66	$ (2.89)
Average Number of Common Shares	**45,100**	44,270	44,207

The accompanying notes are an integral part of these consolidated financial statements.

35

Financial Statements

The financial statements begin the financial section, and generally have one statement per page. This section usually includes the following tables:

Income statement (operations)
Balance sheet
Cash flow statement
Shareholders equity

The demand on this section is readability. The current year's figures may be highlighted, in bold type or reversed out of the background color. If the balance sheet crosses two pages, the bottom line of each side (the assets and the liabilities) should line up across the spread.

The company's name should appear on each page with the title of the table, and the line referring to the applicable notes must also appear below each table.

The notes are an
integral part of the
financials and must
follow the the financial
statements. The SEC
dictates that this sec-
tion be set in 10-point
type with 2-point
leading, or larger.

Tables in the text
may be set in 8-point
type, also with 2-point
leading.

Notes to Consolidated Financial Statements

1. Summary of Accounting Policies

A. Consolidation

The consolidated financial statements include the accounts of all majority-owned subsidiaries of Enron Corp. (the Corporation), except for its wholly-owned finance subsidiaries, after the elimination of significant intercompany accounts and transactions. Investments in unconsolidated subsidiaries are accounted for by the equity method (see Note 6).

B. Inventories

Inventories of liquid petroleum products are priced at the lower of cost or market. Gas in storage of $112.2 million and $84.9 million at December 31, 1987 and 1986, respectively, is priced at lower of cost or market.

C. Depreciation and Amortization

The provision for depreciation and amortization with respect to operations other than oil and gas producing activities (see below) is computed using the straight-line method based on estimated economic lives. Composite depreciation rates are applied to functional groups of property having similar economic characteristics.

D. Income Taxes

The Corporation and its includible subsidiaries file a consolidated federal income tax return. The Corporation utilizes deferred tax accounting for timing differences in the recognition of revenues and expenses for tax and financial reporting purposes.

In December 1987, the Financial Accounting Standards Board issued Statement of Financial Accounting Standards (SFAS) No. 96, "Accounting for Income Taxes." The new standards, which require an asset and liability approach to accounting for income taxes, will be adopted by the Corporation during 1988. Although the effects of the new standards are still being analyzed, the Corporation anticipates that the application of such standards (through the restatement of prior year financial statements) will have the effect of increasing stockholders' equity in excess of $400 million as of December 31, 1987.

The Corporation accounts for investment tax credits related to nonjurisdictional plant additions under the "flow through" method as a reduction in income taxes in the year earned. Pursuant to the revised requirements of the Federal Energy Regulatory Commission (FERC), investment tax credits related to jurisdictional plant additions placed in service on and after January 1, 1986, are to be deferred and amortized over the book lives of the related facilities. Except for certain transition property, the investment tax credit was repealed for plant additions placed in service on or after January 1, 1986.

The Corporation records as equity earnings in partnerships its share of the partnerships' pretax earnings. Income tax expense or benefits resulting from the partnerships are included in the Corporation's income tax expense.

Enron Oil & Gas Company, a wholly-owned subsidiary of the Corporation, has a net operating loss carryforward for tax purposes of $103 million related to the prior acquisition of an oil and gas company. The Internal Revenue Code imposes certain limitations on the amount of net operating loss carryforward which can be utilized in any particular year. The loss carryforward will be available in full until 1994, at which time it begins to expire. No benefit has been recognized for this net operating loss.

E. Earnings Per Share

Primary earnings per share is computed on the basis of the average number of common shares outstanding during the periods after recognition of the preferred stock dividend requirements. Dilutive common stock equivalents are not material and are therefore not included in the computation of primary earnings per share. Fully diluted earnings per share is not presented in the Statement of Consolidated Income because such amounts are the same as amounts computed for primary earnings per share.

F. Marketing Transactions

The Corporation reports as operating revenues the gross margin on liquids marketing transactions which do not affect traditional inventory. This reporting method reduced operating revenues and cost of sales by $2.6 billion in 1987, $1.8 billion in 1986, and $6.9 billion in 1985 as compared to reporting such marketing transactions on a gross revenue basis.

G. Accounting for Futures Contracts

Futures transactions are entered into primarily to hedge inventories and contracts to buy and sell crude oil and petroleum products in order to minimize the risk of market fluctuations. Changes in the market value of futures transactions are deferred until the gain or loss is recognized on the hedged inventory or fixed commitment.

H. Accounting for Oil and Gas Producing Activities

The Corporation accounts for its oil and gas exploration and production activities under the successful efforts method of accounting. Under such method, oil and gas lease acquisition costs are capitalized when incurred. Unproved properties with significant acquisition costs are assessed periodically for any impairment in value on a property-by-property basis, and any reduction in value is recognized currently. Unproved properties whose

acquisition costs are not individually significant are aggregated, and the portion of such costs estimated to ultimately prove nonproductive, based on historical experience and future expected abandonments, is amortized on an average holding period basis. As unproved properties are determined to be productive, the appropriate related costs are transferred to proved oil and gas properties. Lease rentals are expensed as incurred.

Oil and gas exploration costs, other than the costs of drilling exploratory wells, are charged to expense as incurred. The costs of drilling exploratory wells are capitalized pending determination of whether the wells have discovered proved commercial reserves. If proved reserves are not discovered, such drilling costs are charged against income. The costs of all development wells and related equipment used in the production of oil and gas reserves are capitalized.

Depreciation, depletion and amortization of oil and gas properties is calculated on a field-by-field basis using the unit-of-production method. Estimated future dismantlement, restoration and abandonment costs, net of salvage credits, are taken into account in determining depreciation, depletion and amortization.

I. Reclassifications

Certain reclassifications have been made in the 1986 and 1985 amounts to conform with 1987 classifications.

2. Acquisitions

Effective June 1, 1985, the Corporation acquired Houston Natural Gas Corporation (HNG), at an aggregate cost of $2.4 billion. This acquisition was accounted for by the purchase method. In connection with the acquisition, the Corporation entered into an agreement with the Federal Trade Commission (FTC), agreeing to sell its interests in certain pipeline joint ventures. Divesting of these pipeline and gathering facilities will not substantially affect the financial position or results of operations of the Corporation.

On a pro-forma basis, assuming that the acquisition of HNG occurred on January 1, 1985, the Corporation's operating revenues, income from continuing operations and net loss for the year ended December 31, 1985 would have been $10,937 million, $87 million ($.87 per share) and $108 million ($3.53 per share), respectively. Such amounts are not necessarily indicative of the results of operations that would have occurred had the acquisition been consummated on that date.

3. Discontinued Operations

During October 1987, the Corporation discontinued its speculative oil and petroleum products trading operations due to losses incurred from transactions as a result of unauthorized trading activities by certain

individuals engaged in such operations. Losses incurred for 1987 included a charge in the third quarter of $85 million, net of $57 million of applicable income tax benefits. Additionally, it was determined that the individuals engaged in the unauthorized trading activities also engaged in a series of unauthorized activities in 1984, 1985, 1986, and the first two quarters of 1987 designed to shift income (losses) between quarters in such years and between such years. In December 1987, the Corporation filed amendments to its 1986 Form 10-K and its Form 10-Q for the first and second quarters of 1987. Such amendments reflected the restatement of its consolidated results of operations to retroactively reflect the proper timing of income (losses) from and discontinuance of these operations. Accordingly, the financial statements and other information presented herein reflect the restatement as discussed above. The effect of the restatement on the Corporation's net income (loss) and earnings per share is presented below.

| (In Millions Except Per Share Amounts) | Net Income (Loss) | | | |
| | 1986 | | 1985 | |
	Amount	Per Share	Amount	Per Share
As Reported	$57.7	$.21	$(54.7)	$(2.33)
Adjustment	19.9	.45	(24.6)	(.56)
As Restated	$77.6	$.66	$(79.3)	$(2.89)

On November 5, 1986, the Corporation completed the sale of its petrochemicals operations for approximately $600 million. The sale resulted in an after-tax gain of $121.3 million or $2.74 per share.

On December 20, 1985, the Corporation sold its retail natural gas operations for approximately $250 million, resulting in an after-tax gain of $42 million or $.95 per share.

In December 1985, the Corporation wrote off its investment in its coal operations and established a reserve for the estimated costs of lease abandonments, sealing the mine and dismantling facilities. This charge reduced the Corporation's 1985 earnings by $10.2 million or $.23 per share.

41

This section, also referred to as the financial summary, or long-term financial summary, is a 5-year, 10-year or longer look at the company's financial performance, using key indicators such as assets, income and earnings. It is required by the SEC and is unaudited. This section can accompany management's discussion or can precede or follow the audited section of the report. If the auditors' report begins the financial section, the supplemental information following the notes signals the end of the audited area of the report.

Supplemental Financial Information (Unaudited)
Quarterly Results

(In Thousands, Except Per Share)	Operating Revenues	Gross Profit	Income (Loss) From Continuing Operations	Net Income (Loss)	Primary Earnings Per Share (a) Continuing Operations	Net Income (Loss)	Fully Diluted Earnings Per Share (a) Continuing Operations	Net Income (Loss)
1987								
First Quarter	$1,593,975	$512,907	$ 51,992	$ 66,678	$.90	$ 1.23	$.86	$ 1.14
Second Quarter	1,417,432	394,075	4,048	6,708	(.17)	(.11)	(.17)	(.11)
Third Quarter	1,461,636	392,514	9,601	(74,713)(b)	(.05)	(1.92)	(.05)	(1.92)
Fourth Quarter	1,442,723	419,359	4,956	6,974	(.08)	(.04)	(.08)	(.04)
1986								
First Quarter	$3,073,855	$645,516	$ 53,802	$114,188	$.93	$ 2.28	$.90	$ 2.04
Second Quarter	1,622,390	436,525	(15,686)	(13,390)	(.62)	(.57)	(.62)	(.57)
Third Quarter	1,276,524	381,897	(28,922)	(27,059)	(.91)	(.87)	(.91)	(.87)
Fourth Quarter	1,480,569	424,596	(117,075)	3,824	(3.01)	(.19)	(3.01)	(.19)

(a) As a result of activity in the Corporation's common stock held in treasury, primarily during the fourth quarter of 1986, the sum of primary earnings per share for the four quarters may not equal the total primary earnings per share for the year. Such treasury stock activity had a similar effect on fully diluted earnings per share.
(b) See Note 3 to the Consolidated Financial Statements for information on the discontinuance of the Corporation's speculative oil and petroleum products operations during the third quarter of 1987.

Common Share Price Range and Dividends

The following table indicates the high and low prices of the common stock and dividends for the quarters indicated:

	Price Range High	Low	Dividend Per Share
1987			
First Quarter	$48	$39½	$.62
Second Quarter	49¾	43⅝	.62
Third Quarter	53½	45¾	.62
Fourth Quarter	50½	31	.62
1986			
First Quarter	46¾	35¼	.62
Second Quarter	44⅛	33¾	.62
Third Quarter	50⅝	38⅛	.62
Fourth Quarter	46½	38	.62

Convertible Preferred Stock Price Range and Dividends

The following table indicates the high and low prices of the convertible preferred stock and dividends for the quarters indicated:

	Price Range High	Low	Dividend Per Share
1987			
First Quarter	$164	$142	$2.625
Second Quarter	168	160	2.625
Third Quarter	181	162	2.625
Fourth Quarter	173	117¼	2.625
1986			
First Quarter	155	130	2.625
Second Quarter	147½	134	2.625
Third Quarter	175	138⅝	2.625
Fourth Quarter	165	140	2.625

58

Selected Financial and Statistical Information (Unaudited)

	1987	1986	1985	1984	1983
Operating Revenues (millions)	$5,916	$ 7,453	$ 9,458	$6,743	$4,252
Total Assets (millions)	$7,712	$ 8,520	$ 9,570	$5,900	$4,847
Common Stock Statistics					
Income (loss) from continuing operations					
Total (millions)	$ 70.6	$(107.9)	$ 115.4	$229.5	$222.4
Per share—primary	$.58	$ (3.53)	$ 1.51	$ 4.08	$ 4.54
—fully diluted	$.58	$ (3.53)	$ 1.51	$ 3.91	$ 4.42
Earnings (loss) on common stock					
Total (millions)	$ (39.0)	$ 29.3	$(127.8)	$215.8	$197.3
Per share—primary	$ (.86)	$.66	$ (2.89)	$ 4.87	$ 4.45
—fully diluted	$ (.86)	$.66	$ (2.89)	$ 4.58	$ 4.34
Dividends					
Total (millions)	$111.6	$ 111.6	$ 109.8	$106.2	$ 98.3
Per share	$ 2.48	$ 2.48	$ 2.48	$ 2.40	$ 2.22
Book value per share	$21.44	$ 22.87	$ 27.73	$32.31	$31.00
Average number of shares outstanding (millions)	45.2	44.3	44.2	44.3	44.3
Market price range					
High	$ 53½	$ 50⅝	$ 54⅝	$ 42½	$ 41
Low	$ 31	$ 33¾	$ 39	$ 32¾	$ 24⅛
Market Price Ratios (a)					
Dividend payout	427.6%	N/A	164.2%	58.8%	48.9%
Yield	5.9%	5.9%	5.3%	6.4%	6.8%
Price/earnings ratio	72.8X	N/A	31.0X	9.2X	7.2X
Market price as a % of stockholders' equity	197.1%	184.5%	168.8%	116.5%	105.0%
Capitalization (millions)					
Short-term borrowings	$ 256	$ 757	$ 2,062	$ 396	$ 271
Long-term debt	3,712	3,512	2,294	1,243	1,190
Redeemable preferred stock	102	225	227	230	233
Stockholders' equity	1,180	1,203	1,466	1,683	1,628
Total Capitalization	$5,250	$ 5,697	$ 6,049	$3,552	$3,322
Profitability Indicators					
Income as a % of operating revenues (b)	1.2%	N/A	1.2%	3.4%	5.2%
Return on average invested capital (c)	10.3%	5.9%	9.4%	10.4%	12.0%
Return on average stockholders' equity (b)	7.9%	N/A	8.9%	15.4%	14.8%
Interest coverage					
Continuing operations					
Before taxes on income	1.2X	.6X	1.6X	4.3X	4.3X
After taxes on income	1.1X	.8X	1.3X	2.8X	2.7X
Net income	1.0X	1.2X	.8X	3.1X	2.7X

(a) The mean market price and primary earnings per share from continuing operations were used in the computation of these ratios wherever applicable.

(b) Income from continuing operations was used in the computation of these ratios.

(c) Income from continuing operations before interest and related charges was used in the computation of this ratio.

59

Listing of Board of Directors

This listing of the company's Board is required by the SEC, as is the reporting of the members' affiliations and titles. The purpose of this is to allow the investor to know how many of the members of the Board are not employed by the company. Companies may elect to expand the information about the Board, including biographical information that will help the reader understand the quality of the Board members. The listing of the Board is generally in the back of the report, in the last few pages or on the inside back cover.

Individual photographs of the board members or a group photograph may accompany the list, as in the spread below from the 1988 Reuters Holdings PLC report.

Board of Directors

Arthur B. Belfer
New York, New York. Enron Director since 1983. Chairman Emeritus of Belco Petroleum Corporation, a wholly owned subsidiary of Enron Corp. Former Chairman of the Board of Belco Petroleum Corporation.

Robert A. Belfer
New York, New York. Enron Director since 1983. Former President and Chairman of Belco Petroleum Corporation, a wholly owned subsidiary of Enron Corp. Director of NAC Re Corporation, Fenimore International Fund. AB degree, Columbia University; JD degree, Harvard University Law School.

Dan L. Dienstbier
Houston, Texas. Enron Director since 1986. Executive Vice President and President, Enron Gas Pipeline Group. From September 1985 until his appointment in May 1986 to his current position, he served as Enron's Executive Vice President, Gas Pipeline Operations. From 1981 until 1985, he was President of Northern Natural Gas Company, a division of Enron. BS degree, University of Nebraska, Omaha; MBA degree, Creighton University.

William F. Dinsmore
London, England. Enron Director since 1984. Retired General Partner, Hay Associates, a management consulting organization. BS degree, Johns Hopkins University, PhD degree, University of Pennsylvania.

John H. Duncan
Houston, Texas. Enron Director since 1985. Director and Partner of Duncan, Cooke & Co., an investment banking and advisory firm. Co-Founder, Gulf & Western Industries. Founder and Former Chairman, Gulf Consolidated Services, Inc. Director of Texas Commerce Bancshares, Inc. and Mosher, Inc. BBA degree, University of Texas.

Joe H. Foy
Houston, Texas. Enron Director since 1985. Partner, Bracewell & Patterson, Attorneys. Former President of Houston Natural Gas Corporation. Director of Central and South West Corporation and TGX Corporation. BA and JD degrees, Vanderbilt University.

Robert K. Jaedicke
Stanford, California. Enron Director since 1985. Dean and Professor of Accounting of Stanford University Graduate School of Business. Director of Homestake Mining Co., Boise Cascade Corporation, Wells Fargo & Company and California Water Service Company. BA and MBA degrees, University of Washington; PhD degree, University of Minnesota.

Kenneth L. Lay
Houston, Texas. Enron Director and Chief Executive Officer since 1985. Became Chairman of the Board during 1986. Director of Baker Hughes Incorporated, Compaq Computer Corporation and Texas Commerce Bancshares, Inc. BA and MA degrees, University of Missouri; PhD degree, University of Houston.

Charles A. LeMaistre
Houston, Texas. Enron Director since 1985. President of the University of Texas System Cancer Center. Former Chancellor of the University of Texas, Austin. Director of American Physicians Service Group, Inc. BA degree, University of Alabama; MD degree, Cornell University Medical College.

Robert A. Mosbacher, Sr.
Houston, Texas. Enron Director since 1987. Chairman of the Board of Mosbacher Energy Company, an independent oil and gas production company. Director of Texas Commerce Bancshares, Inc. and New York Life Insurance Company. BA degree, Washington and Lee University.

Ronald W. Roskens
Lincoln, Nebraska. Enron Director since 1979. President, University of Nebraska. Director of Guarantee Mutual Life Company, American Charter Federal Savings and Loan Association and Art's Way Manufacturing Co., Inc. BA and MA degrees, the University of Northern Iowa; PhD degree, University of Iowa.

John M. Seidl
Houston, Texas. Enron Director since 1986. President and Chief Operating Officer of Enron Corp. Former president of Natomas North America. Director of CRS Sirrine Co. BS degree, U.S. Military Academy; MA and PhD degrees, Harvard University.

Georgiana H. Sheldon
Arlington, Virginia. Enron Director since 1985. Consultant. Former Commissioner Federal Power Commission and its successor, the Federal Energy Regulatory Commission. BS degree, Keuka College; MS degree, Cornell University.

Charls E. Walker
Washington, D.C. Enron Director since 1985. Chairman of Charls E. Walker Associates, Inc., a governmental relations consulting firm. Former Deputy Secretary of the Treasury. Director of Potomac Electric Power Company and USF&G Corp. BA and MBA degrees, University of Texas; PhD degree, Wharton School, University of Pennsylvania.

Herbert S. Winokur, Jr.
Greenwich, Connecticut. Enron Director since 1985. President of Winokur & Associates Inc., an investment and management services firm, and Managing General Partner of Capricorn Investors, L.P., a private investment partnership. Former Senior Executive Vice President and Director of the Penn Central Corporation. Director of NAC Re Corporation, Paribas Trust for Institutions and Global Growth and Income Fund. BA, MA and PhD degrees, Harvard University.

Honorary Directors

Russell E. Dougherty
Arlington, Virginia. Enron Honorary Director since 1985. Director 1977–85. Retired Commander in Chief, Strategic Air Command. Attorney, of counsel to McGuire, Woods, Battle & Boothe. Institute of Defense Analysis and Aerospace Corp. BA degree, Western Kentucky University; JD degree, University of Louisville; Graduate, National War College.

David L. Grove
Armonk, New York. Enron Honorary Director since 1985. Director 1976–85. Retired Vice President and Chief Economist of International Business Machines Corporation. Presently, an economic and financial consultant, Director of General Public Utilities Corporation and several Aetna Funds. BA and PhD degrees, Harvard University.

John M. Harbert, III
Birmingham, Alabama. Enron Honorary Director since 1987. Director 1985–87. Chief Executive Officer and Chairman of the Board of the Harbert Corporation, a diversified company. Director of Birmingham Steel Corporation and AmSouth Bancorporation. BS degree, Auburn University.

P. Scott Linder
Lakeland, Florida. Enron Honorary Director since 1987. Director 1985–87. Chairman and Chief Executive Officer of Linder Industrial Machinery Company, a sales and service company. Director of General Telephone Company of Florida, Scotty's, Inc., Florida Progess Corporation and First Florida Bank, N.A. BS degree, University of Florida.

60

Principal Corporate Officers

Kenneth L. Lay
Chairman and Chief Executive Officer

John M. Seidl
President and Chief Operating Officer

Dan L. Dienstbier
*Executive Vice President and President,
Gas Pipeline Operations*

Richard D. Kinder
Executive Vice President, Chief of Staff

James G. Barnhart
*Senior Vice President, Administration &
Human Resources*

Royston C. Hughes
Senior Vice President, Federal Government Relations

J. Ronald Knorpp
Senior Vice President and Chief Information Officer

Gary W. Orloff
Senior Vice President and General Counsel

Jack I. Tompkins
Senior Vice President and Chief Financial Officer

Ross Workman
Senior Vice President, Corporate Affairs

Donald H. Gullquist
Vice President and Treasurer

Robert J. Hermann
Vice President, Tax

E. Joseph Hillings
Vice President, Federal Government Relations

Peggy B. Menchaca
Vice President and Secretary

E. G. Parks
Vice President and Controller

Louis E. Potempa
Vice President, Corporate Development

Edmund P. Segner, III
Vice President, Public and Investor Relations

Luther D. Snow
Vice President, Human Resources

Bruce N. Stram
Vice President, Corporate Planning

David G. Woytek
Vice President, Corporate Auditing

61

**The listing of the
officers of the company
generally accompanies
the listing of the Board.
The list of the names
and titles is required.
As with the Board, the
company may choose to
add biographical infor-
mation and portraits.
The lists of the Board
and officers appear on
the same page, when
brief enough to allow
for this.**

Corporate Information

Information the shareholder may need is listed on the last spread of the report. The section is called corporate information, corporate data or shareholder information and includes:

Corporate address
Transfer agent
Registrar
Auditors
Annual meeting date
Stock information
Contact information

Additional information on this page is at the company's discretion, and may include company divisions, plant locations, trade names and registered trademark information. The credits for the report may appear on this page as well, listing the suppliers such as the design firm, photographer and printer. If the company wishes to copyright the report, a copyright mark and date appear on this page. Reports distributed around the world may bear a MADE IN THE USA indication.

Stockholder Information

Corporate Headquarters
Enron Corp.
1400 Smith Street
Houston, Texas 77002
Telephone: (713) 853-6161

Principal Transfer Agent, Registrar, Dividend Paying and Reinvestment Plan Agent
Texas Commerce Bank National Association
Stock Transfer Department
P.O. Box 4631
Houston, Texas 77210-8038
(713) 236-4660

Auditors
Arthur Andersen & Co.
711 Louisiana Street
Houston, Texas 77002

1987 Annual Report
This Annual Report and the statements contained herein are submitted for the general information of the stockholders of the Corporation as such and are not intended to induce, or for use in connection with, the sale or purchase of securities.

Additional Information
The Corporation's Annual, Quarterly and Statistical Reports, Form 10-K and 10-Q reports to the Securities and Exchange Commission and certain other forms are available upon request by calling:

1-800-521-0583 (National), extension 55 or
1-800-492-6414 (Texas only), extension 55

For information regarding specific stockholder questions, write or call the Transfer Agent listed above, or:

Enron Corp.
Stockholder Relations Department
P.O. Box 1188
Suite 4844
Houston, Texas 77251-1188
800-228-2012
(713) 853-5455 collect

Financial analysts and investors who need additional information should call:

Enron Corp.
Investor Relations Department
P.O. Box 1188
Suite 50M04
Houston, Texas 77251-1188
(713) 853-5299 collect

Annual Meeting of Stockholders
The Annual Meeting of Stockholders will be held at 10 a.m. in Houston, Texas, at the Doubletree Hotel at Allen Center on Thursday, April 28, 1988. Information with respect to this meeting is contained in the Proxy Statement sent with this Annual Report to holders of record of the Corporation's common stock and the $10.50 cumulative second preferred convertible stock. The 1987 Annual Report is not to be considered a part of the proxy soliciting material.

Common Stock
Authorized 120,000,000 shares, outstanding at year end: 46,844,299 shares. The Corporation had 28,180 stockholders of record on December 31, 1987. The Corporation's common stock is listed on the New York Stock Exchange, Pacific Stock Exchange, Midwest Stock Exchange and London Stock Exchange.

Dividend Reinvestment Plan
Enron Corp. offers holders of its common stock the opportunity to participate in its Dividend Reinvestment Plan. This plan enables stockholders of record to purchase additional shares of common stock without payment of brokerage commissions or service charges. Stockholders wishing to participate in the Plan may, upon timely application:

—reinvest cash dividends paid on their common stock;
 or
—reinvest cash dividends and up to $2,000 per month in optional cash payments.

Complete details regarding the Dividend Reinvestment Plan are available in the official Plan prospectus. This prospectus may be obtained by contacting either Enron Corp. or the agent for the Plan:

Texas Commerce Bank National Association
Automatic Dividend Reinvestment Plan
P.O. Box 4631
Houston, Texas 77210-4631

Enrollment forms for the Plan also may be obtained from the Texas Commerce Bank National Association.

$10.50 Cumulative Second Preferred Convertible Stock
Outstanding at year end: 2,396,455 shares held by 464 stockholders of record. The Corporation's $10.50 cumulative second preferred convertible stock is listed on the New York Stock Exchange and the Midwest Stock Exchange. In addition to class voting rights set forth in the Certificate of Incorporation, holders may vote with holders of common stock as a single class on matters upon which stockholders are entitled to vote, and shall be entitled to a number of votes per share equal to the conversion rate in effect on the record date of the determination of stockholders entitled to vote at such meeting. The conversion rate is 3.413 at this writing.

62

Stock Splits

Six changes in the number of shares of the Corporation stock outstanding have been effected through splits or stock dividends. In 1932, a split "in reverse," 1-for-10, reduced the number of shares from 2,000,000 ($10 stated value per share) to 200,000 ($100 stated value). On June 5, 1941, there was a 5-for-1 split from 203,000 shares ($100 stated value) to 1,015,000 shares ($20 par value). A 2-for-1 split on September 11, 1947, increased the number of shares from 1,015,000 ($20 par value) to 2,030,000 shares ($10 par value). Since 1947 there have been three 2-for-1 splits effected through the payment of 100% stock dividends ($10 par value) as follows:

Stockholders of Record	Shares Outstanding Increased From	To
March 24, 1958	4,111,313	8,222,626
October 27, 1975	10,979,870	21,959,740
March 28, 1980	22,271,141	44,542,282

Stock Issues

Since December 16, 1947, all of the common stock of the Corporation has been held by the general public. Additional common shares have been sold through subscription rights to stockholders in eight offerings as shown in the following table (without adjustment to subsequent stock dividends):

Record Date	Additional Common Shares	Rights	Subscription Price Per Share
March 30, 1949	406,000	1-for-5	$29.50
May 3, 1950	304,500	1-for-8	31.50
May 5, 1953	548,100	1-for-5	32.25
May 25, 1954	365,400	1-for-9	38.00
January 28, 1958	456,813	1-for-8	47.75
October 17, 1961	428,981	1-for-20	35.00
October 21, 1970	634,760	1-for-15	41.50
September 21, 1971	683,259	1-for-15	44.00

On September 21, 1987, the Corporation exchanged a total of 1,073,578 shares of its $10.50 Cumulative Second Preferred Stock for 2,361,872 shares of its common stock at an exchange rate of 2.2 shares of common stock for each share of $10.50 Cumulative Second Preferred Stock tendered.

Back Cover

The back cover often carries the name, address and phone number of the company, with a logo or trademark if applicable. For reports that are self-mailed (without an envelope), the mailing indicia appear on the back cover.

An annual report can communicate on many different levels. It can tell a story or evoke a mood. It can, as in the case of the 1984 H.J. Heinz Company annual report, celebrate the company and its role in our lives, allowing us to remember the message and the company at the same time. This particular report was built around the theme "The Tomato: Why We So Love It." Artists illustrated the tomato and discussed their relationship with this everyday vegetable. Large black and white portraits of the artists accompanied the text, in contrast to the color in the images. The theme was carried throughout the business section of the report, with text printed in red and green, the colors of the tomato.

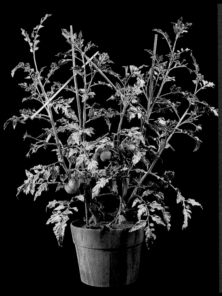

TOMATO PLANT, 1983
Fumio Yoshimura
Wood, American linden, 50 x 40

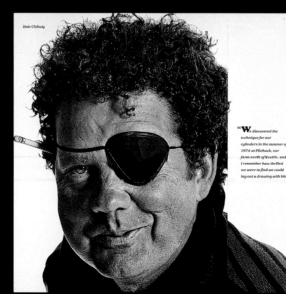

An Annual Report Review

Although all annual reports share most of the same basic ingredients, how those elements are visualized varies greatly. The excitement of annual report design may in fact grow out of the rigid annual report structure, because designers must invent new ways year after year to present much the same information.

The reports reviewed in this section of the book illustrate how various designers have carried out the task of designing reports. Some of these examples are considered to be among the finest reports ever produced; all are shown because they clearly illustrate different styles or objectives.

The 1979 report (top) of Lomas & Nettleton Financial Corporation, a mortgage company, compared forms in nature with industrialized forms to illustrate the focus of the text: a discussion of the needs of growth and our responsibility to the environment.

The 1980 report (bottom) for the same company displayed photographs of summer celebrations around the country (in places where L&N has branches) to illustrate the theme of the American family and the spirit of America. The company's business relies on the financing of homes, most often for families.

The Fourth of July in Willits, California; a part of the Frontier Days celebration observed in the home for over fifty years.

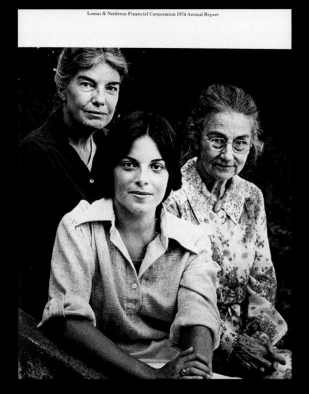

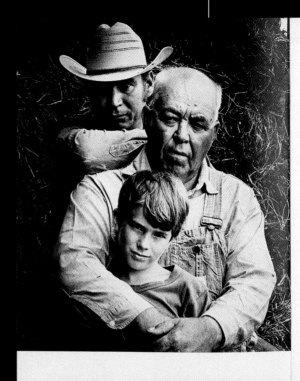

What could be more monotonous than the basic receptacle for the daily mail? Sheer exuberance triumphs over the drabness of the postal

The 1974 Lomas & Nettleton report (top) continued the emphasis on the family, featuring family generations. The opening text set out the theme: "Even in the face of what might seem overwhelming uncertainties, each generation has willingly undertaken the long-term commitments and raised its children in the hope of a greater happiness and self-fulfillment than its own generation might have known. It is to these generations of American families that our business is dedicated and on whom its future ultimately depends."

The 1981 L&N report (bottom) celebrated the home itself, with two-page spreads illustrating a detail of the home. The spread shown here is a collection of mailboxes. Other spreads featured doors, windows, lawns, and so on.

The National Gypsum Company, a manufacturer and supplier to the building and construction industry, stated in the introduction to its 1984 report, "As we move onward, we pay tribute to both the old and the new, for it is in the blending of the two that true progress is found most clearly." The report used engravings and photographs of historical architecture and architectural forms set against contemporary architecture. On spreads dominated by text, the theme was continued with details and captions in the side columns.

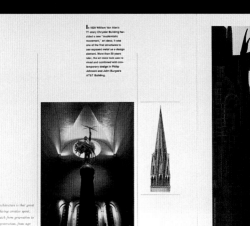

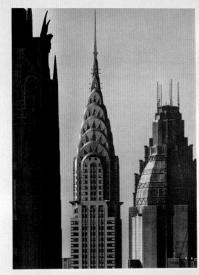

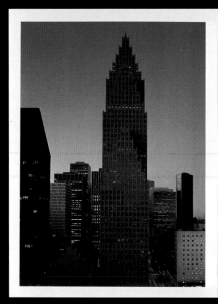

1
p.m.

A number of small but
important jobs at a hotel
or casino are
performed by the staff during
a midday lull.
From landscaping at
Harrah's Del Rio
to washing windows and making
beds at Holiday Inn,
our employees' attention to
detail shows just how much
they care.

2
p.m.

Cool, clear water
and comfortable lounge chairs all
in a row await the guests
at Holiday Inn-JFK International.
Pool attendant
Chris Fields stretches to
get the last bit of
debris off a pristine surface.
"The two things I try
never to run out of are patience
and extra towels.
Patience helps me get my pool
just right."

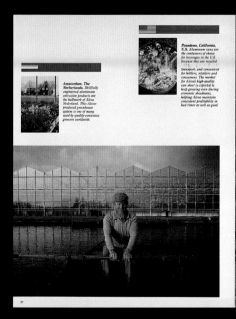

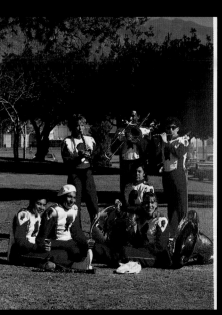

To emphasize that good hotel service goes beyond what the customer actually sees, the Holiday Corporation photographed "Behind the scenes—a day in the life of the Holiday Corporation." This 1988 report (top) took the reader through the employees' day with photos and large captions.

The 1988 Alcoa report (bottom) emphasized the company's international operations, with photographs from around the world. The captions were enhanced with a color bar including a national flag, reinforcing the concept for the reader page after page.

During the latter part of the 19th century, large numbers of Scandinavians and Finns came to America in search of rich Minnesota farmland promised by the Homestead Act of 1862.

As markets changed and technology improved, Northwest Paper moved from making newsprint to a raw stock for wall-paper to printing and business papers.

One of the state's more prolific hardwoods is aspen, once considered a weed species but now basic raw material for Potlatch Oxboard™ plants at Bemidji and Cook, and an important ingredient in Minnesota papers.

Minnesota's waterways filled a crucial need for the early mills at Cloquet and Brainerd. Dams played the dual role of collecting logs and supplying water and energy for the mills.

Potlatch's Duluth & Northeastern Railroad still makes regular runs between Cloquet and Saginaw, Minn., carrying pulpwood and paper-making chemicals.

Minnesota…a state of sharp contrasts and dramatic beauty. Vibrant autumns. Pristine, icy winters. Luxuriant green springs and summers. Still blue lakes mirror the surrounding forests. The quiet conveys a sense of time standing still. But the scenery is deceiving. With all its natural splendor, Minnesota is also a state of thriving industries. On these pages, we explore Potlatch's activities in northern Minnesota.

We are tree farmers and wood converters. From our 1.4 million acre land base in Arkansas, Idaho and Minnesota, we manage forests, harvest timber when it reaches proper size and convert this raw material to wood and fiber-based products.

It is Potlatch policy to manage and utilize the timber of the forest as it grows. As a result, each of our major operating bases is unique, defined by a region's climate and forests, which in turn determine the plant facilities located there and the end products produced.

Of our three land areas, Minnesota has the oldest logging history, dating back to around 1820, and those early years continue to influence its development today. Unlike Arkansas and Idaho, which manufacture primarily softwood-based forest products, the majority of the harvest in Minnesota is hardwoods.

In 1977, Potlatch announced a multi-phased strategy for Minnesota, aimed both at improving our position as a leader in our chosen segments of the printing and business papers industry, and at increasing our utilization of the state's abundant

hardwoods. In 1981, our Minnesota strategy became reality with startup at Bemidji of the nation's first oriented strand board plant. The year also saw completion of large parts of a $100 million modernization project at Cloquet.

But the story of what is now Potlatch in Minnesota really began at the end of the bonanza years of softwood timber logging in the upper Midwest. By 1899, white pine lumber production in Minnesota had peaked at nearly 2½ billion board feet annually. As virgin pine forests disappeared, lumber production fell rapidly and hit a low of only 111 million board feet in the late 1930s.

The Northwest Paper Co.—a division of Potlatch Corp. since 1964 and the nucleus of our current Minnesota operations—was formed in 1898 and prospered on the abundant spruce which had no commercial value as raw material for lumber. Rising demand for newsprint and availability of raw material and water power in Minnesota made papermaking a logical venture for the company's founders.

Originally, both the Cloquet mill, built on the St. Louis River in 1898, and the Brainerd mill, built on the Mississippi River in 1917, produced newsprint. Debarked logs were simply pressed against turning stones

Water is Minnesota's most pervasive resource, and nature has used it generously in creating more than 12,000 lakes throughout the state.

6

7

Many contemporary annual reports strive for a simple, open layout. The 1981 Potlatch report is an example of just how interesting a report with multiple images can be. This complex layout—with art, photographs, large text call-outs and captions—invited the reader to sample, reading bits and pieces while thumbing through the report. The major text invited reading as well, with sections begun by large initial caps.

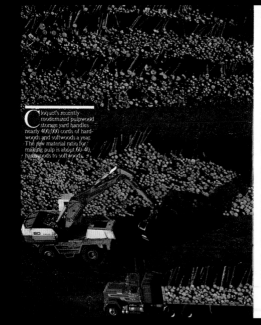

Cloquet's recently-modernized pulpwood storage yard handles nearly 400,000 cords of hardwoods and softwoods a year. The new material ratio for making pulp is about 60-40, hardwoods to softwoods.

A new coordinating plant to increase pulp mill chemical recovery was part of the $100 million modernization project at Cloquet.

To logmen river rapids, Indians and immigrants were feared and they carried millions of cotton candy garland until they reached calmer waters. One of these "portages" is located along the St. Louis River just below Cloquet.

Each year the "Land of 10,000 Lakes" attracts thousands of spectators who come to fish for the cottonwood yellow pike.

To begin river rapids...

An annual tradition in Minnesota is the St. Paul Winter Carnival.

Beaver pelts from Minnesota would for French traders as far back as the late 1800s.

—a key element of our Minnesota strategy: to develop and improve products, such as development of Makers™ Matte, a Northwest Paper coated printing paper introduced in November 1981, and to improve mill operating efficiencies and economics.

The center also conducts projects for other Potlatch operations, such as testing the pulping characteristics of southern and western tree species and improving the processes and products of bleached paperboard and tissue operations.

Another important and historically colorful part of our Minnesota operations is the Duluth & Northeastern Railroad (D&NE), a Potlatch subsidiary, which provides switching service at Cloquet and operates 11.4 miles of mainline track between Cloquet and Saginaw, Minn. The D&NE represents the only surviving portion of hundreds of miles of logging railroads that penetrated this area nearly a century ago.

The Minnesota wood products division is responsible for managing 247,651 acres of Potlatch-owned forestland in the state, procuring wood for all company facilities, constructing and operating the two

Unlike Arkansas and Idaho, the majority of the harvest in Minnesota is hardwoods. Utilizing this abundant yield has been an important phase of our Minnesota strategy, which became reality in 1981 with startup of the nation's first oriented strand board plant.

new oriented strand board plants and running the small-log stud mill at Cloquet. All wood is harvested by independent loggers, providing employment for more than 800 people throughout the northern portion of the state.

In northern Minnesota, the forest is about 70 percent hardwood, primarily aspen and birch, and 30 percent softwood. To assure a supply of the scarcer softwoods for the Cloquet mills, it has become necessary to harvest both hardwoods and softwoods as they grow together in the forests. However, this produces a surplus of hardwoods, mostly aspen.

Potlatch was faced with the challenge of finding a commercially profitable use for the surplus aspen. The answer came in the form of oriented strand board, a new structural panel we call Oxboard™

In June 1981, our first of two Oxboard plants began production in north-central Minnesota, at Bemidji. The plant employs 146 people, normally operates around the clock seven days a week, will consume 120,000 cords of aspen annually, and has a production capacity of 150 million square feet (⅜-inch basis) of panel products. Steam for the production process and heating is generated from wood-waste-fired boilers, making the plant more than 70 percent energy self-sufficient.

Construction of the second Oxboard plant is underway in northeast Minnesota near Cook. Startup is planned for mid-1982.

The Oxboard plants are an integral part of our Minnesota strategy. Part of the strategy is to manufacture a product near a market area that is substantial in size.

Another aspect of the strategy centers on the construction of wood concentration yards at both Oxboard plant sites and near Brainerd, as well. These yards take in wood from the surrounding area via truck. Aspen is consumed at the Oxboard plant, while softwoods are shipped

13

Want to grab attention? The 1984 TGI Friday's Inc. report (top) used unexpected, fanciful illustrations to promote the theories of the restaurant company. The cover illustrated the Triangle Theory: customers, employees and the company in balance to produce quality, growth and profits.

The 1986 Kemper Reinsurance Company report (bottom) used lighthearted images of a person in various spectacles to "look" at the company's results and potential.

Covers

The cover is a billboard for the report, selling the company, its name or logo, and the theme or message of the year's report.

The Mobil and Conrail covers (top) created powerful, colorful images while prominently displaying the company logo.

The Norton and Champion International reports (middle) made a company statement to start the reader thinking about the theme of the report. In Norton's case, the reader was told of results for the year (and introduced to the international theme of the report with the graphic treatment of the name), while the Champion report set the stage for the company's role in a larger industry.

First Bank System (bottom left) simply stated in words the company's philosophy. Dylex—a group of retail apparel stores—set the tone with a single colorful image (bottom right).

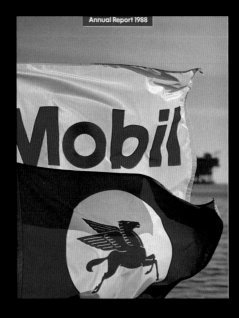

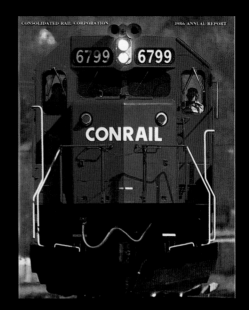

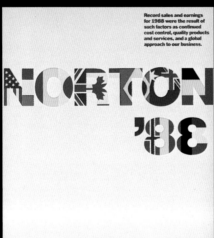

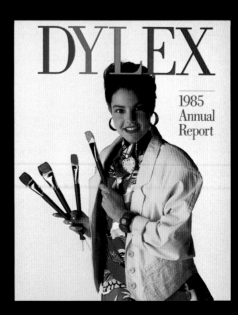

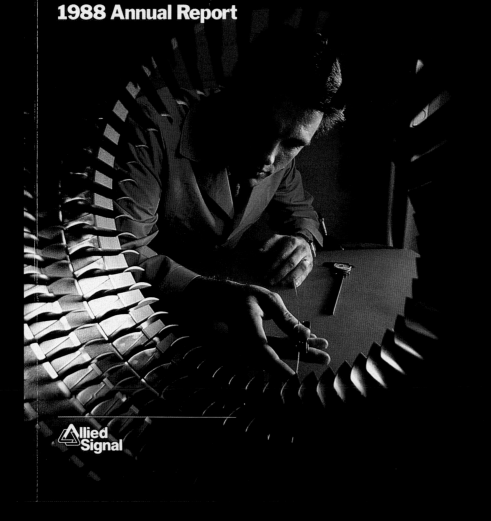

1988 Annual Report

Allied Signal

The 1986 Alcoa Annual Report (bottom left) established its messages with cover quotes, followed by a large statement inside reading, in part: "The quotations on the cover of this report capture the spirit of Alcoa today. Technology. Quality. New Directions. These are elements that are shaping our long-term strategies . . ."

The Reuters Holdings PLC annual report (bottom right) was in two parts, with cover graphics that married the two books together.

Alcoa

"No other company works as hard to understand how their products fit into ours."
Customer

"There's a sharing of information between us, an intense reliance on new knowledge that is basic to our relationship."
Customer

"Alcoa is good at the business of discovery and experimentation."
Customer

"We've come through a period of looking inward… closing capacity, cutting costs…and are now focusing on markets of the future."
Alcoa employee

"Quality, precision, exactness, engineering are my impressions of Alcoa."
Customer

Our Annual Report for 1986

PRODUCTS & TECHNOLOGY

REUTERS HOLDINGS PLC
ANNUAL REPORT 1988

Covers

Product photography was featured on the 1987 report covers of Kraft, Inc. and Leaf, Inc., two food companies (top). Accompanied by the line "Good food and good food ideas," the photograph on the Kraft cover created an inviting image of the company's products in their end use; food prepared by the customer. The Leaf report displayed one of the company's more famous brands with a consumer.

Photographs meant to create a mood while suggesting the companies' raw materials were displayed on the covers of the 1981 Potlatch and 1988 Alcoa reports (middle).

A company's products or services can be beautifully displayed through photography, whether an industrial service such as ENSR (1987, bottom left) or a consumer product from Knudsen Corporation (1981, bottom right).

All the covers on this page used photographs with dramatic lighting and dynamic cropping to project a feeling of high quality that enhanced the companies' corporate messages.

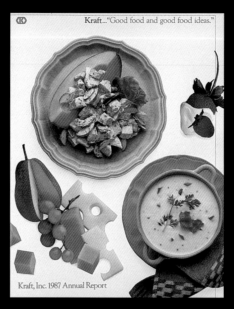

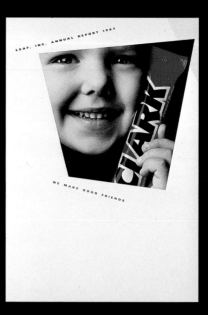

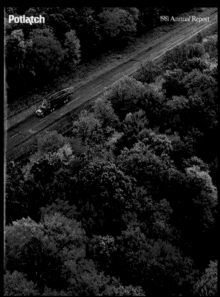

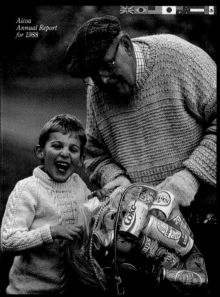

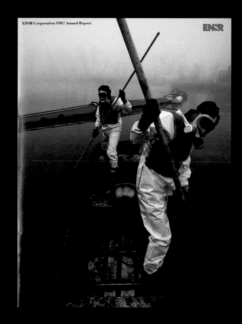

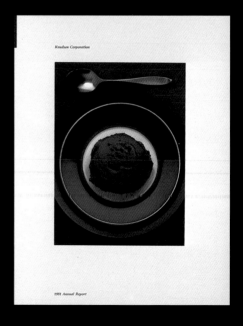

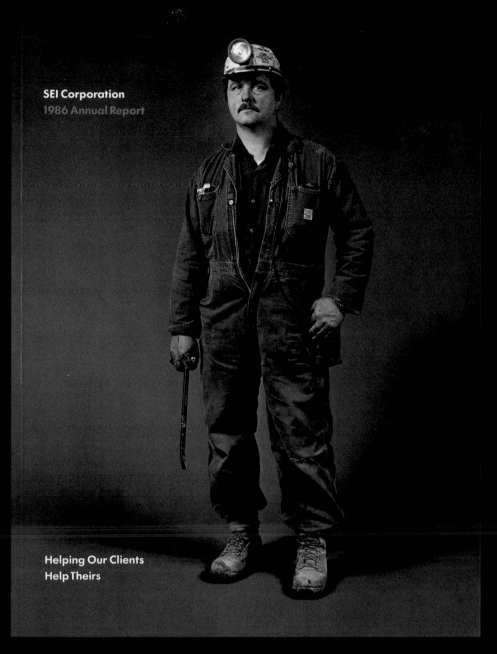

SEI Corporation
1986 Annual Report

Helping Our Clients
Help Theirs

Scale is an important consideration in designing a report's cover. The three covers shown here used photographs of people in dramatic scale to invite the reader to open the report.

In 1986 the SEI Corporation (top) used a an ordinary person photographed in a studio with a backdrop (a treatment common in fashion photography) to create a sense of expectancy. The cover line tells us that this is a client of their clients, and we are drawn in.

The covers of the Houston Metropolitan Ministries and Herman Miller reports used scale in opposite ways. The 1980 HMM cover (bottom left) was flooded with the image of an elderly person, full of character and warmth. The cover of the 1985 Herman Miller report (bottom right) was crowded with people, under the theme line: "Say hello to the owners!" The owners displayed across the cover and the following pages were the employees— the participating owners of the company.

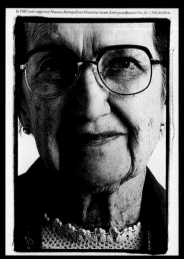

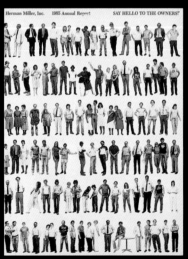

Covers

Textures cover the 1986 Centex and 1984 Doyle Dane Bernbach International reports (top). Centex used close-up photographs of dirt, steel and wood, the elements of the building industry. The major asset of the advertising industry—people—was illustrated with business cards from managers of various DDB agencies.

The covers of Team, Inc. (1988, middle left) and Biogen (1983, middle right) conveyed conceptually where the companies were in their growth during these particular years. Team had just acquired a new company that was altering the makeup of its services. Biogen's cover illustrated the four stages of the biological science company's growth.

The 1984 Intermedics and 1978 Browning Ferris Industries reports (bottom) created environments associated with their products or services. Intermedics manufactures pacemakers, a high-tech implantable for the body, BFI provides waste disposal services.

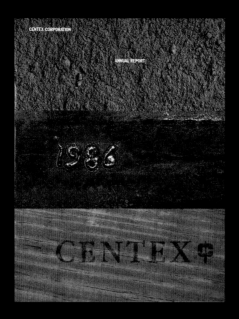

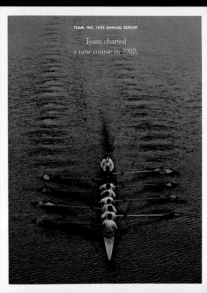

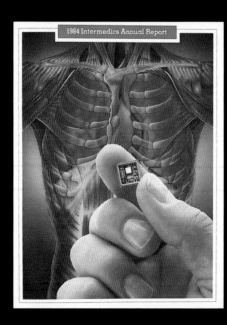

Leaf, Inc. Annual Report 1986

We Make Good Fun

The whimsical cover of the 1986 Leaf, Inc., report (top) illustrates the company's products and a sense of customer satisfaction at the same time.

In 1975 Fannin Bank used a patriotic theme in its report (bottom) to usher in the Bicentennial. The cover was actual cloth, silk-screened as a flag.

Photography

Photography is the most common visual technique used in annual reports, and it can be arrived at in a multitude of ways.

The 1988 Potlatch report (top) displayed large nature photographs taken in natural light, while the 1987 International Minerals report (bottom) used studio lighting to capture the rich detail of its subjects.

In sharp contrast to these approaches, the images for the 1987 Goldman Sachs report (opposite page, top) were black and white candid photographs, which captured the hustle and bustle of the firm's employees.

The portraits illustrating the 1987 Reliance Group Holdings report (opposite page, bottom left) were the results of a special technique, combining black and white photographs with color photographs as insets.

The 1988 First Bank System report (opposite page, bottom right) featured customers and their products. The product shots were used as cutouts (the background of the photograph was cut away) and overlaid across the more formal portraits. An additional inset of bank personnel added a smaller element. All of the photographs were taken in controlled, studio lighting.

*C*reativity in structuring debt offerings in global markets enabled our borrowing clients to obtain lower cost financing and provided investors with attractive opportunities. We were a leader in structuring financings for corporations worldwide, and we lead managed our first issue in the Swiss franc bond market.

*P*articipating in futures and options markets worldwide, Goldman Sachs supported the trading strategies of portfolio managers 24 hours a day. We were prominent in U.S. stock index and financial futures and options, and we provided access to major futures markets elsewhere. We were also a major factor in OTC debt and currency options and a leading broker in energy futures.

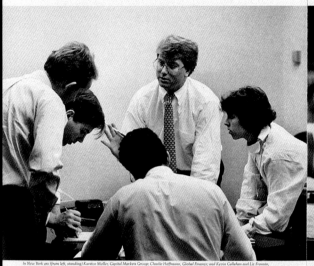

In New York are (from left, standing) Karsten Moller, Capital Markets Group; Charlie Hoffmann, Global Finance; and Kevin Callahan and Liz Froonan, Capital Markets Group.

In Financial Futures and Options, New York are Don Rogan (facing) and Steve Koomar.

18

19

David C. Lau,
Chairman and President,
Aunt Nellie's Farm
Kitchens

A photograph's influence can be enhanced by its use in the report, its size and its relationship to the page.

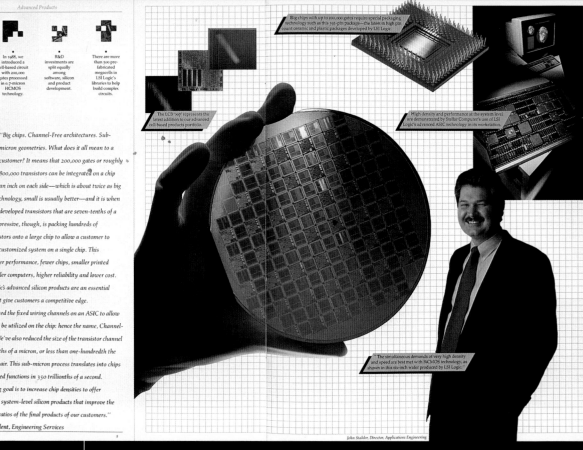

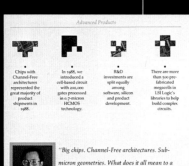

The 1988 LSI Logic Corporation report (top) used a multitude of images in various sizes combined over a background grid. The images were emphasized by their contrasting scale.

Contrasting scale was also used in the 1986 Weyerhauser Paper Company report (bottom). Full-page images taken with a large-format camera (for extra detail) were set against a smaller photograph of one of the company's end products, a cardboard package. (The large photograph also contrasts against the smaller page preceding it, called a short sheet. These pages were inserted throughout the report.)

Pratt & Whitney has over 370 commercial customers and an array of engine products to help them modernize and maintain their fleets, reduce operating costs and meet future traffic growth.

The new-technology PW4000 engine accounted for nearly $3 billion in orders and options in 1988.

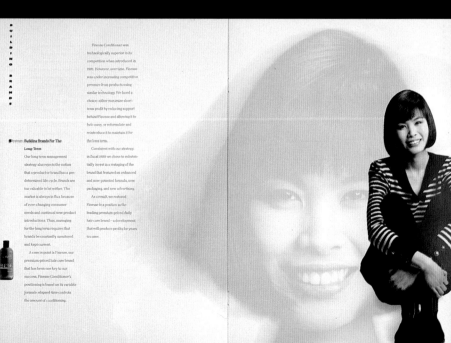

Strategy: Building Brands For The Long-Term

Our long term management strategy also rejects the notion that a product or brand has a predetermined life cycle. Brands are too valuable to let wither. The market is always in flux because of ever-changing consumer needs and continual new product introductions. Thus, managing for the long term requires that brands be constantly monitored and kept current.

A case in point is Finesse, our premium-priced hair care brand that has been one key to our success. Finesse Conditioner's positioning is based on its variable formula: elapsed time controls the amount of conditioning.

Finesse Conditioner was technologically superior to its competition when introduced in 1981. However, over time, Finesse was under increasing competitive pressure from products using similar technology. We faced a choice: either maximize short-term profit by reducing support behind Finesse and allowing it to fade away, or reformulate and reintroduce it to maintain it for the long term.

Consistent with our strategy, in fiscal 1989 we chose to substantially invest in a restaging of the brand that featured an enhanced and now-patented formula, new packaging, and new advertising.

As a result, we restaged Finesse to a position as the leading premium-priced daily hair care brand—a development that will produce profits for years to come.

Photographs with overwhelming size to create backgrounds contrasted against smaller, inset images were used to illustrate the 1988 United Technologies report (top) and 1989 Helene Curtis Industries report (bottom).

Asia and the Pacific—
a fast-growing region.

Nor are we new in Asia. We made our first entry into Japan in 1919 with a short-lived manufacturing venture. Having experienced the difficulties of operating in that country, we returned in 1968 with a joint venture, and now all our SBUs do business in Japan. We're expanding our presence there through internal investment and by seeking partnerships for market entry.

Asia and the Pacific Basin constitute one of the world's fastest growing regions. Our activities in South Korea, Taiwan, Singapore, Malaysia and China could comprise a report in themselves. Our abrasives joint venture in Malaysia is now in full operation; we are negotiating several important joint venture agreements in Korea and China.

Charles Benoit, who has set up the Asian abrasives marketing team operating out of Hong Kong, says he has created his team from aggressive people who know how to sell, speak the language of the customer country as well as English, and who are, above all, resourceful.

A Norton plant in Guarulhos, Brazil, relies on technologically advanced process techniques to manufacture grinding wheels for growing Brazilian markets and global customers.

Coated abrasives made at Sao Paulo are cut into long strips for further processing into various sizes and shapes required by customers.

14

15

Industrial photographs, those depicting a company's operations or services, can give the reader a sense of the company and a feel for its day-to-day workings.

The 1988 Norton report (top) used studio lighting techniques in the company's manufacturing plants to create photographs with rich detail and color.

The 1987 ENSR report (bottom) used location photographs with natural light on an overcast day to create a mood more interesting than the sunny photographs one normally sees in a report. (See the cover of the same report on page 82.)

Consulting and Engineering

The Consulting and Engineering division, which includes ERT, Inc. and ERT Information Services, Inc., is nationally known for identifying, defining, and solving a broad range of tough environmental problems for industry. Our performance has led to assignments from the nation's top law firms and many companies, including nearly all of the Fortune 50. With a staff skilled in over 50 scientific and engineering disciplines and extensive field and analytical testing capabilities, we help clients comply with governmental regulations and assess or manage liabilities related to hazardous materials and toxic pollutants.

Our solutions range from innovative Superfund site cleanups to minimizing risk in potential chemical release incidents. We are designing and permitting hazardous waste incinerators, helping industry bring landfills and surface impoundments up to current standards or close them, and implementing one of the first corrective action programs under the Resource Conservation and Recovery Act (RCRA). ENSR's Consulting and Engineering projects frequently utilize the skills of our Technology and Health Sciences divisions, and result in implementation plans which are carried out by our Remedial Construction and Remedial Operations divisions.

Both our technical expertise and regulatory knowledge have made us adept at handling emerging environmental issues. We have produced significant advances in acid rain knowledge through several major acid-deposition measurement and modeling contracts, and we have won permits for more resource recovery facilities now operating than any other firm. We have negotiated cost-effective solutions for clients in all EPA regions.

Our expertise is regularly used by individual firms and by trade associations to address changing regulatory policies. Practical guides to complex regulations, our handbooks are used by over 50,000 decision makers in industry. ENVIRO-NET™, our regulatory publishing service, is the only service providing up-to-date compliance requirements and environmental audit instructions customized to individual facilities.

With over 700 consulting and engineering professionals in 15 offices and 9 laboratories across the country, we routinely mobilize project teams from several offices quickly and ensure the best results for clients no matter where they are.

Scientists from ENSR's Consulting and Engineering division take water samples and conduct lab analyses for a major corporation to develop a detailed natural resources assessment of an area following an oil spill.

8

ITW operating units continuously develop new products to maintain leadership positions in the industries they serve. These innovations, in turn, help customers maintain their market leadership and improve their competitive positions. Clockwise from top ○ **Builder's Climaseal anti-corrosion coating** for fasteners provides greater protection than standard finishes, is compatible with painted and metal-coated surfaces, covers fasteners completely and exceeds published industry corrosion standards. Developed in the U.S., ITW units today also offer Climaseal in Asia, Australia, Canada and Europe. ○ **Signode's M-50 head** joins steel strapping without the use of a metal seal and is more cost-effective to operate than its predecessor machine, due to a simplified design that contains 50 percent fewer parts. ○ **Shakeproof** developed the **Sigma self-drilling screw** in response to quality problems automakers reported with screws used to fasten trim to auto bodies. Sigma has set the industry standard for drill screw performance and established Shakeproof as a market leader in the automotive segment. ○ **Hi-Cone's photodegradable plastic multipack carrier (ECO)** is the packaging industry's most environmentally-positive, commercially-viable and cost-effective degradable package available today. The ECO carrier successfully addresses litter and solid waste management issues. Carriers begin to degrade within weeks and break up completely after a few months. The polyethylene resin used is composed of hydrogen and carbon molecules naturally occurring in the environment. Residue will meet the requirements of the new federal law mandating the production of degradable ring-type carriers expected to go into effect in 1990. Hi-Cone's ECO carriers are used by Sweden's largest brewer, Pripps, to conform with that country's strict laws regarding degradable packaging. Anheuser-Busch, Inc. is among the first U.S. companies that have converted voluntarily to using plastic Hi-Cone carriers that are degradable. Coca-Cola Consolidated of Charlotte, North Carolina recently announced it is also switching voluntarily to plastic Hi-Cone photodegradable carriers for all the markets it serves. Hi-Cone's leadership in the application of degradable resins has allowed customers to meet legislative requirements as well as to address important environmental and waste disposal issues.

Building on Market Leadership

Food Ingredients Group, formerly known as Industrial Foods Group, enhanced its market leadership position in 1987 with the June acquisition of the Anderson Clayton edible-oil business. Including Anderson Clayton's results for the second half of the year, Food Ingredients Group tonnage and sales were up strongly. Operating profit was slightly lower than last year's level, which benefited from a real estate property gain. The Anderson Clayton acquisition has produced a good balance of strong businesses serving customers in all three channels of food distribution – foodservice, food processing and retail through private label and selected branded products – and is building a larger base in specialty ingredients as well. Kraft is now better positioned to capitalize on the good growth potential for food ingredients. In its specialty ingredients business, the group continued to show growth, providing a wide variety of products to food processors. While reduced demand for dehydrated marshmallow bits resulted in an overall volume decline, specialty ingredients enjoyed volume growth during the year in cream cheese, natural cheese, caramels and baking ingredients. In 1988, Food Ingredients Group expects significant volume growth and good gains in operating profit, reflecting the full-year contribution of the Anderson Clayton business along with cost reductions and the scale efficiencies of the combined businesses.

On December 3, 1987, Kraft announced its intent to sell Duracell Inc. Consequently, Duracell is being treated as a discontinued operation for financial reporting purposes. In 1987, Duracell was a significant contributor to Kraft's overall financial performance as its operations posted solid results throughout the year to make maximum gain, culminating with excellent results in the fourth quarter when battery sales are at their highest. Duracell net income climbed to $54 million compared with a loss of $4 million in 1986, which reflects an after-tax charge of $26 million related to the refocusing of its activities on its core alkaline battery business. Duracell's sales in 1987 rose 18 percent to $1.1 billion from $963 million. Kraft expects to complete the sale of Duracell by mid-1988.

Women's Wear

Women's apparel contributes the largest share to Dylex' combined sales – 57 percent of the total. In this competitive retail environment characterized by quickly evolving trends, our chains consistently anticipate the fashion images that their customers want to project. As shown in the charts below, Canadian sales grew by ten percent in 1985 and operating earnings reached $39 million. Our 1,488 stores in the United States contributed $687 million U.S. in sales and operating earnings of $48 million U.S.

Harry Rosen **Women** Beautiful taste and workmanship are the hallmarks of Harry Rosen Women's business and leisure wear. In response to customer demand, three new stores will be added in 1986 to the existing seven across Canada in executive and professional careers.

Town and Country Women with busy working and social lives find quality and fashionable style at Town and Country and its affiliated Petites stores. Expanded from 107 to 183 stores across Canada in the past five years, the chain has earned a solid reputation by offering a high level of customer service.

Braemar Customers who want to make a fashion statement in both their office and leisure clothing turn to Braemar. The 28-store chain carries a wide range of young apparel including private label goods to meet the needs of young career women. From 13 Ontario stores in 1981, the chain has expanded to key markets in other provinces.

Product photography dominated the three reports on this page.

The 1988 ITW report (top) combined black and white photographs floating together on the page to create an interesting image out of very dissimilar products.

The technique of combining various products in different sizes was also used for the 1987 Kraft report (middle). In this case the images were related to captions interspersed throughout the page.

The 1985 Dylex report (bottom) illustrated the products of its consumer fashion stores on models and as objects, all with studio lighting. To create variety, some of the photographs were cut-outs, with the white page used as the background.

Portraits

The portrait of a company's executives gives the annual report reader a chance to be visually introduced to the top managers, and it can often convey a sense of their personalities. The more interesting portraits are those that blend into the report, becoming part of its theme or concept. The attitude and presence of the people is important, of course, but so are the backgrounds, where additional information about the company can be suggested.

Two reports with fine executive portraits presented in very different scale are the 1987 Reliance Group Holdings report (top), where the portrait was reproduced on a full page; and the 1988 Potlatch report (bottom), which used a small inset of the chairman. (Both reports are also shown on pages 86-87.)

e year of record

he time, it marks

dertaken early in

l of us in the com

shed, but feel that

ure the overall

to the company

The numbers tell a straightforward story. Earnings grew

from $87.6 million in 1987 to $112.4 million, or 28 percent.

Sales were $1,084.1 million, up 9 percent from $992.1 milli

in 1987. The 1988 results are the first for Potlatch in which

net earnings exceed $100 million and sales exceed $1 billion

Return on common stockholders' equity rose from 16 perce

in 1987 to 18 percent in 1988. These results made it possibl

for the Board to raise the dividend 13 percent, for an annu-

alized rate of $1.04 per share compared with $.92 a year ag

The reasons for a good year and for an optimistic out-

look are not so easy to describe. They involve the efforts of

great many individuals who have improved not only their

own efficiency but the efficiency of the way we allocate and

Many executives prefer to be photographed outside their normal environment, the office.

For the 1988 Alcoa report (top), the executives were placed in the company's technical center, emphasizing the importance the company places on technology development.

Surrounded by his company's products, the executive of Leaf, Inc., was photographed in a sea of candy for the 1986 report (bottom). The theme of the report was "We Make Good Fun," and the atmosphere of this photograph followed this through.

Eikki Radii
President and
Chief Executive Officer
Leaf, Inc.

capital, return on average shareholders' equity, gross profit and total return to shareholders – all of these gauges of management achievement have yielded results that place Heinz on a comparative basis in the top rank of its industry. Wall Street has recognized this performance, according a high price-earnings ratio to our shares.

As for the future – always the concern of an alert management – I believe company shareholders have every right to be optimistic. Our core business is strong and growing, while new products and line extensions multiply in response to consumer needs. We back all of our brands with ever-larger marketing expenditures. We pursue our policy of niche acquisitions with diligence. We are planting the Heinz flag in countries such as The People's Republic of China, the Republic of Korea, and, most recently, in Thailand. And, most importantly, we are using our low cost operator initiatives to prepare our company everywhere for the future. Small wonder, then, that company management attitudes are animated by confidence and a pervasive sense of great expectations.

The continuing support of company shareholders is counted a major resource that is never taken for granted. Management understands that its first loyalty runs to those who have invested funds in our shares, including thousands of Heinz employees at all levels. Our activities to achieve a new era of growth for the company are calculated to nurture this vital management-shareholder partnership.

6

Here are two reports utilizing black and white portraits in contrasting styles. The 1987 H.J. Heinz Company report (top) presented a candid photograph of a contemplating executive, while SEI Corporation's 1986 report (bottom) featured a formal pose in a studio setting, complementing the style of the report's other photographs (see the SEI cover on page 83.) A candid portrait such as Heinz used would take preparation and staging before allowing the person to become a relaxed subject.

Pier 1 Presents A Versatile Line Of Director's Chairs.

When you buy director's chairs at Pier 1 Imports you're getting the real thing: a great line of director's chairs, presented by the directors who know director's chairs best. Our colorful, comfortable director's chairs are so popular that we sold over 100,000 last year. Relaxing in the seven above are Pier 1 directors Clark A. Johnson, Marvin J. Girouard, Charles R. Scott, Sally F. McKenzie, Luther A. Henderson, Thomas N. Warner and Lawrence P. Klamon.

Pier 1 imports®

A Place To Discover.™

Apply For Pier 1's New Credit Card At All Participating Stores.

The members of the Board of Directors for Pier 1 Imports were photographed in the style of the company's consumer advertising for the 1989 report (top). Other ads used by the company during the year were displayed throughout the report.

Following the theme of the 1984 Doyle Dane Bernbach International report (see cover, page 84), snapshot-like photographs were paper-clipped to the executives' business cards (bottom).

Brown & Williamson and Popeyes. (The Western Airlines account landed in our office in Los Angeles.)

The new accounts, however, must be viewed as replacement business, which bolsters our egos as much as it does our bottom line. As for the loss of the Atari video games, it came as the market category collapsed; Polaroid was more wrenching, and came after 30 years of effective, award-winning work on the account.

Characteristically, we continued our award-winning ways, and for the sixth consecutive year won more Effies—the most important ones to our clients—than any other agency. And for the Weight Watchers Frozen Foods campaign, we won the prestigious Stephen E. Kelly Award of the Magazine Publishers Association.

Meanwhile, the Company strengthened its office in San Francisco, more than doubling our billings

with the acquisition of The Michael-Sellers Company, and we expanded our international operations into Portugal and New Zealand. We also restructured the whole International Division (more on that later).

The Company put itself into a better earnings-per-share position with the purchase of the Bernbach family's shares of common stock, and at the same time we sold back our Ecom public relations subsidiary and brought the PR function in-house with a strengthened department in order to enhance our public posture.

All in all, we made significant and appropriate moves in 1984 to re-establish our preeminence in the advertising business, and we are grateful for the support of our 3,500 employees around the world, our valued clients and our shareholders. We did it with a new generation at the helm, but holding to our course of true creative excellence.

MICOM

Choices

Choices

complex

Choices Choices for the average customer are more today, and this has inevitably delayed

Choices

a number of decisions for purchasing

data communications equipment.

nnual report a
Growing up with
ower depicted a ten-
sure of his height.
ssed since that
nd the young com-
is begun to mature.
said of the data
lustry at large; we
w. The passage has
e turmoil of adoles-
ition has tempered
and experience has
ons to our perspec-
e must cope with
influences. We must
 a dynamic market-
re. —— Those of
following our prog-
years will recognize
ents to a changing
lard practice for
allmark of our com-
approaching oppor-
 has been no dif-
robing the data
arketplace for new
ossibilities for inno-
xploit market niches
, and modifying our
nd products as our
ments change. ——
the condition of the
s market itself.
e last few years have
t on the computer
found than most
d. For many compa-
tion processing and
ns fields, the effect
ing — for some,
re sobered by the
for the first time

adjusting and then readjusting to slower
product demand. —— Before reviewing
industry factors that influenced the data
communications market, we'd like you
to know what kind of company MICOM
is, what it does, and how it operates.
These three elements are basic to
understanding how we arrived at our
position in the market today, but more
significantly, they will illustrate why
MICOM is so well positioned to respond
to future market directions.

Who We Are MICOM makes and sells
data communications equipment, the
gadgets and systems that enable com-
puters and terminals to "talk" with one
another. With MICOM products, infor-
mation generated by computers can be
used by peripheral devices like printers
and terminals, or these devices may
feed data into the computer. This data
flow might travel just a few feet or sev-
eral thousand miles, and the number of
interacting devices can range from two

to a few to thousands. The data com-
munications equipment itself can be as
simple as a cable connector or as com-
plex as a complete networking system.
We make "widgets" selling for a few
dollars and sophisticated products cost-
ing many thousands. In all, MICOM
sells more than 600 data communica-
tions products. —— It's important to
remember that MICOM does not make
computers or the terminal equipment
driven by them. What it does make is
the transmission equipment in between.
That includes products like statistical
multiplexors, data PABXs or switches,
line drivers and modems, protocol
converters, local area networks and
many other products needed to get data
smoothly, quickly and correctly from
source to destination. —— MICOM
develops and markets devices for which
a market already exists or can quickly
be developed, devices that enhance the
performance of computing equipment
already in place. Our solutions are
quick to install
rapid payback
take the myste
cations and th
installing remo

strategy strategy

The key word in our strategy is strategy "Solutions"

strategy strategy

**Illustration has the abil-
ity to convey complex
ideas, proven by these
fascinating conceptual
illustrations from the
1986 MICOM System re-
port. Played against the
running narrative of the
report, the illustrations
seek to call the read-
ers' attention to such
themes as choices,
strategy and processes.**

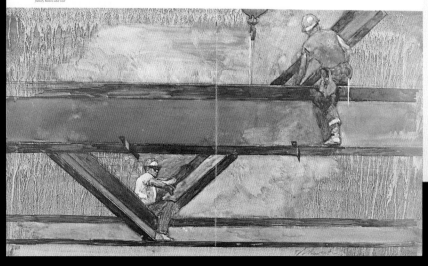

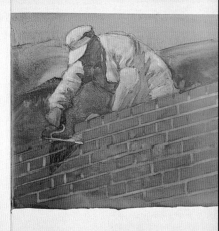

Industrial scenes are portrayed in these two reports:

The 1976 Lomas & Nettleton Financial Corporation report (top) illustrated the building industry, which the company participated in with financing. Through the use of illustration, the report was able to focus on the general industry without having to deal with specific projects, which might have distracted the readers' focus.

The 1983 Vallen Corporation report (bottom) also illustrated a general theme: the need for safety on the job. The report concentrated on the different markets where the company distributed safety equipment.

THE IMPORTANCE OF SAFETY

The National Safety Council has estimated that in 1980, the most recent year studied, deaths and injuries on the job cost business approximately $30 billion. The Safety Council estimates that average cost of a disabling accident to be $9,400.

Corporations are becoming increasingly aware of the mounting cost of on-the-job claims. The call for industrial safety is resurging. It is no secret that lower accident rates foster higher profits.

Although some industries are inherently more dangerous, such as construction, accident rates tend to vary greatly from company to company within the same industry—an indication that industrial safety can be improved through sound programs and a commitment to them. Corporations which establish serious safety programs average a reduction of 38 percent in accidents the first year.

THE HIGH COST OF BEING UNSAFE

Accident and illness costs are advancing faster than the rate of inflation. For the last several years, the cost of employee lost time due to injuries and occupational illnesses has been rising at an average annual rate of 15 percent. If a company's safety performance is just average, that organization will have more than 2.5 lost workdays per 100 employees per year due to injury or illness. Each lost workday now costs the employer from $10,000 to $14,000. This cost does not include indirect expenses such as associated property damage and administrative time which could account for up to five times the direct accident cost.

Incentives to take safety seriously have increased sharply because costs are threatening to get out of hand. Not only are claims bigger, but more ailments and injuries are coming under the coverage of worker's compensation. Although states determine employee compensation rates, employers pay for their own safety records. They buy insurance to pay the claims, or are self-insured up to a minimum which ranges from $250,000 to $1 million per accident. Most states set payment at two-thirds of the injured worker's wage up to a maximum amount. The bulk of worker's compensation claims, until recently, have arisen from accidents. Companies now face additional large and growing liabilities because of the health effects of substances, such as asbestos, used years before their damaging effects became known. Furthermore, the range of ailments which may be attributed to occupational conditions has expanded. Alcoholism or ulcers can now be interpreted as a response to a stressful working environment.

The cost of establishing a corporate safety and health program, depending upon the magnitude of the program required, could include: supervision and management time; accident investigation; job safety analysis; inspection; job hazard analysis; housekeeping; fire prevention; training; first aid and medical treatment; and protective equipment.

VALLEN CORPORATION FISCAL 1983 ANNUAL REPORT

Illustration

These two reports—one highly fanciful and the other very technical—show the range of styles encompassed by illustration.

The 1981 report for L&N Housing Corp. illustrated the concept of housing through the centuries, from medieval times (top) to Victorian times (bottom) and on to the present. The line drawings illustrated the style of housing and the people of different eras in a storybook fashion with great detail, stopping the reader and inviting a longer look at the page.

Implantable lenses have restored near-perfect vision —and a normal life—for millions of cataract patients.

Cataract removal is the third most frequently performed surgical procedure in the U.S. In almost every case, an intraocular lens (IOL) made of biologically inert clear plastic is used to replace the eye's natural crystalline lens.

Recently developed microsurgical tools and procedures enable surgeons to use the "extracapsular" method of cataract extraction, and to position the replacement lens in front of the posterior capsule. This technique, now used more than 80-percent of the time, puts the artificial lens in the anatomically most correct position, places it more securely, and offers lower chances of postoperative complications than other approaches.

A cataract is a clouding of the eye lens. It blocks the passage of light rays through the lens and interferes with vision. Ten years ago, the development of cataracts usually signalled the end of a person's normal life—blurring eyesight, restricting mobility and eventually leading to blindness.

Surgical removal was, and still is, the only treatment proved effective. In the past, to restore vision after surgery, patients would need thick eyeglasses that reduced peripheral vision and distorted depth perception. Or they could try fragile, often bothersome contact lenses.

Today, in more than 90-percent of cataract cases, an intraocular lens is implanted to replace the natural lens at the time of surgery. Frequently, 20/20 vision is achieved.

New alternatives are also available in the composition and design of intraocular lenses. Some lenses are designed to absorb, as does the natural lens, rays of ultraviolet light that may gradually damage sensitive eye tissue. Other IOLs currently in clinical trials are designed to permit use of a YAG laser to perform non-invasive ophthalmologic surgery.

Cataracts blur vision—and lead to functional blindness—by making the natural crystalline lens progressively more opaque, impairing the projection of images on the retina at the back of the eye.

Most intraocular lenses are placed inside the eye between the iris and the posterior lens capsule, in the position of a natural lens.

Intermedics' lens operations outperformed growth expectations. IOL market grew during the period.

The company to take maximum of the trends absorbing and ber lenses th market in the

Intermedics UVEX lenses a portion in the ultraviolet light segment. An is established the posterior required for t "extracapsul procedure.

A high level on the 20 new troduced last consulting se establish a le with the grow patient surgi

Intraocular accounted for or 15-percent 1984 revenue

Intraocular Market Gr

Artificial heart valves open and close 40 million times each year. Lives depend on their strength and smooth operation.

Intermedics' patented Pyrolite carbon is used in more than 85-percent of the mechanical heart valves implanted worldwide.

This bileaflet valve made entirely of Pyrolite carbon is being developed with the Peoples Republic of China. After initial testing, clinical trials are expected to begin in China by 1986.

"biological" valves made of treated porcine or bovine tissue. Both the mechanical and tissue replacements are designed to be durable, biocompatible, and provide smoothness of blood flow. Researchers attribute a recent increase in the use of mechanical replacements both to the fact that biological valves tend to fail after seven to ten years, and to improvements in the design and durability of most mechanical valves.

Early mechanical valves used a "floating ball in a cage" design. Later models used a tilting disc that pivots open and shut in response to the heart's pumping action. The current "valve of choice" is a bileaflet design featuring two pivoting semi-circular discs, a design which produces minimal turbulence.

The inertness of Pyrolite carbon used in most mechanical valves prevents detection by the body's rejection system. And because blood clots can initiate at even the slightest surface imperfection, each part is precision polished and inspected microscopically.

The mechanical segment of the overall valve market is projected to grow slightly faster than the 6.7-percent compound growth rate expected for the market as a whole. Intermedics' sales, however, should grow at least twice as fast as the overall market growth rate because of the shift in preference from valves with one carbon part to all-Pyrolite carbon valves using two or three carbon parts.

Also, Intermedics plans to enter markets outside the U.S. where about two-thirds of all mechanical valves are implanted.

Intermedics will continue its policy of vigorously defending its patents and proprietary carbon technology against infringement or unauthorized use. In fiscal 1984, the company halted the supply of Pyrolite components to a major customer because of such infringement and unauthorized use, reducing near-term sales. The company believes, however, that market demand is strong and that long-term sales will not be affected.

The heart pumps blood through a system of four valves. A defect in any of these valves can reduce the blood flow or allow backflow if the valve is slow to respond or doesn't close tightly. In either case, the blood supply to vital organs and the rest of the body is reduced, and damage to blood cells can occur.

If a defective valve cannot be repaired, it must be surgically replaced. Open heart valvular surgery became routinely feasible in 1954 with the development of the heart-lung machine. The procedure has now evolved to the point that during 1984 cardiac surgery teams performed about 100,000 heart valve replacement procedures worldwide, more than 30,000 in the U.S.

Almost two-thirds of the replacements used are "mechanical" valves, most of them (85-percent) made from or coated with biocompatible Pyrolite carbon. The other one-third are

Heart Valve Market Growth

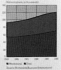

Properly functioning heart valves enable blood to be pumped first from the upper chambers (atria) to the lower chambers (ventricles) and then out to the lungs and the rest of the body.

A Pyrolite carbon artificial heart valve used for mitral replacement to control blood flow between the left atrium and ventricle.

To explain implantology, a field that potential shareholders and financial analysts may not have fully understood, the 1984 Intermedics report used detailed technical drawings to illustrate just how the company's impantable products worked inside the body. The illustrations showed cutaways of the body with the products implanted, with small line drawings to explain further how the products functioned.

Informix Corporation il-
lustrated key phrases
in its 1987 report (top)
with paintings meant to
spark the reader's
imagination while mak-
ing it easier to remem-
ber the company's
thought.

The 1988 Metropoli-
tan Life report (bottom)
featured the company's
collection of landscape
paintings and its rela-
tionship to the arts. The
cover painting sets the
stage for the report,
and at the same time
depicts the company's
home office.

Bright, colorful shapes were used to illustrate the 1988 report of Central and South West Corporation (top), a public utility holding company. The illustrations were captioned in large, loose color bars placed next to the narrative. With this style, the drawings were able to illustrate both events and ideas.

The 1988 Reuters Holdings PLC report (bottom) used diagram-like drawings to illustrate very difficult concepts, such as real-time information (above) and transaction products (below). The full-page drawings began sections in the report, followed by pages of text and small photographs of people, places and processes.

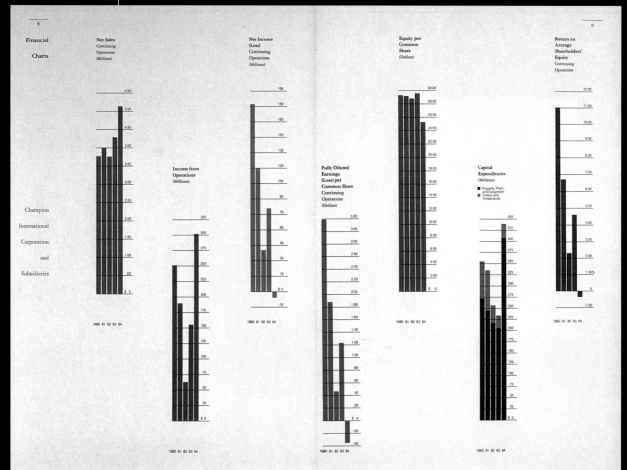

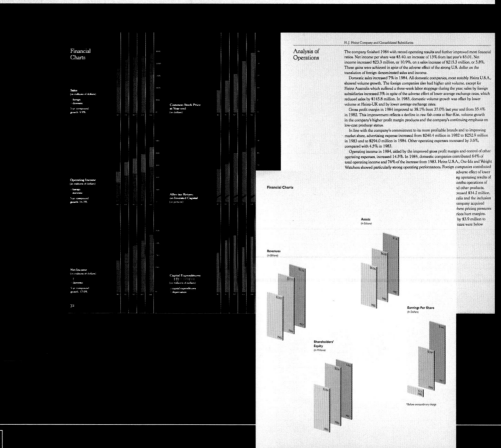

Charts have the ability to present information in a very quick fashion for easy comparison. The degree of detail in a chart can vary, depending on the company's wish for the chart to convey specifics. Often charts are used only to give an impression, to support the hard data presented in the financial documents. This page shows three chart presentations with varying degrees of detail:

The 1984 Champion International report (top) had horizontal cross-reference points for the vertical bars; the 1984 H.J. Heinz Company report (middle) omitted the horizontal reference points. The 1987 Reliance Group Holdings report (bottom), which showed the bars in dimension and perspective, used the most impressionistic approach.

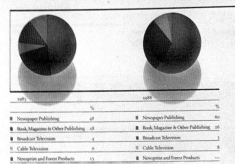

SHARE OF REVENUES BY BUSINESS SEGMENT

Times Mirror's operations are concentrated in three core areas: print media (newspapers and magazines), electronic media (broadcast and cable television), and professional information and book publishing. For current financial reporting purposes, the company uses the business segments shown in the charts on this page, with the exception of Newsprint and Forest Products.

1983	%		1988	%
Newspaper Publishing	48		Newspaper Publishing	60
Book, Magazine & Other Publishing	18		Book, Magazine & Other Publishing	26
Broadcast Television	4		Broadcast Television	3
Cable Television	8		Cable Television	8
Newsprint and Forest Products	11		Newsprint and Forest Products	—
Corporate and Other	11		Corporate and Other	3

OPERATING PROFIT BY BUSINESS SEGMENT

1983	%		1988	%
Newspaper Publishing	39		Newspaper Publishing	58
Book, Magazine & Other Publishing	23		Book, Magazine & Other Publishing	24
Broadcast Television	27		Broadcast Television	8
Cable Television	4		Cable Television	8
Newsprint and Forest Products	(21)		Newsprint and Forest Products	—
Corporate and Other	(11)		Corporate and Other	2

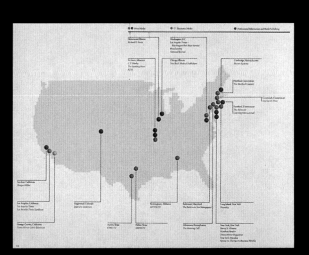

The entire 1988 report for the Times Mirror was illustrated with charts, maps and diagrams based on dimensional balls. Rendered in air style, with an overlay of flat colors, the balls were made to float on the page with the use of drop shadows. Shown here are pie charts (top), a breakdown of the company's business segments (middle) and a location map (bottom).

Maps can be rendered in styles ranging from the very realistic to the highly stylized. The only criterion is that the reader be able to understand the information easily, and not be confused or misled.

The location map from the 1985 Dylex report (top) showed the number of the company's many holdings broken down by state or province, and color-coded by retail name.

The 1984 Pier 1 Imports report (bottom) gave an overview of where the company's products are imported from, with a map mimicking the *National Geographic* magazine style.

Market Coverage

		Stores	Average Size sq. ft.
Retailing Canada			
Women's	B.B. Emporium Value priced fashions for the younger shopper.	26	1,800
	Beaumar Selected lines of sportswear, dresses and coats.	20	3,700
	Fairweather/Daniel Hechter Fashionable moderately priced women's clothing.	124	5,600
	Harry Rosen Women Beautiful and tasteful clothing for the professional woman.	7	1,800
	Bailey/Feathers/Fantasia/Diva Dress and casual footwear.	47	1,300
	Suzy Shier/L.A. Express Medium priced women's fashions.	161	2,600
	Town and Country/Petites Medium priced coats, dresses and sportswear.	103	2,300
		576	
Men's	Big Steel Man Moderately priced clothing for the younger man.	112	1,600
	Harry Rosen Quality apparel for the professional and executive.	17	5,200
	Tip Top Suits and accessories at reasonable prices for men of all ages.	170	3,800
		299	
Family	Bi-Way Low cost clothing and housewares for budget conscious consumers.	164	8,700
	Drug World Wide range of discount products.	3	16,000
	Thrifty's Casual wear and accessories for active lifestyles.	125	2,000
		292	
Total Canada		1,167	
Retailing United States			
Women's	Brooks Fashions Medium priced fashions for women.	781	2,780
	T. Edwards Higher priced selected lines of apparel.	73	3,200
	Foxmoor Young women's clothing at moderate prices.	607	2,400
	Wet Seal Junior sportswear.	27	3,000
		1,488	
Men's	Club International Suits and accessories at reasonable prices for men of all ages.	5	5,050
	NBO Off-price brand name clothing.	20	10,050
Total United States		1,513	
Total Canada and United States		2,680	
Manufacturing			
An assortment of women's and men's clothing.			

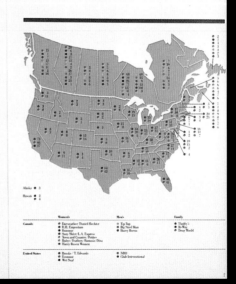

Alaska ● 3
Hawaii ● 2 ● 4

	Women's	Men's	Family
Canada	● Fairweather/Daniel Hechter ● B.B. Emporium ● Beaumar ● Suzy Shier/L.A. Express ● Town and Country/Fantasia-Diva ● Harry Rosen Women	● Tip Top ● Big Steel Man ● Harry Rosen	● Thrifty's ● Bi-Way ● Drug World
United States	● Brooks / T. Edwards ● Foxmoor ● Wet Seal	● NBO ● Club International	

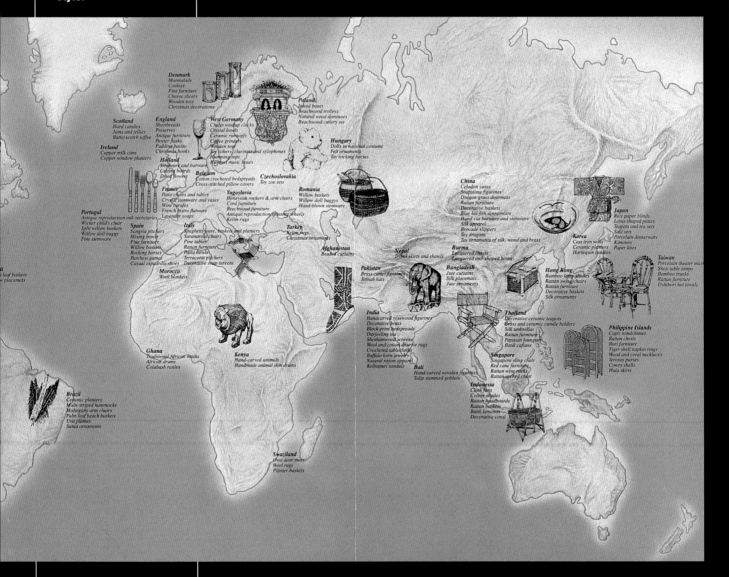

The 1987 Union Texas Petroleum report detailed the company's locations on a realistically drawn world map (top left) with smaller, detail maps spread throughout the report (top right).

Power Authority Network

In contrast to the style of the maps above, the system map for the New York Power Authority in the company's 1985 report (bottom) was a stylized, angular presentation. The map gave the reader an understanding of the area the company's system covered, without the need to be totally accurate geographically.

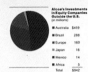

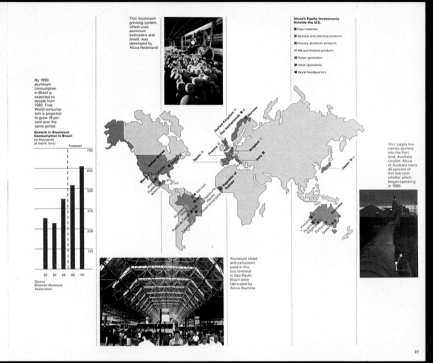

Annual reports have the ability to educate as well as inform, a case in point being the 1986 Alcoa report (top and middle). Charts, maps, diagrams, photographs and descriptive captions were given a large place in this report. The very simple textbook or encyclopedia look of the various pieces of information helped the reader understand the company's locations, products, markets and financial results.

The Intel Corporation used a linear timeline in its 1988 report (bottom) to chronicle the evolution of the company's products and technologies over twenty years. The timeline was reproduced on a three-page foldout.

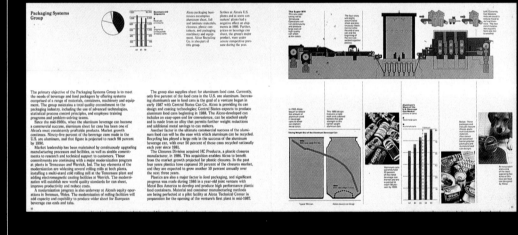

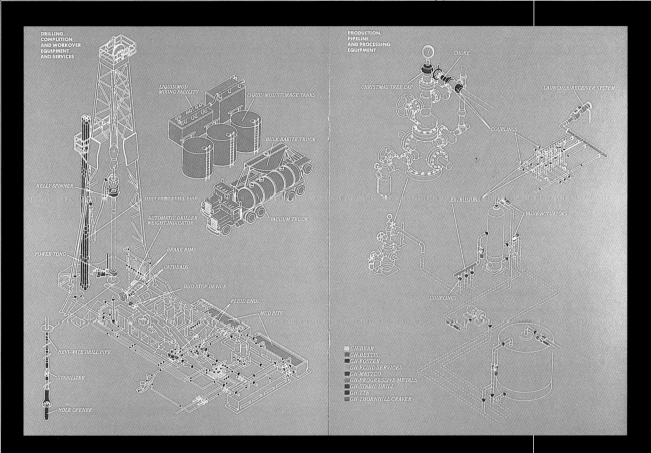

The two-page diagram from the 1979 Galveston-Houston report (top) gave a graphic description of where the products of the company's subsidiaries fit into the oil drilling process.

The 1981 Potlatch report (bottom) used a flowchart to explain how raw material flows through the company's manufacturing process, supported with statistics on assets, capacities, production and sales.

To Our Shareholders

Allied-Signal's overriding 1988 corporate objective was to improve our financial performance in an increasingly competitive world.

Throughout the Company, our managers and employees dedicated themselves to this effort. In each of our three core businesses—Aerospace, Automotive and Engineered Materials—we stressed the basics of cost control, quality and building on our product and market strengths. We sought to balance the need for investments that will secure a profitable future with the requirement to substantially improve our current performance. And we reduced overhead costs and staffing levels, sold non-strategic businesses, curtailed costly new ventures and stabilized research, development and engineering (R,D&E) and capital spending with a greater concentration on near-term business opportunities.

By year end, this emphasis on operating performance started to be reflected in our financial results. Earnings from continuing operations showed a substantial improvement over 1987 after large one-time items for that year are excluded. And selling, general and administrative expenses declined slightly despite a 7 percent increase in sales to nearly $12 billion.

At the same time, earlier investments in R,D&E and in capital programs began to pay off as our core businesses successfully commercialized new products and systems that will provide for our future growth.

The Engineered Materials sector continued to achieve dramatic earnings growth throughout the year in all of its operating divisions. Income for the 12 months was $236 million, a 44 percent improvement over the previous year, excluding streamlining and restructuring charges. Sales

were $3 billion, up 9 percent over 1987.

Automotive sector net income was up $14 million, or 13 percent over last year, after excluding streamlining and restructuring expenses. Sales for the year increased by $555 million, or 16 percent, passing the $4 billion threshold for the first time to a total of $4.1 billion.

The Aerospace sector continued to invest in large and promising new development programs for the 1990s. These continued costly investments and lower sales in several product lines reduced the sector's income by $31 million, or 16 percent compared to 1987, after excluding streamlining and restructuring charges. Sales of $4.8 billion were essentially flat.

Emphasis on Performance

During 1988 each sector initiated aggressive programs to improve weak or underperforming units, to be more selective in the use of resources and to emphasize near-term performance.

The Automotive sector, for example, sold its electronics business to Siemens AG. The automotive electronics market is large and attractive, but it had become obvious that building a major position in it would require massive infusions of cash.

We elected instead to concentrate our investments on programs to integrate electronics into our current lineup of automotive products, especially new antilock braking and air bag restraint systems, in order to make our core products among the most technically advanced and cost competitive in the marketplace.

In the Aerospace sector, the AiResearch group, which had been hampered by long-standing manufacturing and product delivery problems, made steady and substantial

3. Surface-mount technologies that help create smaller, lighter, faster, proprietary circuitry are integral to the operation of the Bendix/King TCAS II collision avoidance system for commercial aircraft.
4. Mechanic Carlos Logacho inspects the gear assembly of a Garrett TPE331 engine. More than 11,000 of these turboprops are in service today.
5. The main landing gear for the U.S. Navy's F-14 carrier-based aircraft, seen here in a paint-drying oven, is among many Allied-Signal products for military aircraft.

quarter-to-quarter improvements throughout 1988. This turnaround in on-time shipments, inventory controls and profitability reflected the hard work and commitment of all 11,000 AiResearch employees.

Automotive's Garrett Turbocharger division also took decisive action to improve its performance with a program to consolidate the unit's 15 North American and European manufacturing plants into eight, and to eliminate about 500 positions over the next two years.

Finally, the Corporation undertook several major programs to reduce overhead costs. Numerous staff activities were reduced or eliminated. This effort resulted in an estimated annual cost savings of about $150 million, most of which will be realized by year-end 1989, and a reduction of approximately 1,500 positions. The Company also launched a redesigned medical benefits program to control the soaring cost of employee health care. While our health care costs will continue to increase, the new program sets the rate of increase for 1988 and the next two years at a level well below the expected average for U.S. industry.

Manufacturing Improvements

But cost savings and other efficiencies are only part of the formula for a successful company. Global markets continued to offer significant growth potential. Almost one-third of Allied-Signal's sales are from international customers and we continued to use joint ventures, teaming arrangements and other tactics to expand our customer and product bases in these foreign markets.

Each of our businesses also made major efforts to upgrade manufacturing capability. For example, Norplex Oak initiated a substantial expansion of its Hoosick Falls, New York, plant to increase output by 30 percent. Bendix Heavy Vehicle Systems announced a $20 million investment in a flexible machining system at its Charlotte,

North Carolina, plant and the Aerospace company's Bendix Wheels and Brakes unit started work on a $27 million expansion of its South Bend, Indiana, production and testing facilities. Manufacturing commitments like these are central to the Company's plan to improve performance in the coming years. Total capital spending for 1988 was $602 million compared to $609 million in 1987.

Though we are being more selective, Allied-Signal aggressively continues to seek and develop new products, processes and technologies. In 1988, Company-funded R,D&E totaled $467 million, down $20 million from 1987. There was also another $585 million in customer-funded work. And there is substantial evidence throughout Allied-Signal that such investments are paying off with exciting new products, sizeable new contracts and growing sales.

Engineered Materials

Most of the Engineered Materials sector's businesses performed at a record-setting pace in 1988. The Fibers, Engineered Plastics, High-density Polyethylene, Fluorine Products and Norplex Oak units reported especially strong earnings.

The sector also continued its strategy of investment in product and manufacturing improvements, especially in those markets where we command leading market shares. Today's *Anso V Worry-Free* nylon carpet fiber, for instance, is a fifth generation product that represents the latest in fiber technology. Investments in such advanced products, coupled with strong marketing, contributed to the Fibers division's outstanding sales and profits for the year.

The Fluorine Products group moved aggressively to advance its product technology and keep pace with a

1. Technician Thomas Busacca positions one of the crash-sled dummies used to test air bags at Automotive's Troy, Michigan, technical center.
2. Horace Young, senior operator, completes the assembly of an actuator/modular unit, part of a computer-controlled Bendix antilock braking system that applies and releases hydraulic pressure at the wheels 12 times per second. The action allows the vehicle to come to a controlled stop.

The important requirement of a report's type is readability. The text in a report should be easy for the reader to follow, with elements (such as subheads and captions) that will draw attention and explain at the same time.

The 1988 Allied-Signal report (top) used these devices well. Subheads and large initial caps broke up the running text with easy-to-read captions keyed to the small photographs.

Large headlines normally associated with magazines or advertisements carried the reader into the text in the 1988 report of Team, Inc. (bottom). Short subheads that further organized the text were repeated throughout the report.

THE COMPANY IN 1988

Team made a dramatic turn in 1988, building on existing strengths and acquiring new ones as it set the course for continued growth and profitability.

THE COMPANY

Team, Inc. is a diversified service company providing a comprehensive line of repair, maintenance, monitoring, project management and transportation services. The Company employs 815 people throughout its 47 locations in 23 states. Through its joint venture, Teamine Europe, the Company has foreign licenses in six European countries. The Company's customers include governmental entities at every level, as well as major companies in the petroleum, chemical, refining, power, telecommunications, health care, paper, steel and other industries.

A YEAR OF RESULTS

For Team, 1988 was a year of results, one of those pivotal points in time where performance and opportunity meet, creating a bridge from the past to the firm foundation of the future. During this 12-month period, the plans and actions of more than four years converged to create a larger, stronger, more integrated company positioned at the forefront of promising new markets.

In 1988, Team channeled these resources along a new business path, one that led directly to expanded capabilities and to earnings substantially higher than they have been in five years.

EXISTING STRENGTHS

The strides made, in a single year, were dramatic. But the strong, supporting structure has long been in place:
· The sophisticated problem-solving capabilities and commitment to service upon which the Company has built an international customer base.
· An established operating network comprised of 47 sites in 23 states and licensees in six European countries.
· An integrated group of products and services including on-stream plant repair and maintenance, utility and public works repair, systems monitoring and project management.
· The technical expertise that has given Team the proprietary edge in many of its targeted markets.

Based on this solid infrastructure, Team developed a long-term plan for pinpointing new markets, consolidating operations, capitalizing on existing strengths—and acquiring new ones. In 1988, that plan yielded significant results.

1988 HIGHLIGHTS

In December 1987, Team made a major move into the rapidly expanding privatization market with the acquisition of Universal Services Co., Inc., a company on the leading edge of the nationwide movement toward private enterprise meeting public needs. Universal adds extensive experience in road repair, project management and facilities maintenance to Team's specialized service capabilities in a mar-

ket that holds exceptional potential for long-term growth. A recent study by the Congressional Joint Economic Committee, for example, puts the bill for expanding and maintaining eight of the nation's public works systems—a prime market for privatization—at $1.2 trillion through the year 2000.

Team's diversification into new service areas was complemented by expansion of the Company's most profitable business lines. New proprietary products were introduced, and existing services were expanded. Customer bases were broadened, both nationally and internationally. Consolidation, too, continued throughout the year as Team reduced its transportation assets while exploring new market opportunities for their profitable utilization.

NEW DIRECTIONS

Together, these strategies have set Team on a course of continued growth in size, in scope, in earnings. The momentum is already established and the solid infrastructure is firmly in place. The collective sights of each individual Team manager and technician, engineer and service specialist, are focused on turning recent gains into a lasting competitive advantage.

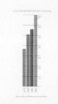

New Directories Alter Market

A Boom in Direct Marketing Catalogs

The Systems That Tie It Together

Folk Art From Peru.

The 1984 Champion International Corporation report (top) featured a textbook style, with running copy in a large columns flanked by small illustrations, photographs, charts, maps and diagrams in the side columns. The reader had the option of systematically reading the report's major text, or browsing through the pages' many images and captions.

Wide columns of large text under a simple headline dominated the 1989 Pier 1 Imports report (bottom). The simple approach to the text allowed the other elements—photographs, charts and the company's retail advertisements—to float around the format.

Typography

The financial spreads of an annual report need to be clear and readable. These pages usually have no extraneous graphic elements, but on occasion charts may be found here. On even rarer occasions, photographs or elements of the narrative are continued through the financial pages. The company's accountants have some influence over the presentation of these pages, including illustrative elements, since it is the auditing firm that signs its name to the content contained here.

The 1985 Centel Corporation report (top) displayed the financials in a clearly defined format, using rules to separate spaces and define areas of the tabular material. A neutral background color was used to reduce the contrast between the type and the background. This is a common technique to aid in the readability of the figures.

Another way of treating the financial pages is to print them on a stock different from the narrative. The 1987 American National Corporation report (bottom) produced the narrative section of the report on a coated stock and the financial section on a textured, uncoated stock. To begin the financial section, a table of contents was produced on the last page of the coated stock.

Here are two reports that utilized graphics in the financial section:

The 1984 Intermedics report (top) used charts and captions to help explain the financials. A background color was used to keep the audited text separated from the comments.

The 1984 W.R. Grace & Co. report (bottom) also used charts and graphs in a side column throughout the financials.

Top report (1984 Intermedics)

Note 9 — Long-term Liabilities ($ Millions)

Note 7 — $8.6 million of potential tax benefit available in unused financial NOL carryforwards.

Note 8 — May Partnership note fully repaid in December 1986.

Comments in margin also relate to Management's Discussion & Analysis, pp. 42–45.

Note 9 — $30 million line of credit available in January 1987.

8. NOTES PAYABLE AND LETTERS OF CREDIT

9. LINES OF CREDIT AND LONG-TERM LIABILITIES

10. LEASES

11. BENEFIT PLANS

Subsequent Event

W. R. Grace & Co. 1984 Annual Report

Capital Expenditures, Net Fixed Assets, and Depreciation, Depletion and Lease Amortization

($ millions)	Capital Expenditures 1984	1983	1982	Net Fixed Assets 1984	1983	1982	Depreciation, Depletion and Lease Amortization 1984	1983	1982
Operating Group									
Chemical									
Specialty	$129	$119	$128	$617	$584	$553	$66	$62	$61
Agricultural	38	8	34	233	223	214	28	28	25
Natural Resources	66	86	237	950	1,047	1,091	100	95	97
Consumer									
Retailing	36	42	53	323	309	321	30	26	25
Restaurant	71	55	49	384	371	364	42	39	36
General Business	24	24	26	102	82	76	13	13	12
Total Operations	364	334	527	2,609	2,616	2,619	279	262	253
General Corporate	16	19	33	95	99	89	11	10	9
Total	$380	$353	$560	$2,704	$2,715	$2,708	$290	$272	$262
Geographic Location									
United States/Canada	$300	$293	$466	$2,361	$2,386	$2,368	$251	$232	$224
Europe	52	29	53	182	182	206	22	23	21
Latin America, Far East and Other Areas	12	12	8	66	48	45	6	7	8
Total Operations	364	334	527	2,609	2,616	2,619	279	262	253
General Corporate (United States)	16	19	33	95	99	89	11	10	9
Total	$380	$353	$560	$2,704	$2,715	$2,708	$290	$272	$262

Capital Expenditures/Working Capital Provided by Operations ($ millions) — Net Fixed Assets

Research and Development

Grace's research and development activities are directed toward improving and expanding existing businesses and developing new business and investment opportunities. The distribution of research and development expenses among major objectives is shown in the following table:

Research & Development Expenses 1984 — Existing Products 41%, New Investments 21%, New Products 32%, Basic Research 6%

($ millions)	Existing Products & Processes	New Products & Processes for Existing Businesses	New Business & Investment Opportunities	Basic Research/Technical Information	Divested Businesses	Total
1980	$18.8	$16.0	$5.5	$1.6	$2.9	$44.8
1981	24.7	18.2	7.3	1.9	2.6	54.7
1982	27.1	17.2	14.0	2.8	.4	61.5
1983	32.3	20.1	14.5	3.8	—	70.7
1984	32.1	24.9	16.7	4.9	—	78.6

Average Annual Growth Rate 1980–1984: 14.3% | 11.7% | 32.0% | 32.3% | — | 15.1%

The Company's Research Division in Columbia, Maryland and research facilities associated with the Company's operating groups are responsible for generating the technologies and products needed to expand existing businesses and to enter new business areas. Current examples of these activities include petroleum processing catalysts, catalysts for emission control, technology relating to corrosion control coatings for automobiles and specialty polymers and chemicals for water treatment.

The Research Division is also the headquarters of the Company's biotechnological activities. Programs to develop bioprocesses for specialty chemicals such as amino acids are advancing toward commercialization, while a broad spectrum of more long-range research is being conducted under contracts with leading universities and other research organizations.

In 1985, the Company plans to increase research spending by approximately 17% to $92 million, with continuing emphasis on the Research Division's programs in biotechnology, catalysis and engineering research.

Environmental Protection

In constructing and operating its plants, mines and other facilities, Grace had environment-related capital expenditures of approximately $8 million, $13 million and $20 million during 1984, 1983 and 1982, respectively. Such expenditures are expected to be approximately $14 million in each of 1985 and 1986 and to average approximately $12 million per year in 1987 through 1989.

The health and safety of Grace employees and the communities in which Grace facilities operate are matters of the highest concern. Thorough reviews of plant processes and workplaces are conducted on a regular, periodic basis to assure the continued safe operation of all facilities. Grace has annual awards to recognize operations with the best overall health and safety records and the most improved performance.

Grace conducts safety programs with respect to its operations, including those in which hazardous materials are used. These programs include safety training, emergency procedures, regular surveillance by employees and mechanical detection equipment and periodic inspections by employees and outside consultants. The estimated annual cost of these programs is $10 million.

28 29

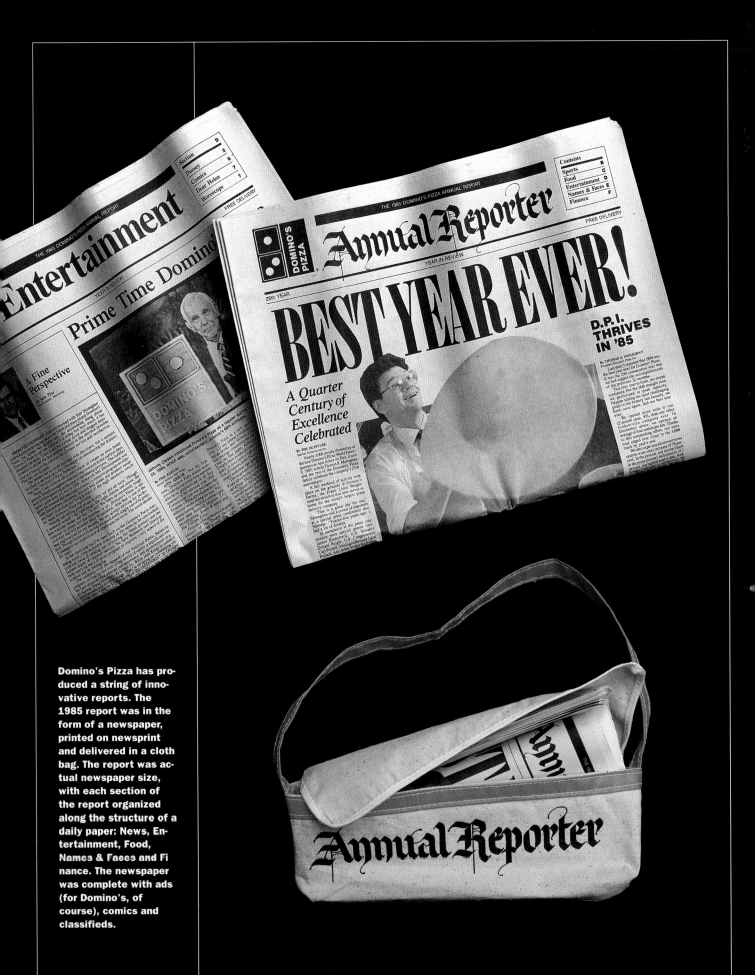

Domino's Pizza has produced a string of innovative reports. The 1985 report was in the form of a newspaper, printed on newsprint and delivered in a cloth bag. The report was actual newspaper size, with each section of the report organized along the structure of a daily paper: News, Entertainment, Food, Names & Faces and Finance. The newspaper was complete with ads (for Domino's, of course), comics and classifieds.

Breaking the Mold

There is a generally respected form for the annual report—that is, a standard size (8½ x 11") with the narrative and financial information presented in an order close to that outlined on pages 50-71. Although the variations on this form are endless, most annual reports produced every year come close to this basic form. From time to time, however, an annual report comes out that breaks our perceptions of what a report should look like. These form breaking reports may be shrugged off as "being different for the sake of being different," but sometimes they are a refreshing approach that makes the reader sit up and notice this company and what it is saying.

The reports highlighted in this section represent a small number of the reports that have tried to stand out and be noticed through packaging—the size, shape and form of the report.

Most annual reports are filed by the recipients, which keeps the report to a maximum size of 9 x 12". When a company sends a report that violates this size constraint, it is saying "Notice me; don't file me away." At times the form of the report is pushed well beyond size, into three-dimensional presentations, recordings or video (although most recording or video presentations are accompanied by some form of printed report).

In general, the report that breaks the mold is asking the reader to think about the company in a way that is different from the rest of the corporate crowd. The company wants the reader to know that its attitude is more creative, more innovative. It wants to be noticed.

"The Making of the Panhandle Eastern Annual Report" was produced as a video record of the planning, photography and production of this company's 1988 annual report. This recording of the annual report production process became a report in itself, with company officials delivering the messages about the year interspersed throughout the video.

These two pages show four more Domino's Pizza annual reports that carried out the company's tradition of fanciful reports:

In 1986 the report was in the form of a wirebound class notebook (top). The company admitted that the previous year had not lived up to expectations, so "That's why we went back to school last year. In order to improve ourselves, we hit the books and reviewed the fundamentals of pizza making and customer service."

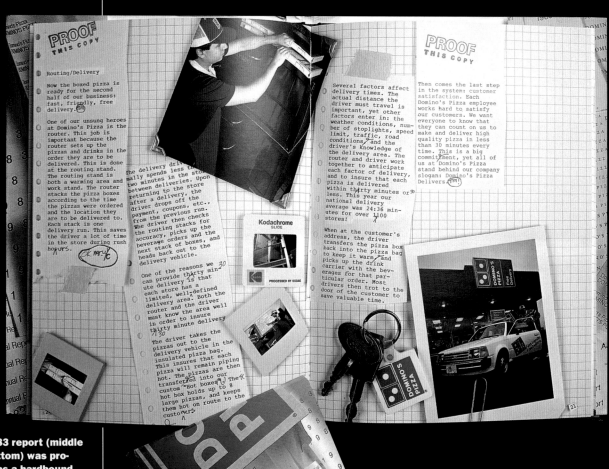

The 1983 report (middle and bottom) was produced as a hardbound book with a dust jacket. Although this suggests a very formal presentation, the pages were actually a series of type proofs, snapshots, small objects, newspaper clippings and financial statements randomly taped together and presented in their rough form.

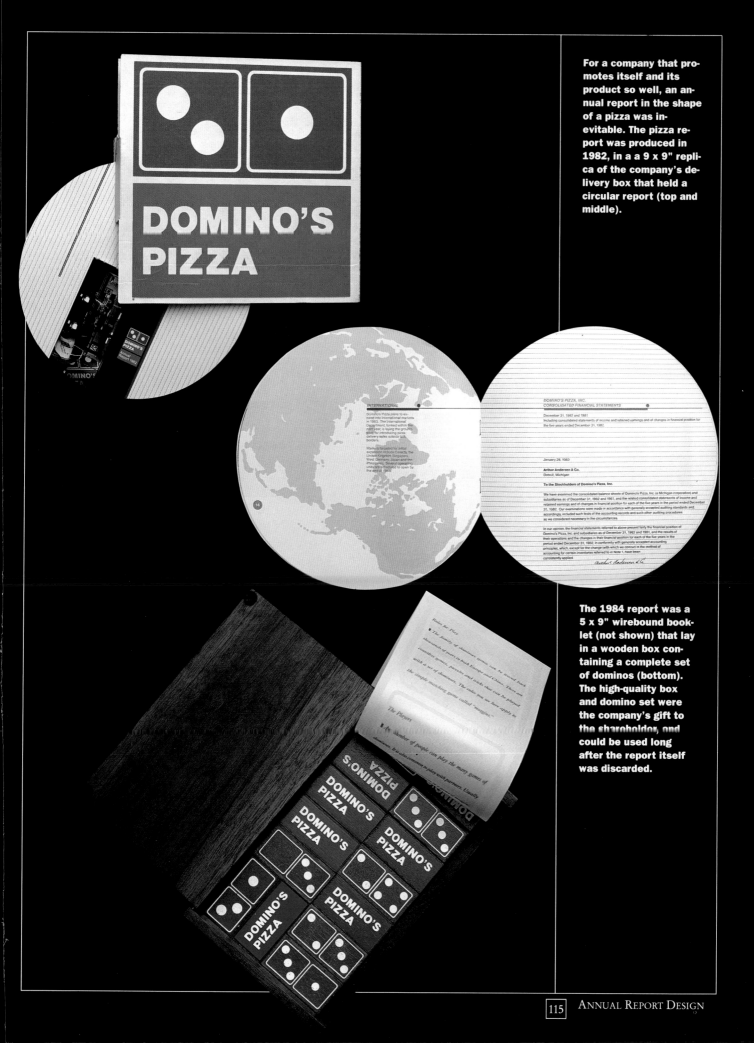

For a company that promotes itself and its product so well, an annual report in the shape of a pizza was inevitable. The pizza report was produced in 1982, in a a 9 x 9" replica of the company's delivery box that held a circular report (top and middle).

The 1984 report was a 5 x 9" wirebound booklet (not shown) that lay in a wooden box containing a complete set of dominos (bottom). The high-quality box and domino set were the company's gift to the shareholder, and could be used long after the report itself was discarded.

Here are two reports by Herman Miller that entertain as they inform:

The 1982 report (top) came with a foldout, reminiscent of a travel postcard, in a glued pocket on the cover. The foldout carried color photographs of the company's employees, neighbors and clients (bottom right). The remaining brochure was all text, presented in a straightforward fashion.

In 1979 the report had a front and back cover with a revolving wheel inside that, when turned, revealed pieces of information (bottom left). The front cover showed the company's Systems/Products/Services, the inside front cover was a capsulized president's report, the inside back cover turned to show the directors and officers, and the back page revealed facilities.

1982 Annual Report Herman Miller, Inc., and Subsidiaries

herman miller president's report 1979

Just a short time ago, the term *facility management* was unknown.
Now the powerful influence of the work place on people and productivity is better understood.

Our systems, products, and services have been designed to assure that the influence of the facility is positive, in all work environments.

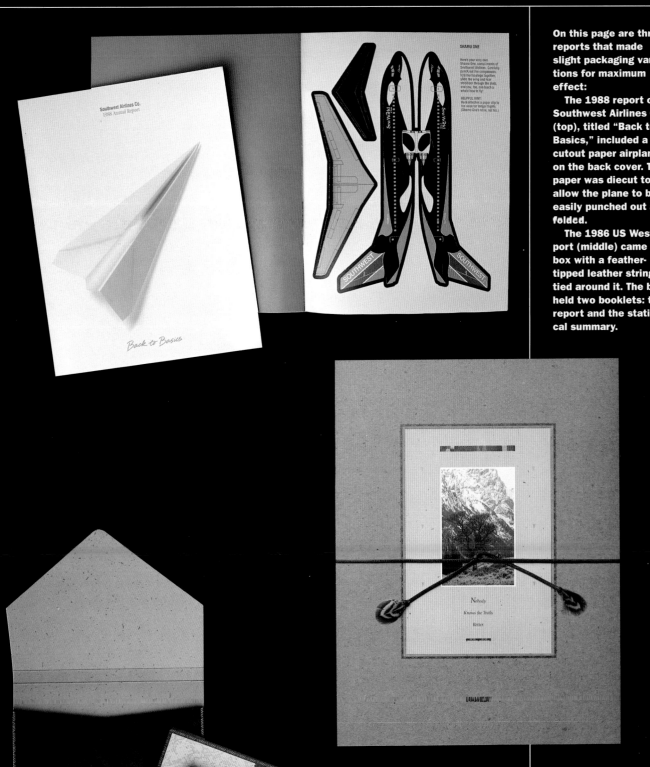

On this page are three reports that made slight packaging variations for maximum effect:

The 1988 report of Southwest Airlines Co. (top), titled "Back to Basics," included a cutout paper airplane on the back cover. The paper was diecut to allow the plane to be easily punched out and folded.

The 1986 US West report (middle) came in a box with a feather-tipped leather string tied around it. The box held two booklets: the report and the statistical summary.

US West again sent two reports in 1987, enclosed in a full-color, embossed box evoking the graphics of the booklets inside (bottom).

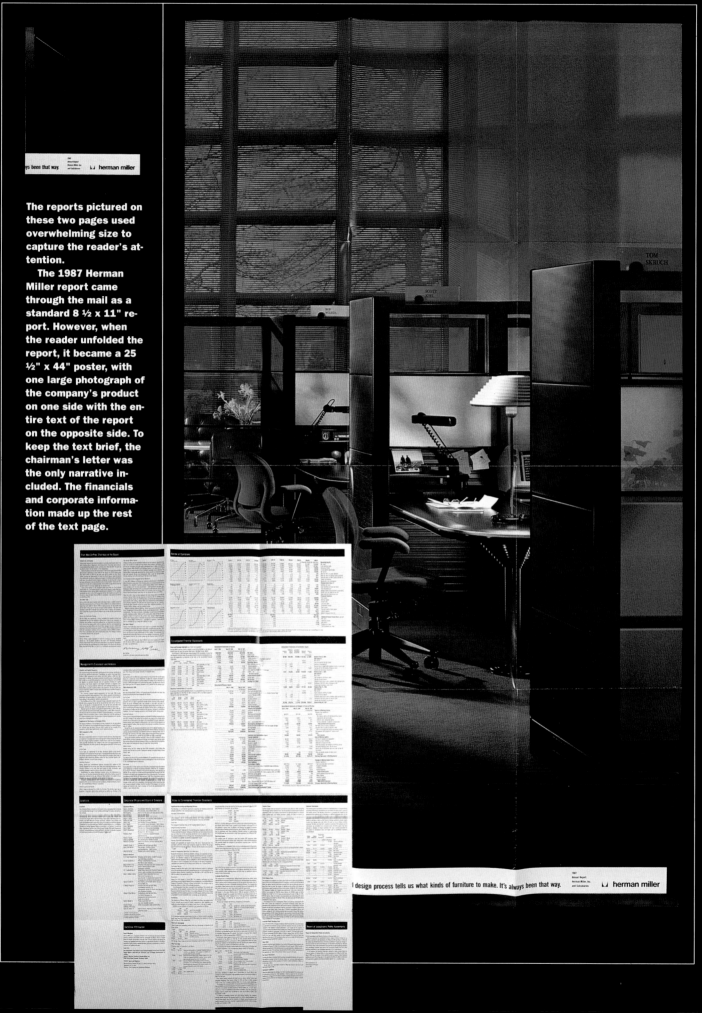

The reports pictured on these two pages used overwhelming size to capture the reader's attention.

The 1987 Herman Miller report came through the mail as a standard 8 ½ x 11" report. However, when the reader unfolded the report, it became a 25 ½" x 44" poster, with one large photograph of the company's product on one side with the entire text of the report on the opposite side. To keep the text brief, the chairman's letter was the only narrative included. The financials and corporate information made up the rest of the text page.

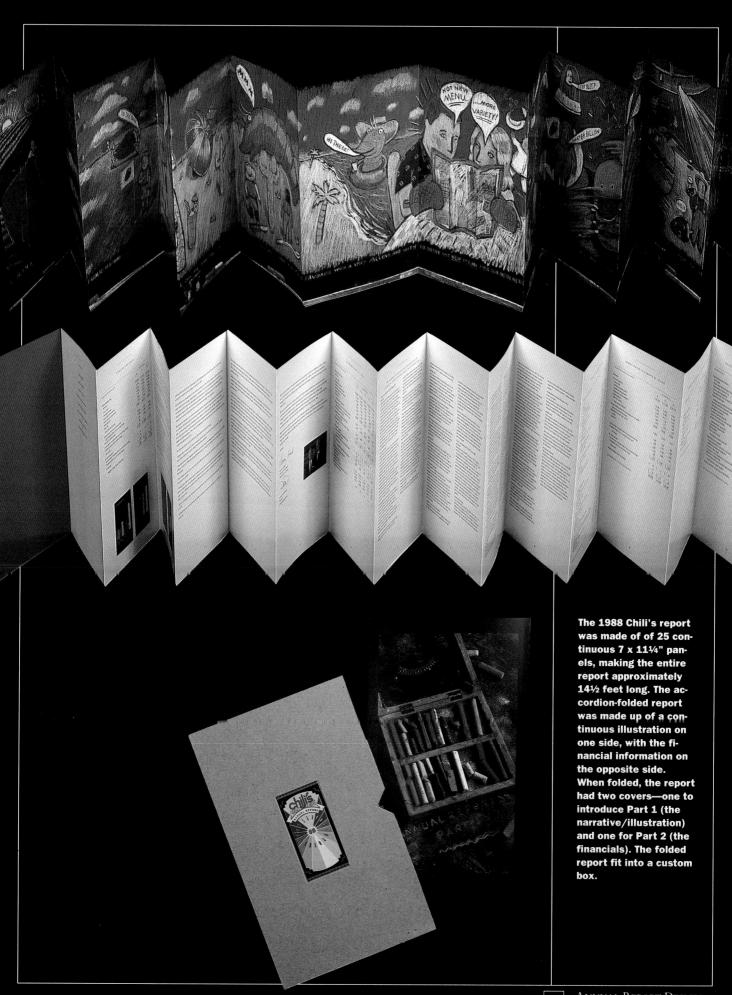

The 1988 Chili's report was made of of 25 continuous 7 x 11¼" panels, making the entire report approximately 14½ feet long. The accordion-folded report was made up of a continuous illustration on one side, with the financial information on the opposite side. When folded, the report had two covers—one to introduce Part 1 (the narrative/illustration) and one for Part 2 (the financials). The folded report fit into a custom box.

Meeting Notes

Decisions made in meetings can be easily misinterpreted or just plain forgotten. It is a good idea to follow up a meeting with notes of the meeting that state the points of discussion and specific decisions that were made.

Meeting Report

Project	1989 Annual Report
Date	September 25, 1989
Present	(Company): (Design Firm): J.H. J.H. M.P. S.F. T.T. K.S.
Items Discussed and Decisions Made	**DISCUSSIONS:** The ideas that were discussed in today's meeting: The report needs to have a photographic approach, preferably large photos. The markets of the company need to be defined, with each having its own spread in the report. People are important, but the theme does not need to revolve around people photos. No management figures will be photographed with the exception of the CEO. Travel for photography can begin October 16th, and must be concluded by December 15th. The financials will be released on November 22nd. Four charts will be included in the book, the same as last year. At least one map will be included, maybe more if the divisions need to have a map. **DECISIONS:** Bids are to be taken on the printing, limited to three area printers. The paper will be agreed upon in the next meeting, scheduled for October 2nd. The preliminary budget for photography was approved, allowing photography to begin. **NEXT MEETING:** October 2nd, 9:00 am in the (company's) main conference room.

Paperwork

The management of the annual report process is a major project, and the paperwork documenting the process reflects its magnitude. Because the process stretches over such a long period of time, neither the designer nor the corporate communicator should rely on their memory for keeping track of the ebb and flow of the report. Decisions will be made that can be forgotten, costs can escalate unnoted, or schedules will change without all the parties being aware of it.

"Document every aspect of the process carefully," Janis Koy of Koy Design counsels, "updating estimates, change orders, meeting notes, addenda, and so on."

The best forms for keeping track of the annual report process are those fashioned by the designer or client themselves. Every design firm works differently, and paperwork that is appropriate for a 20-person company may not be as appropriate for a 3-person group. How large the project is and the length of time involved also have direct bearing on the need for paperwork.

The best rule of thumb for designer and client alike is, "No surprises."

"I've shown prospective clients our work and they respond to it in a very positive way. In addition to the design solutions, it is our forms which they want to talk about. I think it is because now I am talking their language. Corporate people understand the need for tracking a project, and when they see I can relate to their needs, they think that is terrific."
James Cross,
Cross Associates

Extensive Contract

This contract, designed and drafted by the American Institute of Graphic Arts (AIGA) and reproduced here with permission, spells out in extensive detail the working arrangement between designer and client. This contract is copyrighted and cannot be reproduced directly from this book but is available from the AIGA, 1059 Third Avenue, New York, N.Y. 10021.

The American Institute of Graphic Arts
Standard Form of Agreement for Graphic Design Services
General Edition

This document is intended to be used as a basis of agreement between designers and their clients. It has important legal consequences. Consultation with an attorney is encouraged with regard to its completion or modification.

The Client and Designer agree as follows:
Agreement made as of date

Between the Client

And the Designer

For the Project referred to as

1. The Project

Description of the Project
1.1 The Project that is the subject of this agreement shall consist of:

2. Services

The Designer shall provide the Basic and Supplementary Services specified below.

Basic Services
2.1 The Designer shall provide Basic Services for the Project consisting of consultation, research, design, checking quality of Implementation, and coordination of the Project and its Execution. In connection with performing Basic Services, the Designer shall prepare and present materials to the Client that demonstrate or describe the Designer's intentions and shall prepare various materials, such as artwork, drawings, and specifications, to enable the design to be printed, fabricated, installed, or otherwise implemented.

Supplementary Services
2.2 In addition to the Basic Services described above, the Designer's fee may also include the provision of certain specialized Supplementary Services, but only to the extent described below. Such Supplementary Services might include: Creative services including copy development, writing, editing, photography, and illustration. Preparation of special artwork including drawing of logotypes, nonstandard typefaces, maps, diagrams, and charts, and preparation of existing materials for reproduc-

tion such as partial or complete redrawing, line conversion, retouching, captioning within an illustration, diagram, or map, and making camera-ready color separation overlays. Production services including typesetting and proofreading. Preparation of special presentation materials including detailed renderings, models, mockups, and slide presentations. If any of these other services are required, but are not to be provided by the Designer as Supplementary Services, they will be coordinated by the Designer, provided by others, and billed to the Client as reimbursable expenses.
The Supplementary Services to be provided by the Designer with respect to the Project shall consist of:

Implementation
2.3 The Designer's services under this Agreement do not include Implementation such as printing, fabrication, and installation of the Project design. The Client and Designer agree that any such Implementation is to be provided by others, and the Designer's services with respect to such Implementation shall be restricted to providing specifications, coordination, and quality-checking. Unless otherwise specified in this Agreement, the Designer shall have no responsibility to the providers of such Implementation, and charges therefor shall be billed directly to the Client. While not responsible for Implementation, in a supervisory capacity the Designer may assume responsibility for paying such charges, and the Designer shall be entitled to reimbursement from the Client for Implementation costs plus such handling charge as is specified in Section 3.2.

3. Compensation

Fees
3.1 The Client shall pay the Designer for the services described in this Contract as follows:

Hourly Rates
3.2 Where specified in this contract, the Client shall pay the Designer at the Designer's standard rates as in effect at this time.
The Designer's standards rates currently in effect are as follows:

No change shall be made in the Designer's standard rates prior to _____

Initial Payment

3.3 Upon signing this Agreement, the Client shall make a payment of _____
This initial payment shall be credited against the amounts due hereunder as follows:

Payment Schedule

3.4 After receipt of an invoice, the Client shall make payments within _____
The Designer may render invoices according to the following schedule:

Revisions and Additions

3.5 A fixed fee or fee estimated not to exceed a specified amount is based upon the time estimated to complete the services specified in this Agreement during normal working hours. Any revisions or additions to the services described in this Agreement shall be billed as additional services not included in any fixed fee or estimated fee specified above.
Such additional services shall include, but shall not be limited to, changes in the extent of work, changes in the complexity of any elements of the Project, and any changes made after approval has been given for a specific stage of design, documentation, or preparation of artwork.
The Designer shall keep the Client informed of additional services that are required and shall request the Client's approval for any additional services which cause the total fees, exclusive of any surcharge for rush work, to exceed the fixed or estimated fees set forth in section 3.1 by more than the following amount:

Rush Work

3.6 The Client shall pay a surcharge for any services requiring work to be performed outside of normal working hours by reason of unusual deadlines or as a consequence of the Client not meeting scheduled times for delivery of information, materials, or approvals.
The surcharge for rush work shall be at the standard rates plus _____
Normal working hours for this Project are as follows:

Reimbursable Expenses

3.7 The Client shall reimburse the Designer for all out-of-pocket expenses incurred by the Designer with respect to the Project including, but not limited to, expenditures for: Implementation, typesetting, photostats, photoprints, photography, film and processing, acetate color overlays, transfer proofs, presentation and artwork materials, electrostatic (xerographic) copies, Fax and long-distance telephone charges, postage, and local deliveries, including messengers, out-of-town travel, and shipping. Automobile travel will be charged at a standard rate per mile of _____
Reimbursable Expenses will be billed at cost plus a surcharge of _____

Reimbursable and Implementation Budgets

3.8 Any budget figures or estimates for Reimbursable Expenses or Implementation charges such as printing, fabrication, or installation are for planning purposes only. The Designer shall use his or her best efforts to work within stated budgets but shall not be liable if such expenses exceed budgets.

Records

3.9 The Designer shall maintain records of hours and reimbursable expenses and shall make such records available to the Client for inspection on request.

Late Payment

3.10 The Client shall pay a service charge for all overdue amounts of _____

4. Client's Obligations

Client's Representative

4.1 The Client shall appoint a sole Representative with full authority to provide or obtain any necessary information and approvals that may be required by the Designer. The Client's Representative shall be responsible for coordination of briefing, review, and the decision-making process with respect to persons and parties other than the Designer and its subcontractors. If, after the Client's Representative has approved a design, the Client or any other authorized person requires changes that require additional services from the Designer, the Client shall pay all fees and expenses arising from such changes as additional services.

Materials to be Provided by the Client

4.2 The Client shall provide accurate and complete information and materials to the Designer and shall be responsible for the accuracy and completeness of all information and materials so provided. The Client guarantees that all materials supplied to the Designer are owned by the Client or that the Client has all necessary rights in such materials to permit the Designer to use them for the Project.
The Client shall indemnify, defend, and hold the Designer harmless from and against any claim, suit, damages and expense, including attorney's fees, arising from or out of any claim by any party that its rights have been or are being violated or infringed upon with respect

to any materials provided by the Client.

All copy provided by the Client shall be in a form suitable for typesetting. Where photographs, illustrations, or other visual materials are provided by the Client, they shall be of professional quality and in a form suitable for reproduction without further preparation or alteration. The Client shall pay all fees and expenses arising from its provision of materials that do not meet such standards. The Designer shall return all materials provided by the Client within 30 days after completion of the project and payment of amounts due. The Client shall provide the following materials and services for the Project:

Liability of Designer

4.3 The Designer shall take reasonable precautions to safeguard original or other materials provided by the Client. The Designer shall, however, not be liable for any damage to, or loss of any materials provided by the Client, including artwork, photographs, or manuscripts, other than or on account of willful neglect or gross negligence of the Designer.

Approval of Typesetting and Final Artwork

4.4 The Client shall proofread and approve all final type before the production of artwork. The signature of the Client's Representative shall be conclusive as to the approval of all artwork drawings and other items prior to their release for printing, fabrication, or installation.

Instructions to Third Parties

4.5 The Client specifically grants to the Designer the right to act on the Client's behalf to give instructions on behalf of the Client to any person or entity involved in the Project, such as photographers, illustrators, writers, printers, and fabricators. Any such instructions or approvals by the Client may only be made through the Designer. The Client shall be bound by all such instructions given by the Designer within the scope of this Agreement.

5. Rights and Ownership

Rights

5.1 All services provided by the Designer under this Agreement shall be for the exclusive use of the Client other than for the promotional use of the Designer. Upon payment of all fees and expenses, the following reproduction rights for all approved final designs created by the Designer for this project shall be granted:

Ownership

5.2 All drawings, artwork, specifications, and other visual presentation materials remain the property of the Designer. The Client shall be entitled to temporary possession of such materials only for the purpose of reproduction after which all materials shall be returned, unaltered, to the Designer.

All preliminary concepts and visual presentations produced by the Designer remain the property of the Designer and may not be used by the Client without the written permission of the Designer.

The Designer shall retain all artwork, drawings, and specifications, for which reproduction rights have been granted for a specified period from the date of the signing of this Agreement. Upon expiration of this period, all such materials may be destroyed unless the Client has requested, in writing, that they be retained and agrees to pay reasonable storage charges. The Client shall have reasonable access to all such materials for the purpose of review.

The specified time for the Designer to retain such materials shall be _____

Third Party Contracts

5.3 The Designer may contract with others to provide creative services such as writing, photography, and illustration. The Client agrees to be bound by any terms and conditions, including required credits, with respect to reproduction of such material as may be imposed on the Designer by such third parties.

The Designer will endeavor to obtain for the Client the same reproduction rights with respect to materials resulting from such services as the Designer is providing the Client under this Agreement except as specified below:

6. Miscellaneous

Code of Ethics

6.1 The Designer's services shall be performed in accordance with the AIGA Code of Ethics and Professional Conduct for Graphic Designers.

Credit

6.2 The Designer shall have the right to include a credit line on the completed designs or any visual representations such as drawings, models, or photographs and this same credit shall be included in any publication of the design by the Client. The Client shall not, without written approval, use the Designer's name for promotional or any other purposes with respect to these designs. The Designer's credit line shall read as follows:

Samples and Photographs

6.3 The Client shall provide the Designer with samples of each printed or manufactured design. Such samples shall be representative of the highest quality of work produced. The Designer may use such copies and samples for publication, exhibition, or other promotional purposes.

The number of samples to be provided to the Designer shall be _____

The Designer shall have the right to photograph all completed designs or installations and shall have the right to use such photographs for publication, exhibition, or other promotional purposes.

Confidentiality

6.4 The Client shall inform the Designer in writing if any portion of any material or information provided by the Client or if any portion of the Project is confidential.

Sales Tax

6.5 The Client shall pay any sales, use, or other transfer taxes that may be applicable to the services provided under this Agreement, including any tax that may be assessed on audit of the Designer's tax returns.

Applicable Law

6.6 This Agreement shall be governed by the Law of the principal place of business of the Designer.

Assignment

6.7 Neither the Client nor the Designer may assign or transfer their interest in this Agreement without the written consent of the other.

Termination

6.8 Either party may terminate this Agreement upon giving written notice to the other as specified below. Upon termination of this Agreement by the Client or by the Designer for cause, the Designer may retain any initial payment and the Client shall pay the Designer for all hours expended on the Project, up to the date of termination, at the Designer's standard rates together with all other amounts due hereunder. Any initial payment that has been received shall be credited against any such amounts due. All indemnities shall continue even after any such termination.

The amount of written notice to be given by either party shall be _____

Arbitration

6.9 Either party may request that any dispute arising out of this Agreement shall be submitted to binding arbitration before a mutually agreed upon arbitrator pursuant to the rules of the American Arbitration Association. The arbitrator's award shall be final and judgment may be entered upon it in any court having jurisdiction thereof.

Entire Agreement

6.10 This Agreement represents the entire agreement between the Client and the Designer and may be changed or modified only in writing.

Representations

6.11 The Client represents that it has full power and authority to enter into this Agreement and that it is binding upon the Client and enforceable in accordance with its terms. The Designer represents that it has full power and authority to enter into this Agreement and that it is binding upon the Designer and enforceable in accordance with its terms.

7. Time Schedule

The Designer and Client agree that the work shall be completed according to the following schedule:

The Designer reserves the right to adjust the schedule in the event that the Client fails to meet agreed deadlines for submission of materials or granting approvals and to allow for changes in the scope or complexity of services from those contemplated by this Agreement.

8. Continuations and Other Conditions

9. Defined Terms

Basic Services	As described in Section 2.1.
Client	As defined on page 1.
Designer	As defined on page 1.
Implementation	As described in Section 2.3.
Project	As described in Section 1.
Reimbursable Expenses	As described in Section 3.7.
Supplementary Services	As described in Section 2.2.

10. Signatures

This Agreement was entered into between the Designer and the Client as of the day and date set forth on page 1.

Designer

Client

© 1988 American Institute of Graphic Arts
Reprinted with permission.

**This form of proposal,
used by designer Jack
Summerford, outlines
the report tasks and
cost in a letter. It is
brief and to the point.**

Date

Client Name
Client Address

Dear Client:

The following is the cost estimate/proposal for our services for your
1988 Annual Report as we discussed previously:

Design, layout (including sample comp spreads, chart/map design
and art, and cover solution), type specification, mechanical art
preparation, art direction, consultation and meeting time, all pro-
duction supervision (including press checks) and general coordina-
tion; $000 per page $00,000.00

Note: This estimate is based on the 1987 Annual Report.

Proofing: All art is checked prior to printing, but final proofread-
ing responsibilities rest with the client. A number of proofreading
steps are included in the process.

Suppliers: Our design firm prefers to have a voice in the selection
of all suppliers (printers, photographers, etc.). This assures a
quality product.

Revisions: Additional mechanical revisions past the second blue-
line are billed at $00.00 per hour.

Not Included: This proposal does not include costs such as print-
ing, typesetting, photostats, photography, illustration, tax, travel,
long distance calls, Federal Express deliveries, or freight and ship-
ping.

Payment: Monthly invoices reflecting the previous month's activi-
ty such as were used in the preparation of the 1987 Annual
Report are preferred.

I cannot stress enough how happy I am to be involved in the report again
this year. Thank you for the vote of confidence. I look forward to design-
ing and producing another great one.

Respectfully,

Designer Signature

Annual Report Budget/Actual Cost Update

CLIENT _____

PROJECT _____ 1986 Annual Report

DESCRIPTION _____ 60 page plus cover 64 page plus cover

DATE _____	0/0/00 ORIGINAL ESTIMATE	0/0/00 REVISED ESTIMATE	0/0/00 BILLED TO DATE
DESIGN/LAYOUT _____ $	00,000.00 $	00,000.00 $	00,000.00
PHOTO DIRECTION _____ $	0,000.00 $	0,000.00 $	0,000.00
PHOTOGRAPHY _____ $	0,000.00 $	0,000.00 $	0,000.00
TRAVEL DAYS _____ $	0,000.00 $	0,000.00 $	0,000.00
FILM & PROCESSING _____ $	0,000.00 $	0,000.00 $	0,000.00
EXPENSES _____ $	000.00 $	0.0 $	0.0
TRAVEL EXPENSES _____ $	0,000.00 $	0,000.00 $	0,000.00
STOCK PHOTOGRAPHY _____		$ 000.00 $	000.00
RETOUCHING _____ $	0,000.00 $	0,000.00 $	0,000.00
ART/ILLUSTRATION (Maps/Charts) $	0,000.00 $	0,000.00 $	0,000.00
CHART CORRECTIONS _____		$	000.00
TYPESETTING _____ $	00,000.00 $	00,000.00 $	00,000.00
PHOTOSTATS/PRINTS _____ $	0,000.00 $	0,000.00 $	0,000.00
MECHANICAL PRODUCTION (60 Pages) $	00,000.00 $	00,000.00 $	00,000.00
MECHANICAL REVISIONS (14 Pages)		$	0,000.00
PRINTING QUANTITY: (125,000) $	000,000.00 $	000,000.00 $	000,000.00
PRINTING REVISIONS (Blueline)		$	0,000.00
SPECIAL BINDING (500 wire-bound)		$	000.00
PRINTING SUPERVISION _____ $	0,000.00 $	0,000.00 $	0,000.00
DELIVERY/FREIGHT _____ $	000.00 $	000.00 $	000.00
CONTINGENCY _____ $	00,000.00 $	0,000.00	
SUB-TOTAL _____ $	000,000.00 $	000,000.00 $	000,000.00
TAXES _____ $	00,000.00 $	00,000.00 $	00,000.00
TOTAL _____ $	000,000.00 $	000,000.00 $	000,000.00

This budget/cost update form used by Herring Design is designed to track the cost of an annual report throughout the process. Once a budget is established, changes are reflected in a revised estimate column, and costs billed to date are also noted.

Change Order

When a decision is made that will affect the cost of the report project, a change order, letter or some form of written communication should document the change. Having a form that the company signs is helpful in making sure the company is fully aware of the change and the cost implications.

Change Order

Project 1988 Annual Report

Date January 10, 1989

To M.R. (Company)

From J.H. (Design Firm)

Items
to be
Changed
and
Cost
Differences

ALTERATION TO PRINTING ESTIMATE:

As per our meeting on January 9th, the full-page photograph and small inset photograph on page 12 will be changed, and new separations will be ordered. The cost for the new separations, with the color enhancement to the sky, will be:

 Separations, one full page and one minimum size: $425.00

The total estimate for the printing with the above change included now stands at $164,367.82 for 125,000 copies.

If the cost of this alteration is agreed to, please sign and return a copy of this change order.

Approved _____

Date _____

(Date)

(Designer/Client)
(Address)

Dear (Designer/Client)

This letter confirms our agreement that (Photographer) will provide services as required to produce photographs for use by

(Company/Project)

Fees for these services will be at the rate of $___0,000.00 per day, $___000.00 per half day or fraction thereof. Travel and meeting days will be one-half these rates. Expenses will be additional at full cost. Invoices are payable thirty (30) calendar days from date of invoice. Accounts will be charged 2% interest for each 30 days overdue.

Upon full payment of all fees and expenses, usage rights are hereby granted for use of photographs interchangeably in annual reports, quarterly reports, capability brochures, marketing presentations, personnel recruitment, slide presentations, trade shows, and other company public relations uses.

Supplementary fees for additional usage of photographs in any placed media will be negotiated in accordance with the rate schedules published in the current edition of ASMP Business Practices in Photography.

If these proposals are agreeable to you, please sign and return one copy of this letter.

_____ _____
By By

_____ _____
For (Design Firm/Client) For (Photographer)

Photography Agreement

An agreement should be drawn up between the designer or company with the report's photographer or illustrator. The agreement spells out the photographer's or illustrator's services, costs and rights. These agreements can be customized to fit each occasion, depending on the requirements of the company and the wishes of the person producing the work.

**Standard Model
Release**

Standard model release
forms are available
from various sources.
This particular one is
from *Model Release
Forms for Photographers*, published by
Amphoto Books. Copies
are available from
Watson-Guptill Publications, Distribution Center, 1695 Oak Street,
Lakewood, N.J. 08701.

MODEL RELEASE

For and in consideration of my engagement as a model by _____ , hereafter referred to as the photographer, on terms or fee hereinafter stated, I hereby give the photographer, his legal representatives and assigns, those for whom the photographer is acting, and those acting with his permission, or his employees, the right and permission to copyright and/or use, reuse and/or publish, and republish photographic pictures or portraits of me, or in which I may be distorted in character, or form, in conjunction with my own or a fictitious name, on reproductions thereof in color, or black and white made through any media by the photographer at his studio or elsewhere, for any purpose whatsoever; including the use of any printed matter in conjunction therewith.

I hereby waive any right to inspect or approve the finished photograph or advertising copy or printed matter that may be used in conjunction therewith or to the eventual use that it might be applied.

I hereby release, discharge and agree to save harmless the photographer, his representatives, assigns, employees or any person or persons, corporation or corporations, acting under his permission or authority, or any person, persons, corporation or corporations, for whom he might be acting, including any firm publishing and/or distributing the finished product, in whole or in part, from and against any liability as a result of any distortion, blurring, or alteration, optical illusion, or use in composite form, either intentionally or otherwise, that may occur or be produced in the taking, processing or reproduction of the finished product, its publication or distribution of the same, even should the same subject me to ridicule, scandal, reproach, scorn or indignity.

I hereby warrant that I am under/over twenty-one years of age, and competent to contract in my own name insofar as the above is concerned.

I am to be compensated as follows:

I have read the foregoing release, authorization and agreement, before affixing my signature below, and warrant that I fully understand the contents thereof.

DATED _____

_____ L.S.
NAME

_____ L.S.
WITNESS

ADDRESS

ADDRESS

I hereby certify that I am the parent and/or guardian of _____
an infant under the age of twenty-one years, and in consideration of value received, the receipt of which is hereby acknowledged, I hereby consent that any photographs which have been or are about to be taken by the photographer may be used by him for the purposes set forth in original release hereinabove, signed by the infant model, with the same force and effect as if executed by me.

_____ L.S.
PARENT OR GUARDIAN

ADDRESS

Photographer: 1–Fill in terms of employment.
 2–Strike out words that do not apply.

PHOTOGRAPHY COPYRIGHT TRANSFER LETTER OF AGREEMENT

DATE: (Date of Agreement)

TO: (Photographer)

FROM: (Corporate Communicator)

SUBJECT: Photography for 1986 Annual Report

It is the understanding of (Company), the purchaser of photographic services for the
(Company Name) Annual Report, that the general scope of photography and the rights
and usage of such photography are as follows:

General Description of Photography

PORTRAIT: CEO Photograph, Denver

LOCATIONS: Nine (9) location photos in Texas, New York, Florida,
 California and Michigan

Rights

The owner of the final photography will be (Company) and the usage will be for the
1986 Annual Report, the subsequent quarterly reports for 1987 and all descending
usage to include unlimited collateral, P.R., corporate advertising and internal
usage for one year. (Company) will retain possession of the slides indefinitely;
however, the photographer will be compensated with published stock rates for usage
beyond those stated above.
 The use of the photographs by third parties--such as outside publications or
suppliers to (Company)--will require consultation with and compensation to the
photographer.
 The photographer may keep a selection of slides that are duplicates or unused
photographs that can be used by the photographer for the promotion of the
photographer. Any use of the photographs by the photographer for third party usage,
such as stock photography, will require the consent of (Design Firm) and (Company).
 The spirit of this agreement is that (Company) has the use of the photographs for
their own purposes, and is insured against the images appearing in publications that
(Company) or (Design Firm) do not find acceptable, but the photographer does not
relinquish his right to compensation when non-(Company) groups are allowed to use
the photographs, or additional uses beyond the stated uses occur.

(Signature, Date) (Signature, Date)
----------------------------- -----------------------------
Name of Designer Name of Photographer
Name of Design Firm Name of Photography Firm
Address of Design Firm Address of Photography Firm

(Signature, Date)

Name of Corporate Communicator
Name of Company
Address of Company

Line-Item Calendar

Calendars can take different forms. A line-item calendar is helpful in outlining the tasks, dates, people responsible, and overall flow of the report.

1988 ANNUAL REPORT PRODUCTION SCHEDULE

Company:	(Corporate Communicator)	621-0000
Designer:	(Designer)	560-0000
Writer:	(Writer)	521-0000
Typesetter:	(Typesetter, Contact)	520-0000
Printer:	(Printer, Contact)	780-0000

June 2	Thu		Initial meeting with CEO/Company/Designer/Writer
June 16	Thu	Designer	Initial Layouts/Budget/Schedule to Company
June 22	Wed	Designer	Revised Layouts/Costs/Schedule to Company
June 28	Tue	Company	Review revised Layouts/Costs/Schedule
June 28-July 1		Writer	Interview business areas
July 5-July 8		Writer	Interview CEO
July 18	Mon	Writer	Outline/Copy Direction due to Company/Designer
July 22	Fri	Company	Approval/Corrections of Outline to Writer/Designer
July 29	Fri	Company	Clean Financials to Designer
Aug 1	Mon	Designer	Financials to Typesetter
Aug 1	Mon	Writer	First Draft of Copy due to Company/Designer
Aug 5	Fri	Designer	Deliver Financial Galleys to Company
Aug 5	Fri	Company	Corrected First Draft to Writer
Aug 12	Fri	Company	Corrected Financial Galleys to Designer
Aug 12	Fri	Writer	Final Copy due to Company/Designer
Aug 15-Aug 19		Designer	Produce Mechanicals
Aug 19	Fri	Designer	Photocopy of Mechanicals to Company/Writer
Aug 19	Fri	Company	Final Approval of Color Photography
Aug 22	Mon	Designer	Release all Color to Printer
Aug 23	Tue	Company	All Mechanical Corrections to Designer
Aug 26	Fri	Designer	Release Final Mechanicals to Printer
Aug 29	Mon	Printer	Blueline Proof to Company/Designer
Aug 31	Wed	Designer	Final Corrections to Printer
Sept 1	Thu	Printer	Final Proof to Company/Designer
Sept 2	Fri	Company	Final Okay to Print
Sept 5	Mon	Printer	On Press
Sept 12	Mon	Printer	Deliver AR's to Company/Bank/Mail House
Oct 27	Thu	Company	Annual Meeting

1989 ANNUAL REPORT PRODUCTION SCHEDULE

	S	M	T	W	T	F	S
JUNE		12	13	14	15	L/O 16	17
	18	INTERVIEWS 19	20	21	22	23	24
	25	26	27	28	29	30	1
JULY	2		PORTRAIT 6			REVISED L/O DRAFT 7	8
	9	PHOTOGRAPHY 10	11	12	13	14	15
	16	17	18	19	20	FINAL DRAFT 21	22
	23	24	25	26	APPROVED TEXT 27	28	29
	30	31	1	2	GALLEY 3	MOCK UP OF BOOK / REVISED GALLEY 4	5
AUG	6	MECHANICALS 7	8	9	10	11	12
	13	14	15	FINAL COLOR CHECK 16	17	18	19
	20	21	22	23	BROWNLINE 24	25	26
	27	28	FINAL CORRECTIONS 29	30	REVISED PROOF 31	1	2
SEPT	3	OK TO PRINT 4	ON THE PRESS 5	6	7	8	9
	10	11	FINAL DELIVERY 12	13	14	15	16
	17	18	19	20	21	22	23
	24	25	26	27	28	29	30
OCT	23	24	25	26	ANNUAL MEETING 27		

Traditional Calendar

Laying out the schedule on a conventional calendar helps everyone see the overlapping tasks, shows clearly how many actual workdays are allocated to these tasks and highlights key dates. A side benefit of a traditional calendar is that most of us can relate to this calendar form and can pencil in our own personal dates. Make sure that you have penciled in others' personal dates as well, and that three-day weekends and holidays are accounted for in the allocation of time.

Production Schedule

This particular schedule was designed by the office of Robert Miles Runyan, and it goes into great detail in a very clear format. Tasks and dates are outlined in flowchart form. Specifications, such as number of pages and papers used are also noted.

client		job	
contact		phone	
job number		date schedule submitted	
dimensions		number of pages	
quantity		envelope quantity	
cover stock		cover colors	
text stock		text colors	
photographer		illustrator	

month

date

preliminary approach meeting

rough copy or estimated copy length

design and layout of presentation comps

presentation and approval of comps

printing estimate

photography, illustration, keyline art

select and size photos

approval of photo section

retouching

color subjects to printer

inspect 1st color proofs

color correction

inspect 2nd color proofs

final text copy due[1]

text copy at typesetter

inspect text checker proofs[2]

layout of text section with checkers

approval of text section

text checker proofs back for repro

final financial copy due[1]

financial copy at typesetter

inspect financial checker proofs[2]

layout of financial section with checkers

approval of financial section

financial checker proofs back for repro

paste-up camera-ready art

final inspection and approval of paste-up[3]

printer prepares brownline

inspect first brownline

back for corrections

inspect and approve 2nd brownline[4]

plate/presswork

bindery

partial delivery (quantity:)

balance of delivery

This production schedule allows a normal amount of time in each phase to meet the delivery date. If a date cannot be met we can only compensate by going into overtime in subsequent phases or by extending the delivery date.

1. It is most advisable that copy be thoroughly checked at this point to be sure it is in final form — radical copywriting changes (other than normal proofing corrections) can be unnecessarily costly in the typesetting and following stages.

2. This is the last opportunity to make changes in copy before final art is prepared and stay on schedule.

3. This is the last opportunity to make changes on art before it is turned over to the lithographer.

4. This is the final check point before the report is printed. Anything requiring a change at this point would have to be of the most imperative nature and would result in additional costs.

Robert Miles Runyan & Associates
200 East Culver Boulevard
Playa del Rey, California 90291
(213) 823-0975

Text Style Guide

The style guide found on pages 136 through 143 is excerpted from the "Corporate Annual Reports Inc. Style Guide" and is reproduced here with the permission of Corporate Annual Reports Inc., New York.

Although this book is primarily devoted to the design process, working with the copywriter on an annual report project and being aware of the text are part of the designer's responsibility. Consistency in the text should be a goal for the team assembling the report. These pages present a practical guide for language usage in the report, written by the staff at Corporate Annual Reports, a leading annual report producer.

Punctuation

Omit the comma before *and* in a series, unless a comma is needed for clarity.

Sales, earnings and dividends all increased in 1987.

The operation benefited from improved balance between costs and prices, further diversification into hog and livestock equipment, and conversion of surplus manufacturing capacity into more profitable areas.

Use a comma before and after the state name when it is preceded by a city.

Our facility in Wilmington, Del., was completely renovated.

Don't use a comma between the month and year when no day is given, but do use a comma between the day and the year.

There was a blizzard in February 1987.
There was a blizzard on February 12, 1987.

Use commas to set off per-share figures.

Net income totaled $2.5 million, or 30 cents per share, for the three months ended March 31.

If a clause is essential to the meaning of a sentence, don't set it off by commas. If it is parenthetical in nature, set it off by commas.

We are building deep-water port facilities at our Kentucky plant located on the Mississippi River.

At the Wickliffe paper mill, one of our four plants in Kentucky, we are expanding capacity by 25%.

Punctuation at the end of quoted words, phrases or sentences:
Period and comma always go within the quotation marks. Colon and semicolon always outside the quotation marks. Dash, question mark and exclamation point within the quotation marks when they apply to the quoted matter; outside when they refer to the whole sentence.

"The near-term outlook is uncertain," he said, "but I am optimistic for the long term."
Our position can be described as "fluid."
Did you say your position is "fluid"? Last quarter we called our position "fluid"; now it is firm.

The semicolon is used to separate a series of phrases containing commas, as well as closely related or contrasting statements.

The Board made its decision after interviewing members of three different groups: machinists, assemblers and die cutters; plant foreman; and labor union officials.
The floor not only reduced the harvest; it also delayed the planting of next year's crop.

Hyphens are used when an adjective is joined with a noun to form a compound adjective: *Short-term results, long-range plans, first-quarter sales, 174,000-square-foot building, five-ton truck, 12-foot ceiling.*

Adjectival phrases consisting of an adverb and a verb are usually hyphenated: *A well-designed report.* But when the adverb ends in "ly," it is not hyphenated: *A poorly written report.*

When each word in a job title designates a function, use a hyphen or slash: *Secretary-Treasurer* or *Secretary/Treasurer.* However, separate with a dash, not a hyphen, titles in which the area of responsibility is designated: *Vice President—Marketing.* Other means of designating responsibility are: *Vice President, Marketing* and *Vice President of Marketing.*

Don't use apostrophes to form plurals of numbers.

The 1980s, the low 90s, Boeing 747s.

Capitalization

Don't capitalize *government*, *federal* or *national*, unless it is used as part of a proper noun.
The federal housing program is being phased out.
The Federal Housing Administration is cutting staff.

Corporate style, unlike journalistic style, leans toward capitalization of job titles: *John Jones, Chairman and Chief Executive Officer; Jane Doe, Vice President.* If your company style is to capitalize job titles, do so for all positions, not merely for officers.

Avoid titles in front of names. That privilege is generally reserved for high government officials: *President Reagan, Secretary of State Schultz.*

Capitalize the words *Company* and *Corporation* when referring to the parent organization. This violates business journalism style, but it is almost a universal practice in annual reports. By the same token, capitalize *Board of Directors* and its shortened version, *Board*, as well as the title *Director*.

Capitalize the full names of major operating units, but not subsequent abbreviated references.
The Automotive Parts Division had record profits.
In addition, the division introduced 12 new products.

Words that should not be capitalized in general reference include: *group, subsidiary, annual report, committee* and *annual meeting*. Too many capitals make the copy seem amateurish and faintly antique.

North, South East and *West* are capitalized when they refer to sections of the United States, but not when they are used as directions.
Three sales offices were opened in the West.
We expect to expand north of New York City.

Capitalize other specific regions, such as *Midwest, Southern California.*
In titles or headings, do not capitalize prepositions, conjunctions or articles unless they start a line.
A List of Major Companies
In the Retailing Business

On the second and subsequent references to individuals, use the surname preceded by Mr., Mrs. or Miss, as appropriate. Ms. can be used if the marital status of a woman is unknown or if she prefers it as a title of courtesy to the more conventional ones.

Abbreviations

The following are standard abbreviations for state names. States with six letters or less are not abbreviated.

Ala.	Hawaii	Mass.	N.M.	S.D.
Alaska	Idaho	Mich.	N.Y.	Tenn.
Ariz	Ill.	Minn.	N.C.	Texas
Ark.	Ind.	Miss.	N.D.	Utah
Calif.	Iowa	Mo.	Ohio	Vt.
Colo.	Kan.	Mont.	Okla.	Va.
Conn.	Ky.	Neb.	Ore.	Wash.
Del.	La.	Nev.	Pa.	W. Va.
Fla.	Maine	N.H.	R.I.	Wis.
Ga.	Md.	N.J.	S.C.	Wyo.

Postal Service abbreviations follow. Do not use them in written text. Do use them when listing addresses of corporate and subsidiary offices.

AL	HI	MA	NM	SD
AK	ID	MI	NY	TN
AZ	IL	MN	NC	TX
AR	IN	MS	ND	UT
CA	IA	MO	OH	VT
CO	KS	MT	OK	VA
CT	KY	NE	OR	WA
DE	LA	NV	PA	WV
FL	ME	NH	RI	WI
GA	MD	NJ	SC	WY

In written text, omit state names for larger cities, unless there are cities with the same name in two or more states.
Los Angeles, Chicago, Atlanta; but *Portland, Ore.*

Use *a.m., p.m.* and *EDT*, not 9 o'clock in the morning or Eastern Daylight Time and never the redundant 9 a.m. in the morning.

The following are standard abbreviations for months. Abbreviate only when using them with full dates. Months with five letters or less are not abbreviated.

Jan.	April	July	Oct.
Feb.	May	Aug.	Nov.
March	June	Sept.	Dec.

When referring to the month or including it with a year, never abbreviate.
She was hired in November 1987.
He retired in November.

Do not abbreviate corporate titles.
Lynn Smith, Manager of Corporate Relations, not *Mgr. of Corp. Rel.*

Figures and Signs

Write out numbers one through nine and use arabic numerals for 10 and above (unless the number begins a sentence, in which case spell it out). There are, however, exceptions:

Dimensions (4 by 9 feet); degrees of temperature (6 below zero); percentages (4%); numbers with a dollar sign ($5 million); statistical data, especially when used in tables and charts (5 tons).

If you must start a sentence with a year or a numeral, spell it out.

Nineteen eighty-seven was a year of exhilaration.

Don't write out *dollar* as in "ten million dollars." Always use the arabic numeral and dollar sign: *$10 million.*

When reporting rounded-off figures, the following form is appropriate: *$4.5 million*, not *$4,500,000*. Millions should be rounded off to the closest $100,000; billions should be rounded off to the closest $100 million.

Nd, th and the like are obsolete in dates and addresses. Make them simply: *June 19* and *112 East 31 Street.*

Use commas in numbers of more than three digits.
1,440 rooms

The preferred usage is a percent sign (%) rather than spelling out *percent*. If spelled out, *percent* is preferred over *per cent*. We don't know what percentage of annual reports use % or *percent*, but there are a good many on both sides of the issue. Whichever you choose, be consistent.

In chart data, the cent sign (¢) should be used when all figures are below $1.00. When figures are both above and below $1.00, use the decimal point with the dollar sign: *$1.25, $.25.*

Interest rates are usually given in fractions; indexes of various kinds in decimals.

The prime rate is 12¼%.
The Dow Jones Industrial Average rose to 2,428.54.

Spelling

Compounds take on a one-word form and the hyphen is dropped once they become established. In line with this practice, the following prefixes generally don't require hyphens:

anti	*intra*	*pre*
bi	*multi*	*semi*
co	*non*	*trans*
inter	*post*	*under*

The following suffixes generally don't require hyphens:

fold (as twofold)
wide (as worldwide)

The correct (or, in some cases, the preferred) spelling for words and phrases that commonly appear in annual reports follows:

all right	*per-share*
benefited	*(as adjective)*
canceled	*pretax*
catalog	*(as adjective)*
first-in, first-out	*short-term*
(FIFO)	*(as adjective)*
focused	*sizable*
input	*start-up*
judgment	*totaled*
last-in, first-out	*transferred*
(LIFO)	*under way*
long-term	*year-earlier*
(as adjective)	*(as adjective)*
ongoing	*year-end*
output	

Syllabication

When a whole word will not fit at the end of a line, try to break it in such a way that you do not begin the second line with a single letter or, if the word is multisyllabic, with only two letters. In any event, never put *ed* alone on the second line if the *e* is silent as in *walked*. When there's a question about proper syllabication in dividing words, check the dictionary.

Captions

Put the first sentence describing the action in the picture in the present tense. The subsequent sentences, giving the background or the consequences of the action, should be in the past tense.

John L. Brown, Chairman and Chief Executive Officer, turning the first shovelful of earth at the site of Amalgamated's new laboratory. Construction began in mid-July 1986 and was completed in June 1987.

Publication Titles

Italicize the names of magazines and newspapers. Put the titles of books, magazine articles, speeches, TV programs, etc. in quotation marks.

A new novel about Wall Street, "The Happy Insider," was reviewed in *Business Week.*

The article "The Caring CEO" appeared in *The Wall Street Journal.*

Trade Names

Italicize trade names: Babysmooth, or indicate the trademark in the first reference with a superscript TM, Babysmooth™. Do not indicate trade names with capitals (BABYSMOOTH) or small capitals (BABYSMOOTH).

General Word Usage

Authoritative sources for checking word usage are Fowler's "Modern English Usage" and Theodore Bernstein's "Watch Your Language." "The Elements of Style" by William Strunk, Jr., and E.B. White has an excellent chapter on misused words and expressions. Here are a few improper usages that corporate publications seem partial to.

"The Wall Street Journal Stylebook" reminds us that *record* should not be preceded by *new*. If it's a record, it has to be new.

Compared with is used when contrasting one year's results with another's. *Compared to* is used only to liken two things or to put them in the same category.
> *Total revenues for the Company were $5,211,880, compared with $4,255,781 last year.*
> *The lagging fund drive can be compared to a runner getting his second wind.*

Comprise is a frequently misused word. It means *include*; it is not synonymous with *compose*.
The whole *comprises* the parts; the parts *compose* the whole. A phrase to avoid is *comprised of*.
> *The company comprises three divisions: manufacturing, sales and administration.*
> *The company is composed of three divisions: manufacturing, sales and administration.*

Continual means over and over again.
> *Our machinery is being continually upgraded.*

Continuous means unbroken.
> *Earnings have been growing continuously for the past five years.*

Downsize, downsizing, are euphemisms devised by those who favor corporatese over English. One 1986 annual report, for instance, referred to "restructuring and downsizing." What the company meant, but didn't have the heart to say plainly, was that it had become smaller by laying people off and terminating certain operations.

As a noun, *impact* means a forceful contact, collision or onset, and also the force of impression or operation of one thing or another.
> *The uncertainties of the American economy had an adverse impact on last year's sales.*
As a verb, however, it means to impinge, wedge, press together or pack.
> *Teeth are impacted, but companies are not.*

Presently means *soon* or *shortly*, not *currently* or now.

Hopefully means *with hope*. It should not be used to mean I or we hope. The sentence *Hopefully, the Company will increase sales by 10% next year* means the company will be in a hopeful state of mind when it increases sales by 10%.

Avoid the neologism *finalize*. Strunk and White call it "pompous and ambiguous."

Net income, net earnings and *profit* all mean the same thing: what is left after taxes.

Shareholder, shareowner and *stockholder* are synonymous, but they should not be used interchangeably in the annual report. The company should decide which word to use, and then stick with it.

Substantially and *significantly* are two of the most overworked words in corporate literature, probably because they seem to say something without saying anything. Try to be concrete; give actual figures wherever possible.

That and *which* are sometimes misused in annual reports, because some people incorrectly consider *which* the more literary word. Use *that* to introduce restrictive clauses and *which* to introduce nonrestrictive clauses. The *which* clauses, because they are not essential to the meaning of the sentence, are set off by commas.
> *Our newest silver mine, which is producing 50,000 tons of ore a day, began operation last March.*
> *The exploratory oil well that shows the most promise is located 175 miles north of Calgary, Alberta.*

Very is another overworked word. Descriptive words and hard facts don't need to be propped up by a tired old intensive like *very*.

Your Company was once commonly used in the letter to shareholders to indicate a close relationship between stockholders and management. In this era of institutional investors, it sounds a little forced. *Our Company* or *the Company* are more in keeping with the times.

How to Prepare Copy for Typesetting

When preparing copy to be typeset, observe the following guidelines:

Always double-space copy.

Always indent the first line of a paragraph. While the style of your annual report may be not to indent paragraphs, for manuscript purposes it is far less confusing to indent and allow the graphic designer to indicate to the typesetter the format of the report.

Have copy typed to the character count assigned by the graphic designer. When using a word processor, never use proportional spacing as this throws off the character count.

Center copy on the page if lines are short. If lines are long, leave extra space on the left side of the page.

Don't underline a word unless you want it set in italic. With subheads or headlines, however, you can underline when you want to indicate boldface or headline type.

Avoid using all-capital words for emphasis.

Identify all pages pertaining to each section of copy. In other words, if the CEO's letter is four typewritten pages, write "CEO's letter" on all four pages and number them. Try not to break paragraphs between pages. Note the end of each page before the final one by marking "—more—" at the bottom. The last page of a section should be marked "—end—" at the bottom.

Do not send handwritten copy to the typesetter. Sometimes harried accountants try to save time by sending handwritten financial statements or footnotes directly to the typesetter. This procedure is far more costly, time-consuming and error-prone than taking the time to type out the material.

Insertions. Indicate a large insertion by noting "Insert A" in the correct space. Staple "Insert A," typed copy on a separate sheet of paper, to the bottom of the page.

How to Prepare Copy for Electronic Transmission

Electronic transmission is the process of taking the original keystrokes in your word processor and zipping them to the typesetter by modem over telephone lines. Some advance work is required before you transmit; the typesetter must prepare a translation table to enable his typesetting computer to translate your word-processing computer's language.

The key to success is a consistent style in the copy you transmit. If, for example, the sender always tabs five spaces for a paragraph, there'll be no problem. But if the number varies throughout the copy, the typesetter cannot apply the translation table. Instead, he must manually scroll through the copy and make the "fixes" one at a time, increasing the cost of the typesetting.

To maintain consistency no matter how many different typists process the copy, develop a style for all word-processing operators to use. Feel free to differ from our style examples, but, please, be consistent.

Example	Style
Filling in blanks	XXX
Headlines and subheads	Two spaces above one below (not all CAPS)
Fractions	1/2 (one, slash, two)
Dashes	-- (space, two hyphens, space)
Tabs	In the same position, even in different tables
Special symbols (i.e., cent sign, trademark, etc.)	If you need to use these notify the type house
The numeral "1"	Never use the lower-case "L"
Spacing	Never use proportional spacing

The normal—and most cost-effective—procedure is for the client to proofread electronically transmitted copy. If you want backup proofreading from the typesetter, request it and provide hard copy. Careful! A devilish mixup can occur if the transmitted copy and the hard copy don't exactly match. This can happen, for example, if you make a last-minute change after the copy has been transmitted but before the hard copy is printed out. The proofreader normally will assume the transmitted copy is correct and ignore the hard-copy changes.

How to Edit Galleys

There is probably nothing in the field of publishing that gets more heavy editing than the annual report galley. The proofreading procedures suggested here are especially designed to take into account the large volume of changes that must be handled in the preparation of an annual report.

A Few Items of Basic Information
Typesetters charge by the hour; the longer it takes to figure out the changes, the more it costs. So mark your changes clearly.

To effect even a single change, an entire paragraph may have to be rekeyboarded. Consequently, when checking any correction, it is advisable to proofread the entire paragraph to make sure no new mistakes were made.

There are two kinds of type galleys: rough and reproduction (repro) proofs. Repro proofs, which are normally reserved for final copy, are images of high resolution on paper or film capable of maintaining high resolution. Rough proofs are the same images transferred onto material not capable of supporting high-resolution images. They are useful as readers' proofs for content, style and position.

General Rules on How to Edit Galleys
For each correction, you need two notations. One is within the galley to indicate the point at which the correction is to be made. The other is in the margin showing the actual change to be made.

All corrections should be noted in the margin because typesetters do not go through the type line-by-line; they read only the indicated corrections in the margins.

Make all notations in pencil. Pencil marks can be erased; ink and marker can only be crossed out. Also, galleys are often on coated paper which allows marker and ink to run and smudge.

Editing marks may be made in the right and left margins. To determine which to use for a given correction, divide the column of type by an imaginary line down the center, making all changes to the left of that line in the left margin, changes to the right in the right margin.

When deleting words, do not obliterate them. Draw a single line through the word, or words, so the typesetter can still read what is to be deleted. The same is true when deleting sentences, paragraphs, galleys, etc.

Make as few marks on the galley as possible, confining them to corrections to be made.

When making changes in numbers, observe the following example:
Change $45,979 to $45,189
$45,979 *18*

In other words, only rewrite the digits you are changing, not the entire number.

Insertions: Indicate a large insertion by noting "Insert A" in the correct space. Staple "Insert A" copy, which should be typed on a separate sheet of paper, to the bottom of the galley. If you are inserting a replacement piece of copy, handle it in the same manner, being sure to indicate the area to be deleted by encircling but not obliterating it.

When there are two or more changes in a line, it is best to retype the entire line and treat it as an insert. Similarly, if there are changes in more than half of the lines in a paragraph, it is best to retype it.

Incorrect Procedures That Bedevil Typesetters
Marking changes on an outdated galley. If, for example, you have changes on a third series of proofs and inadvertently make them on a second series proof, you may find that changes made earlier on the second proof do not show up on the fourth proof. Mass confusion is created for the the typesetter and for you. The typesetter's only recourse is to reset the entire section. This is not only costly, but carries the danger that the typesetter will make new errors in the process.

Retyping or retelecommunicating an entire set of galleys. This makes it impossible for the typesetter to determine what changes should be made. His only recourse is to reset the entire section.

Marking broken letters on rough proofs. You can't tell on rough proofs if letters are broken. Mark broken letters only on repro proofs.

When making changes, always use the annual report proofreading symbols on page 143. An example of an edited galley is shown on page 142.

TO OUR STOCKHOLDERS: *Shareholders:*

Sales for First-Second Corporation rose in in fiscal 1987 to record level of $1.1 billion, up over 10% from the 1986 level of $973.6 million. Net income, also a record, climbed 5 percent to $31.1 million, or $3.22 share, up 5 percent from $29.6 million, or #3.08 in per share, a year ago.

First-Second made 2 major acquisitions during 1987. Smergstein Development Corporat6on, a South Dakota home-buidlng furm with 1986 xxx revenues of $8.6 million, was acquired by First-Second in Alpril.

Shortly thereafter, FirstSecond completed plins to acquire, The Cloverdale Mining Company of New York. Details of these acquisitions may be found in the Development and Manufacturing Division review on Page 17. I am also pleased to announce the development of the Companys new textured fiber line. Production was begun at the Oneonta, New York and Pittsburgh, Pa. facilities in early June.

INSERT A

```
, a drilling-rig manufacturer
with 1986 sales of $18.8 million.
```

Note: In practice, a galley with such excessive changes as these should not be sent to the typesetter; if time permits, it should be retyped.

To Our Shareholders:

Sales for the First-Second Corporation rose in fiscal 1987 to a record level of $1.1 billion, up over 10% from the 1986 level of $970.6 million. Net income, also a record, climbed to $31.1 million, or $3.22 per share, up 5% from $29.6 million, or $3.08 per share, a year ago.

First-Second made two major acquisitions during 1987. Smergstein Development Corporation, a South Dakota home-building firm with 1986 revenues of $8.6 million, was acquired by First-Second in April.

Shortly thereafter, First-Second completed plans to acquire The Cloverdale Mining Company, a drilling-rig manufacturer with 1986 sales of $18.8 million. Details of these acquisitions may be found in the Development and Manufacturing Division review on page 17.

I am also pleased to announce the development of the Company's new textured fiber line. Production was begun at the Oneonta, N.Y., and Pittsburgh facilities in early June.

Instruction	Symbol	Mark in Type	Corrected Type
Delete	*e*	Our ~~record~~ sales *e*	Our sales
Insert	∧	Our sales record	Our record sales
Close up space	⌒	Our re cord sales ⌒	Our record sales
Insert space	#	Ourrecord sales #	Our record sales
Start paragraph	¶	Our record sales ¶	Our record sales
Run in (no spacc)	run in	Our record sales run in	Our record sales
Capitalize	UC ≡	our record sales UC	Our record sales
Make lower case	lc /	Our Record Sales lc	Our record sales
Let it stand	stet	Our ~~record~~ sales *e* stet	Our record sales
Insert period	⊙	Our record sales ∧ ⊙	Our record sales.
Insert comma	∧	Record sales which	Record sales, which
Insert hyphen]-[Long term debt]-[Long-term debt
Insert colon	∴	Our record sales ∴	Our record sales:
Insert semicolon	∧	Our record sales ∧	Our record sales;
Insert apostrophe	∨	The Companys ∨	The Company's
Insert quotation marks	⟨⟨ / ⟩⟩ /	∧Our record sales∧ ⟨⟨/⟩⟩/	"Our record sales"
Insert parentheses	(/)/	∧in 1987∧ (/)/	(in 1987)
Move left	[[Our record sales	Our record sales
Move right]]Our record sales	Our record sales
Align	‖	‖1987 ‖1988	1987 1988
Transpose	tr ∽	Our record sales tr	Our sales record
Broken type	✗	✗Our record sales	Our record sales
Set in italic	ital	Our record sales ital	*Our record sales*
Set in roman	rom	*Our record sales* rom	Our record sales
Set in bold	bold	Our record sales bold	**Our record sales**

© 1987 Corporate Annual Reports Inc. Reprinted with permission.

SEC Requirements

The list of SEC requirements found on pages 144 through 146 is excerpted from the "Annual Report Checklists" and is reproduced here with the permission of Doremus & Company, Chicago.

Annual reports are governed by the rules of the SEC, the Securities and Exchange Commission. While most of the rules refer to accounting procedures, there are directives that concern the designer and the design of the report. The following constitutes the current, applicable guidelines. In addition to the *requirements* listed here, there is a list of materials recommended for inclusion by Doremus & Company.

SEC REQUIREMENTS

Audited Financial Statements

☐ Consolidated balance sheets (2 years)
☐ Consolidated statements of income (3 years)
☐ Consolidated statements of changes in financial position (3 years)
☐ Consolidated statements of shareholders' equity, or footnote disclosure (3 years)
☐ Notes to consolidated financial statements
☐ Report of independent public accountants

Supplementary Financial Information
Selected Quarterly Financial Data (2 years):

☐ Net sales
☐ Gross profit
☐ Income (loss) before extraordinary items and cumulative effect of any change in accounting policies
☐ Per share data based upon such income (loss)
☐ Net income (loss)
☐ Disagreements on accounting and financial disclosure matters

Selected Financial Data for Five Years

☐ Net sales or operating revenues
☐ Income (loss) from continuing operations (in total and per common share)
☐ Total assets
☐ Long-term obligations and redeemable preferred stock (including capital leases)
☐ Cash dividends declared per common share
☐ Additional items that will enhance understanding and highlight trends in financial condition and results of operations
(Such data may be combined with the five-year summary information on the effects of inflation and changing prices if required by FASB Statement No. 33, as amended by Statement No. 82.)

Management Discussion and Analysis of Financial Condition and Results of Operations

Discuss financial condition, changes in financial condition and results of operations; provide other information believed necessary to an understanding of the Company's financial condition. Areas to be covered include Liquidity, Capital Resources and Results of Operations. Discussions of Capital Resources and Results of Operations may be combined whenever the two are interrelated.

Generally, the discussion shall cover the three-year period covered by the financial statements.

☐ Liquidity: Identify any trends, demands, commitments, events or uncertainties that will materially increase or decrease liquidity. If material deficiency is identified, indicate course of action to remedy situation. Identify and describe internal and external sources of liquidity: briefly discuss any material unused sources of liquid assets.

☐ Capital Resources: Describe material commitments for capital expenditures as of end of latest fiscal period; indicate general purpose of such commitments and anticipated source of funds needed. Describe any known material trends, favorable or unfavorable, in capital resources. Indicate any expected material changes in mix and relative cost of such resources. Discussion shall consider changes between equity, debt and any off balance sheet financing arrangements.

☐ Results of Operations: Describe any unusual or infrequent events or transactions, or significant economic changes, that materially affected reported income from continuing operations. In each case indicate extent to which income was affected. Also describe any other significant components of revenues or expenses that would enhance an understanding of results. The discussion should use year-to-year comparisons or any other format that will enhance a reader's understanding. Where trend information is relevant, reference to the five-year selected financial data may be necessary. Trends or uncertainties that may have material impact on sales or revenues and income must be described. Any events that will cause a material

change in the relationship between costs and revenues (cost increases in labor or materials, or price increases or inventory adjustments) must be disclosed. If there are any material increases in net sales or revenues, provide narrative discussion of the extent to which such increases are attributable to price increases in the volume or amount of goods or services sold, or to the introduction of new products or services. Discuss the impact of inflation and changing prices on net sales and revenues and on income from continuing operations.

Industry Segment Breakdown for Three Years
☐ Revenue (with sales to unaffiliated customers and sales or transfers to other industry segments shown separately), operating profit or loss, and identifiable assets attributable to industry segments and geographic areas, for three years. Classes of similar products or services, foreign and domestic operations, export sales.

Financial Reporting and Changing Prices Information
☐ Five-year summary: effects of inflation and changing prices; may be combined with Selected Financial Data

Information on the Market for Common Stock and Related Security Holder Matters
☐ High and low sales prices of stock for each quarterly period in last two years
☐ Frequency and amount of dividends paid
☐ Principal market(s) in which the company's securities are traded and stock symbols

Identity
☐ A brief description of the company's business

Directors and Executive Officers
☐ Name, principal occupation, title, employer's principal business.

Litigation
☐ Cite significant cases; include any in which civil rights, ecological statutes or ethical conduct of directors or executive officers are involved.

Form 10-K
☐ Offer of free copy of Form 10-K in annual report or proxy statement in boldface type (not required if annual report is incorporated by reference into the Form 10-K and is filed with the SEC in satisfaction of disclosure requirements).

Type-Size Requirements
☐ Financial statement and notes—Roman type at least as large and legible as 10-point Modern; if necessary for convenient presentation, financial statements may be Roman type at least as large and legible as 8-point Modern; all type leaded at least 2 points.

Distribution
☐ Distribution of annual report to all stockholders, including beneficial owners underlying street names, analysts, brokers, press.
☐ Annual report must precede or accompany proxy statement if proxies are solicited in connection with an annual meeting.

Significant Accounting Policies
☐ The SEC requires that these subjects be reported in accordance with generally accepted accounting principles:
☐ Principles of consolidation, summary of accounting policies, changes in accounting principles
☐ Inventories: valuation method
☐ Property, plant and equipment: depreciation policy
☐ Lease commitments
☐ Translation of foreign currency transactions
☐ Effects of changing prices and general inflation
☐ Long-term debt agreements, short-term borrowings
☐ Pensions: accounting and funding policies
☐ Potential effects of Tax Reform Act of 1986 on future financial position, liquidity, and results of operations

MATERIAL RECOMMENDED FOR INCLUSION
Feature Items
☐ Front cover design to establish theme for report
☐ Financial highlights and table of contents
☐ Letter to stockholders and photographs of chairman and president
☐ Discussion of rate of internal growth
☐ Explanation of growth of production, market shares and industry trends
☐ Forward-looking information: projections of sales, income, earnings per share, capital expenditures, dividends, capital structure; corporate goals and objectives
The SEC's "safe harbor" rule protects companies from liability if such statements are made on a "reasonable basis" and in "good faith", underlying assumptions, if disclosed, are also protected.
☐ Significant effects of foreign exchange translations
☐ Regulatory climate and compliance actions, including impact of wage and price standards
☐ Management report on internal accounting control
☐ Depth of management: training programs, promotion from within
☐ Financial strength: debt, profit-center control
☐ Marketing skills: sales force and technical service backup
☐ Production achievements: new equipment, unit cost control list of facilities

☐ Research capability: scientific disciplines, achievements, programs
☐ Corporate policies: markets served, product development, acquisitions
☐ Regulatory climate
☐ Social responsibilities
☐ Political action programs

International Operations
☐ Sales: trends, percentage of consolidated total, market share
☐ Taxes: local regulations, amount
☐ Foreign currency translation
☐ Earnings: equity interest
☐ Unrepatriated earnings

Five- or Ten-Year Financial Summary
(ten years preferred)
☐ Sales
☐ Cost of goods
☐ Selling, general and administrative expenses
☐ Operating costs
☐ Operating margin
☐ Other income
☐ Interest and other financial charges
☐ Pretax earnings
☐ Income taxes—total and as percentage of pretax earnings
☐ Extraordinary items and discontinued operations
☐ Net earnings—total and per share
☐ Earnings as a percentage of sales
☐ Percent earned on average shareholders' equity
☐ Dividends declared or paid—total and per share
☐ Shares outstanding: average number (adjust for stock dividends and stock splits)
☐ Number of shareholders
☐ Price/earnings ratio range
☐ Debt ratio
☐ Total invested capital
☐ Percent earned on average total invested capital
☐ Research and development costs
☐ Capital spending for plant and equipment
☐ Depreciation
☐ Number of employees—worldwide

Miscellaneous
☐ Notice of annual meeting
☐ Names and addresses of legal counsel, auditors, transfer agent, registrar, public relations or investor relations counsel
☐ Disbursement of sales dollar
☐ Company's rank: "Fortune," "Forbes," "Business Week"
☐ Market research orientation: total industry, competitors, market share
☐ Economic environment orientation: U.S. and important foreign countries
☐ Graphs, tables and charts to illustrate key points in text
☐ Photographs to emphasize theme of annual report
☐ Tabulation of company's divisions, locations, products and managers
☐ List of major distributors of company's products
☐ Procedure for joining company's dividend reinvestment plan
☐ Procedure for stockholder participation in programs for the purchase of company's products
☐ Stockholder profile or opinion survey questionnaire

DELIVERY OF REPORTS
Note:
Following are the delivery requirements of the annual report to your shareholders, based on where your securities are listed or traded.

NYSE
15 days before annual meeting: not later than 90 days after close of your fiscal year.

AMEX
10 days before annual meeting; not later than 120 days after close of your fiscal year.

OTC
No delivery of annual report to shareholders is necessary unless there is an annual meeting for which proxies are being solicited. State laws governing corporate activities should be checked to determine how many days before your annual meeting the annual report must be delivered.

© 1989 Doremus & Company
Reprinted with permission.

Good Advice

After pages of information and examples, this section is to sum up some of the bits of advice that I have collected from various designers, writers and corporate communicators. In roughly the order of the report process, here are some thoughts and rules of thumb that I wish someone had told to me before my first annual report.

Involve the CEO early. It is hard enough to produce a good annual report. It is almost impossible to do so in the dark. The person who knows what the company needs and where the company is going is the CEO. Make sure that person is part of the early decision-making process.

Limit those involved in the day-to-day flow of the report. Input is great, and necessary. Once the production process begins, however, too many cooks will most certainly slow down the report and add unnecessary cost.

Document every aspect of the report. Keep good notes. Keep everyone involved in the project aware of decisions, changes and the flow of expenses. Production of the average annual report will stretch from four to six months, far too long to rely on memory for all the financial and logistical details of an annual report.

Make the cost of alterations or changing plans known at the time the change takes place. No one likes surprises, so make sure the client is aware of changing costs. It can be difficult later in the process to remember exactly why a change was made, or who authorized it, which may lead to unnecessary arguments or resentments. Also, if the actual cost was known at the time the change was ordered, that order may be rescinded if the cost is deemed to be too high.

Schedule in time to make alterations and changes. Changes and corrections will take place. When setting a calendar, schedule in adequate time for approvals and corrections.

Schedule the press time in advance. The annual meeting date is set; the mailing date for the annual reports is set. Now meet with the printer and reserve the needed time to print the report.

Order the paper for the annual report early. Paper supplies are sometimes limited, especially since most annual reports are printed at the same time on the same types of paper. Order the paper as soon as the size of the report, the quantity to be printed, the printer and the budget have been decided upon.

Make a paper dummy early. How thick is the report; how much will it cost to mail? When choosing a paper, have the printer or paper supplier make a dummy to actual specifications. Don't be surprised later, after you own three carloads of paper, that the report is too flimsy or too heavy.

Make presentations that are clear. Mock up the report so that items such as background colors, chart colors and size of type are clear. During the proofing stage, when the printer is preparing the report for printing, is no time to find out that the CEO doesn't like blue or can't read the type.

Plan the photographic trips in great detail. Make sure that great care is taken in scheduling the photographic trips. Make sure that the needed contacts have actually been reached. Do not take anything for granted. A photographer, client and I were once held hostage on a ship in international waters while the ship's captain cooled off after a simple misunderstanding. He thought we had been given permission to board and take photographs *from* the ship; we had come to take photographs *of* the ship. The captain would not allow it, and he was not pleased.

Double-check the travel itineraries. Check them yourself. No one knows as well as the person taking the trip what will be needed, when it will be needed and where it will be needed.

Make sure the scope of the photography assignment is clear. "While you're here can you just take a picture of. . . ." Taking photographs can be very time-consuming, so it is important that the time allotted be well used. Make sure that the client and the people involved, such as the client's regional manager, are aware of what photographs you have come to take, so that time and money are not wasted taking "extras."

Make sure the images being used in the report are free of copyright restrictions.

Changes

Changes in an annual report can be very expensive when made late in the process. For instance, changing a simple word on a 24-page annual report with a run of 10,000 copies can have the following cost consequences:

Draft of Text	$0
Laser Print	$1
Galley	$25
Blueline	$125
On Press	$450
After Printing	$3,500
After Binding	$35,000
After Mailing	$?

Whether using original photography, stock images, or slides from the company files, make sure the images are copyright-free or that arrangements have been made with the photographer or owner of the rights.

Settle the issue of ownership before the photography or illustration is begun. The client, design firm and photographer or artist should have a clear understanding beforehand of who owns the copyright, what the use of the work will be and who will keep the finished work. It is very difficult to reach mutual understandings *after* the fact.

Keep track of where the photographs or art are during the process. Things get lost or misplaced. The client thinks the printer has the photographs while the designer thinks the client does. To avoid these problems, keep good records of where the work is being sent. Lost photographs or artwork can have serious financial consequences, such as having to pay to redo the work, or possibly compensating the artist for the loss if the artist was retaining ownership.

Be clear about instructions for handling art and materials. Clients will fingerprint transparencies, write on original photographs and mark over reproduction-quality type with ballpoint pens. They don't do this to be mean or stupid; they do so because no one has taken a moment or so to explain the value of the materials in the client's possession.

Make others involved in the project aware of costs for changes and alterations. Accountants are famous for ordering correction after correction in the type, often involving rush charges for changes sent in at 7:00 p.m. for delivery at 8:30 the next morning. There are times when this is necessary, but after three straight weeks of rush orders, one begins to suspect that there might be a more efficient way to make adjustments in the text or numbers.

Remember to attain a good set of signatures. Ask the CEO and anyone else whose signature will appear in the report to take a sheet of white paper and make multiple signatures, so the best one can be chosen. For good reproduction, use a black felt-tip or ink pen and avoid ballpoint pens and blue ink.

Have a type density test made. Before the type is ordered, have the typesetter produce a sample galley with the type to be used, so the density can be checked. The density can be altered, making the type darker or lighter. Done ahead of time, the cost is negligible.

Review the photographs carefully before sending to printer. Scratches or flaws in the film, or areas that may need retouching, need to be dealt with before the initial separations. The printer will charge for new separations if the originals separations are unusable because the film from the designer was flawed.

Double-check the proofs. Before the report gets near a printing press, make sure that the proofs, all the proofs, are perfect. Before the printer prints, the designer and the client will be required to sign off on the proofs. The signature says that whatever happens after this stage, the responsibility for costly changes are not the printer's.

Prepare everyone for the press check. Make a list of the people who will be coming to the press check, and note their daytime and nighttime telephone numbers. Make sure they are aware of where the printing plant is, and the general time needed. If the checks will go on through the night, let them know about this possibility ahead of time.

Be at the press check. After months of work, this is when the report actually becomes ink on paper. It is the last chance to correct a potential disaster, and for this reason alone a company representative should be at the press checks. For the designer, the adjustments made here can make the difference between good and bad printing.

Plan for the final delivery of the reports ahead of time. Do not take the delivery of the reports for granted. This can be a very complicated time in the process, when mistakes or delays can be traumatic. Make a list of where the reports will be sent. Who needs them overnight? Is the printer using its own truck or a freight company? Does the final destination, such as a mail house, know they are coming? Is there a loading dock? These can be very important questions. For instance, I once sent a shipment of reports to a bank in New York using a freight company. Every detail was planned for, except the *clearance* of the bank's truck dock. The bank was prepared for vans but not large trucks, so the reports had to be unloaded outside and carried to the dock. Had it been raining, we would have had a major problem on our hands.

Verify delivery. After the reports have been delivered, attain the verification. Who signed for the reports, how many did they sign for and when did they sign for them.

Expect the unexpected. A designer tells the story of the truck driver who, while delivering a load of annual reports, stopped off in Las Vegas on his journey. After losing the money he had for fuel, he became depressed and was "lost" for three days as everyone else involved in the report frantically burned up the phone lines looking for him.

Resources

There are resources available to find suppliers, find information about the annual report process or elements, or just find out which annual reports are judged to be "good." Here are some of those resources:

Competitions

AR 100 Awards
Annual competition and book
Alexander Communications
212 W. Superior, Suite 400
Chicago, Illinois 60610

ARC Awards
Annual competition as part of the Annual Report Conference & Investor Relations Forum
MerComm, Inc.
165 West 91st Street
Suite 15-G
New York, New York 10024

American Insitute of Graphic Arts (AIGA) Communication Graphics
Annual graphic design competition and book, which includes annual reports
AIGA
1059 Third Avenue
New York, New York 10021

Communication Arts Design Annual
Annual graphic design competition and book, with section for annual reports
Communication Arts
410 Sherman Avenue
P.O. Box 10300
Palo Alto, California 94303

Financial World
Annual competition
Financial World Magazine
Mead World Headquarters
Courthouse Plaza NE
Dayton, Ohio 45463

Graphis Annual Reports
International biannual competition and book
Graphis Press Corp.
107 Dufourstrasse
CH-8008 Zurich
Switzerland

Mead Annual Report Show
Annual competition and catalog
Mead Paper
Mead World Headquarters
Courthouse Plaza NE
Dayton, Ohio 45463

Print Casebooks, The Best in Annual Reports
Annual competition and book, with in-depth look at the winning entries
Print Magazine
104 Fifth Avenue, 9th Floor
New York, New York 10011

Annual Resources

(Catalogs of designers, photographer, printers and other suppliers)

AR, The Complete Annual Report and Corporate Image Planning Book
Alexander Communications
212 W. Superior, Suite 400
Chicago, Illinois 60610

Corporate Showcase
American Showcase, Inc.
724 Fifth Avenue, 10th Floor
New York, New York 10019

Newsletters

The Corporate Annual Report Newsletter
Monthly newsletter
Lawrence Ragan Communications, Inc.
407 S. Dearborn
Chicago, Illinois 60605

Sid Cato's Newsletter on Annual Reports
Monthly newsletter
Sid Cato Communications, Inc.
Box 738
Waukesha, Wisconsin 53187-0738

Books

(On annual reports)

Graphis Annual Reports
Graphis Press Corp., Distributed by Watson-Guptill Publications
1515 Broadway
New York, New York 10036

(On charts, diagrams and maps)

Graphis Diagram 1
Graphis Diagram 2
Graphis Press Corp., Distributed by Watson-Guptill Publications
1515 Broadway
New York, New York 10036

Paper companies publish booklets of interest to annual report producers, often on an annual basis. "Annual Report Trends" by S.D. Warren Company is one such publication. Simpson Paper Company and Potlatch Paper Company also create booklets on a yearly basis that are mailed to designers and others responsible for annual report production.

Glossary

During the process of producing an annual report, any number of people are apt to enter the picture, using terms and expressions that may be foreign to you. On these four pages I have listed some of the terminology that relates to the production of annual reports, and have provided short explanations. Following each term (in parentheses) is the general area of use, such as the printing industry or the accounting profession.

4 x 5 *(Photography)* A large-format photographic negative or transparency measuring 4 x 5", which gives greater clarity and crispness than a smaller format photograph.

10-K *(Accounting)* A financial form all publicly owned companies are required by law to file with the SEC.

10-K Wrap *(Design)* A printed piece that is simply the 10-K form with a cover, used to replace a normal annual report.

2¼ *(Photography)* A photographic negative or transparency measuring 2¼ x 2¼"; it is larger than the commonly used 35 mm, but smaller than a 4 x 5" format.

AA's *(Typography)* A term used to designate changes made by the client (author's alterations).

airbrush *(Illustration)* A style of illustration using a technique of applying paint or ink in a spray-gun manner, using a tiny aperture for gradations of color. The technique is also used in retouching photographs.

annual meeting *(Company)* The yearly meeting between management and shareholders to discuss the year's results and any other matters concerning the company, elect directors to the board, and form company policy.

assets *(Accounting)* The sum total of everything the company owns, or is owed. Usually itemized for the annual report.

assistant *(Photography)* The person who assists the photographer, moving props, helping with the lighting, and so on. Most photographers require an assistant be included to make the time allowed for photography more efficient.

auditor *(Accounting)* An accountant or accounting firm retained to examine the company's books.

auditors' report *(Accounting)* The statement of the independent (not part of the company) auditors, included in the annual report.

balance sheet *(Accounting)* A statement of the company's assets, liabilities and shareholders' equity.

bar chart *(Graphics)* A statistical representation using vertical or horizontal bars to indicate relative amounts.

bleed *(Printing)* The ¼" of image, whether a photograph, illustration or rule, that must extend beyond the edge of the page area on the printed sheet in order to cover the entire page in the final, trimmed piece.

blueline *(Printing)* A photographic process proof from the printer, made in blue from the film that will be used for printing, to show to the designer or client in order to get approval of the placement of all elements, including type, photographs and so on.

brownline *(Printing)* Another term for blueline. (An older process produced brown proofs.)

CEO *(Company)* Chief executive officer.

chart *(Graphics)* Any visual, as opposed to typographic, statistical representation.

coated paper *(Printing)* Paper with a smooth, polished clay surface for quality print production. Can be a glossy or dull surface.

color key *(Printing)* A color proof made with layers of process color on acetate, which, when laid on top of each other, give an indication of the printed piece. This color system does not duplicate color as accurately as the Cromalin or matchprint systems.

column *(Typography)* A vertical section of type on the page. Columns of type are separated by a vertical band of white or empty paper. There are usually one to four columns on a page.

comp *(Design)* A comprehensive layout, mocking up page size, colors to be used in the actual piece, proposed type styles and sizes, and styles of photography the designer proposes.

concept *(Design)* Another word for idea or theme, the concept is the story line and/or the visual approach of the report.

copy fitting *(Writing/Typography)* The procedure used to measure the amount of space that a given amount of typewritten copy will occupy when set in type, or the process of making the typeset text fit a specific area.

copywriter *(Writing)* The person who writes the words: taking the information about the company, organizing it and creating the text that will be read in the report.

corporate profile *(Company)* A company's who, what, when, where and why. The paragraph or two that is generally on the inside front cover that explains the company's beginnings, the goods or services it produces and its general direction.

cover paper *(Printing)* A paper stock used for the cover of the report that is thicker or heavier than the stock that makes up the inside pages of the report.

Cromalin *(Photography)* A Du Pont trade name for a color proof of a multicolor subject, either process color or screens of the process colors to make up a color. A Cromalin produces near press-quality results, and is used to find flaws in the separations and ultimately used to approve the separations for printing.

day rate *(Photography)* The photographer's charge per day when shooting photographs. Photographers generally charge by the day, with a lesser fee for travel time.

debossing *(Printing)* The opposite of embossing, producing an imprint that is below the surface of the sheet *(see* embossing).

designer *(Design)* The person who is responsible for the visuals of the report, whose task it is to mold the type and images into a pleasing visual form that can be easily and enjoyably understood. The designer is responsible for the overall look and visual coherence of the report, and may initiate the concept or theme as well.

diecut *(Printing)* Any part of the piece that has an opening cut in it for insertions, or is cut into a shape other than the standard rectilinear page. Requires a steel die to be made for each instance.

digitize *(Printing)* Any translation of visual information (generally photographs) into computer language, to make it usable and reproducible by computers. Retouchers may digitize an image to manipulate it. Printers or color separators may use digitizing equipment to create the separations.

director *(Company)* A member of the company's board of directors. The person may be an employee of the company, or someone asked to serve on the board from outside the company.

dividends *(Company)* A payment to the shareholders from the company's earnings; can be cash or stock in the company.

divider pages *(Design)* Any pages that are used to separate sections of text. They can be heavier stock, colored stock, or otherwise visually distinct from the regular pages.

double stitching *(Printing)* Stapling in two or more signatures into one cover. Two different kinds of paper can be used, such as glossy text pages in the front or narrative section of the report and uncoated stock for the financials.

dull *(Printing)* A text stock that has a dull or matte surface as opposed to a glossy finish.

dummy *(Design)* A layout or mock-up of all the pages of the report in booklet form for presentation purposes.

duotone *(Printing)* A black and white photograph that is printed using black plus a tone of another color to give the printed image more depth or richness.

embossing *(Printing)* A process for raising an image or type from the surface of the page; produced by pressing the stock between two dies, one relief, one recessed. Heat may be used in the process.

fever chart *(Graphics)* A chart that shows information in a series of two or more connected points across a field or grid.

financial highlights *(Accounting)* The condensed version of the key financial statements , usually found on the first page of the report.

financial statements *(Accounting)* The balance sheet, the statement of cash flow, the statement of shareholders' equity, and the income statement.

financials *(Company)* The entire section devoted to financial tables, as opposed to the narrative section, which documents the year's financial activities and events.

five-color *(Printing)* Using another roller in the press beyond the four process rollers, usually to print an extra color or varnish.

flat color *(Printing)* A printed color that is not one of the process colors. If the process colors are used, this color may be referred to as the fifth color.

flysheet *(Printing)* A special paper generally placed between the cover and text pages. It is frequently a different weight, texture or color from the other stock.

foil embossing *(Printing)* A process using a combination die to foil-stamp and emboss at the same time.

foil stamping *(Printing)* A process using heat and pressure to apply a metallic- or dye-based film to the surface of the paper.

footnote *(Writing/Accounting)* A note placed at the bottom of a page that comments on or cites a reference for a designated part of the text.

form *(Printing)* The pages of a report (usually 4-16 pages) on a press sheet in a proper position for printing and binding. A form may refer to a sheet of printed paper.

four-color *(Printing)* Printing in full color, using the standard combination of four inks: magenta, cyan, yellow and black. These inks in combination produce all the varied tones of natural colors.

galley proofs *(Typography)* Long columns of typeset copy that is not broken into page-depth lengths, presented to the client for proofreading and changes before setting in position.

gatefold *(Printing)* A folding method in which an extra page, or in the case of a double gatefold, two pages, fold inward toward the gutter.

gloss *(Printing)* A shiny surface on a sheet of printing paper.

graph *(Graphics)* A visual representation of statistical information. *(Copywriting)* A short version of the word *paragraph*, used to refer to a section of copy.

gutter *(Printing)* The area between pages or between columns of type. Sometimes used to refer to the fold in the middle of a spread.

gutter jump *(Printing)* Copy or imagery that runs across and through the gutter, or fold.

illustration *(Design)* A hand-drawn or hand-painted image. Often referred to as artwork.

keystroking *(Typography)* The act of entering copy into a computer on a keyboard, whether formatted or not.

lamination *(Printing)* The process of applying either a rigid sheet of plastic or a liquid plastic that seals the sheet of paper, resulting in a very glossy surface.

large format *(Photography)* Negatives or transparencies that are larger than the standard 35 mm size. Generally 4 x 5", 5 x 7", or 8 x 10".

laser print *(Typography)* A printout of computer type run on a laser printing device that is very much like the final output from the typesetting machine, but is on plain paper, and has less resolution (crispness) than the final version.

layout *(Design)* A drawing showing the proposed positioning of visual elements and type areas for a page, or for an entire piece.

leading *(Typography)* The amount of space between lines of type, expressed in points, and relative to the point size of the type itself. For instance, 10/12 means 10-point type with the bases of the typeset lines 12 points apart. This can be expressed as 2 extra points of leading. If the point size of the type and the leading are the same, the leading is called "solid" and the lines of type are packed very close together. Generally speaking, one or two points of leading make the type more readable.

liabilities *(Accounting)* The financial obligations of a business enterprise.

location *(Photography)* A site where photographs are shot—for instance, in a factory or in the office of the executive—as opposed to shooting in the photographer's studio.

management *(Company)* The people who direct or administer the company.

management's discussion and analysis *(Accounting)* The comments by management on the results of operations and the financial statements.

matched screens *(Printing)* Creating colors by using screens or tints of the process colors. For instance, 50% of magenta and 100% of yellow will make an orange color, while 80% magenta and 100% yellow will make a redder color.

mechanical *(Design)* All elements needed for making printing negatives, pasted in exact positions onto a "board," a heavy piece of paper that has nonreproducible marks for trimming the pages and indication marks for stripping in actual photos. The paste-up will include reproduction-quality typesetting and position stats of the photographs used to shoot for printing.

modem *(Typography)* The electronic device by which copy or other information can be sent from one location to another over phone lines.

narrative *(Company)* A written explanation of the company's performance over the fiscal year covered by the annual report.

officer *(Company)* A member of the senior executive management of the company who has been designated an officer, and will be listed in the annual report as such.

operations *(Company)* The activities or businesses of the company.

pagination *(Design)* The arrangement of pages and numbering the pages in sequence.

PANTONE MATCHING SYSTEM®* *(Printing)* A standardized system of numbered color formulas used in printing that allows the designer to specify an exact color to be used to print type or any visual area of the mechanical. Color samples are available to attach to the board. (*Pantone, Inc.'s check-standard trademark for color reproduction and color reproduction materials.)

paper dummy *(Printing or Design)* A booklet made with the actual paper stock or stocks that will be used in the report in the final size and number of pages.

perfect binding *(Printing)* The process of using adhesive binding to hold the text of the report to the cover. The individual pages are cut into sheets and glued into the cover, producing a stiff, squared spine.

pica *(Typography)* A unit of measure equal to ⅙ inch, or 12 points.

pie chart *(Graphics)* A visual representation of statistics using a circle divided into segments to express amounts.

point *(Typography)* A unit of measurement equal to 1/72 inch. Normal text in a report usually measures ten points.

press check *(Printing)* A visit to the printer by the designer during the actual printing run, to oversee the quality of the final product.

proofing or **proofreading** *(Typography)* The task of reading the typeset copy for errors and typos (mistyped words or letters).

proofs *(Printing)* Typeset or printed representations of the pages or images to be looked at by the designer, proofreader and/or client, to check for errors and make approvals.

proxy *(Company)* A person authorized to vote for a shareholder at the annual meeting.

repro *(Typography)* Typeset copy that is reproducible. This refers to the quality of the paper and process used to produce the type. In phototypesetting, the standard modern method, repro is a photographic image of the characters produced by a typesetting device.

retouching *(Photography)* The process of altering a photograph to add or remove objects, to fix imperfections in the print or transparency or to change the color of any part of the photo.

saddle stitch *(Printing)* A method used in sewing together the leaves of a book at the fold line, with either thread or wire staples.

scoring *(Printing)* A method of making folds in heavy paper, by pressing the paper with a metal die that does not go through the entire thickness of the stock.

screen tint *(Printing)* A matrix of dots used to cover an area with a tone of gray or color, which can be specified in percentages, from the darkest (100 percent) to the lightest visible tones (usually 10 percent).

SEC *(Accounting)* Securities and Exchange Commission, a government body that regulates all transactions involving securities, and protects the interests of investors.

separation *(Photography)* The process of shooting a color transparency through four colored filters to make four separate negatives, one for each of the standard printing ink colors (magenta, cyan, yellow and black).

shareholder *(Accounting)* A person who owns at least one share in a company, and therefore is a part owner of the company.

shareholders' equity *(Accounting)* The amount of ownership in the company that each share represents.

shares *(Accounting)* A unit of a company's capital stock, divided at the time of incorporation. The number of shares may be increased by a decision of the stockholders.

sheetfed *(Printing)* A type of offset printing press that mechanically feeds one sheet of paper at a time through the rollers.

signature *(Printing)* A large sheet printed with four or a multiple of four pages that when folded becomes a section of the book.

six-color *(Printing)* Using two special ink colors in addition to the four process inks.

slug *(Typography)* The heading of a typeset proof, stating the name and address of the typographer as well as the date and information about how the computer file is stored in the typesetting system, so that it can be recovered for alterations.

statements *(Accounting)* Financial tables in the annual report that show the financial status of the company at the time of the report.

stock *(Accounting)* A share, or body of shares, in a company. *(Printing)* Paper used for printing.

stockholder *(Accounting)* A shareholder in a company.

stripping in *(Printing)* To take a portion of a page that has been altered and isolate it either electronically or manually, and place it correctly in the mechanical or negative.

studio *(Photography)* The workplace of a photographer, equipped with special backgrounds, lighting and other accoutrements to facilitate the photographing of an object or person. The studio shot is an alternative to a location shot, which provides the actual setting, but does not have all the advantages of special equipment provided in the studio.

stylist *(Photography)* An assistant to the art director and/or photographer who obtains and arranges objects, or works with the hair and make-up of the models in the photographs.

table *(Design)* An arrangement of statistical information, in type only, to express quantities.

text paper *(Printing)* A medium weight of paper that is used for the inside of the report.

theme *(Creative)* *(See* concept.)

thumbnail *(Design)* Small layouts of the entire report to give a sense of flow and page allocation.

transparency *(Photography)* A transparent color photograph; all sizes of transparent photos (35 mm, 2¼", 4 x 5", 5 x 7", 8 x 10") are called transparencies, while the 35 mm transparency in a casing is also called a slide.

travel day *(Photography)* The time spent in traveling to and from a location shot, required for distant sites, which must be considered in planning the time involved in photography for a piece. Usually billed at half the day rate.

typo *(Typography)* A mistyped or incorrectly typeset word. For instance, *aslo* instead of *also* is a typo.

uncoated paper *(Printing)* Paper that is not coated with clay or other substances.

varnish *(Printing)* A glossy or dull substance applied over a printed area to give it a particularly shiny or matte finish and possibly to set off one area of a page from another, or to highlight one image or section of type.

web *(Printing)* An offset press that feeds a large roll of paper continuously through the rollers and cuts it after printing.

work & turn *(Printing)* A method of printing a two-sided piece with one plate whereby both sides are on the same plate. Half of the number of impressions are run; then the sheet is turned over and the remainder are run from the same plate on the back side of the paper.

x-height *(Typography)* The height of a lowercase *x* in a particular typeface. The x-height indicates the body of a character, as opposed to the entire character including ascender and descender.

year-end *(Accounting)* The point at which the fiscal year ends for the company. Financial statements are usually prepared at year-end in an annual report.

Credits

Knudsen Corporation 1981
Robert Miles Runyan &
Associates, *Design Firm*
Bob Stevens, *Photographer*

Page 83
SEI Corporation 1986
George Tscherny, *Designer*
George Tscherny, Inc.,
Design Firm
James H. Karales, *Photographer*

**Houston Metropolitan
Ministries 1980**
Jerry Herring, *Designer*
Herring Design, *Design Firm*
Jim Sims, *Photographer*

Herman Miller 1985
Stephen Frykholm,
Sara Giovanitti, *Designers*
Bill Lindhout with Andy Sacks,
Kerry Rasikas, Brad Trent,
Photographers

Page 84
Centex 1986
Woody Pirtle, *Designer*
Pirtle Design, *Design Firm*
Arthur Meyerson, *Photographer*

Doyle Dane Bernbach 1984
Doyle Dane Bernbach
International Inc., *Agency*

Team, Inc. 1988
Jerry Herring, *Designer*
Herring Design, *Design Firm*

Biogen 1983
Michael Weymouth, Tom
Laidlaw, *Designers*
Weymouth Design Firm,
Design Firm
David Wilcox, *Illustrator*

Intermedics 1984
Jerry Herring, *Designer*
Herring Design, *Design Firm*
Keith Kasnot, *Illustrator*
Ron Scott, *Photographer*

Browning Ferris Industries 1978
Jay Loucks, *Designer*
Loucks Atelier, *Design Firm*
Walter Nelson, *Photographer*

Page 85
Leaf, Inc. 1986
Pat and Greg Samata, *Designers*
Samata Associates, *Design Firm*
Terry Heffernan, Mark Joseph,
Dennis Dooley, *Photographers*

Fannin Bank 1975
Jack Amuny, *Designer*
Art City, *Design Firm*

Page 86
Potlatch 1988
Kit Hinrichs, Terry Driscoll,
Designers
Pentagram, *Design Firm*
Tom Tracy, *Photographer*

**International Minerals and
Chemicals Corporation 1987**
Pat and Greg Samata, *Designers*
Samata Associates, *Design Firm*
Terry Heffernan, Mark Joseph,
Photographers

Goldman Sachs 1987
John Laughlin, *Designer*
Arnold Saks Associates,
Design Firm
Burt Glinn, *Photographer*

Reliance Group Holdings 1987
Bennett Robinson, *Designer*
Corporate Graphics,
Design Firm
Bill Hayward, *Photographer*

First Bank System 1988
Frank James, *Designer*
James Nancekivell, *Art Director*
Nancekivell Design Office,
Design Firm
Gregory Edwards, Mark LaFavor,
Photographers

Page 88
LSI Logic Corporation 1988
Margaret Hellmann, *Designer*
Lawrence Bender & Associates,
Design Firm
Geoffrey Nelson, *Photographer*

**Weyerhauser Paper
Company 1986**
John Van Dyke, *Designer*
Van Dyke Company,
Design Firm
Terry Heffernan, *Photographer*

Page 89
United Technologies 1988
Ingo Scharrenbroich, *Designer*
Arnold Saks Associates,
Design Firm
Mark Meyer (and others),
Photographers

Helene Curtis Industries 1989
Greg Samata, *Designer*
Samata Associates, *Design Firm*
Jean Moss, *Photographer*

Page 90
Norton 1988
Ingo Scharrenbroich, *Designer*
Arnold Saks Associates,
Design Firm
Mason Morfit, Klaus Meyer,
Photographers

ENSR 1987
Lowell Williams, *Designer*
Lowell Williams Design,
Design Firm
Joe Baraban, *Photographer*

Page 91
ITW 1988
Carl Wohlt, *Designer*
Crosby Associates Inc.,
Design Firm
Dave Jordano, *Photographer*

Kraft 1987
Janet Gulley, Bart Crosby,
Designers
Crosby Associates Inc.,
Design Firm
Laurie Rubin, *Photographer*

Dylex 1985
Robert Jakob, *Designer*
Arnold Saks Associates,
Design Firm
Jim Allen, *Photographer*

Page 92
Reliance Group Holdings 1987
Bennett Robinson, *Designer*
Corporate Graphics,
Design Firm
Bill Hayward, *Photographer*

Potlatch 1988
Kit Hinrichs, Terry Driscoll,
Designers
Pentagram, *Design Firm*
Tom Tracy, *Photographer*

Page 93
Alcoa 1988
Anne Chesnut, *Designer*
Arnold Saks Associates,
Design Firm
Cheryl Rossum,
Major Photographer

Leaf, Inc. 1986
Pat and Greg Samata, *Designers*
Samata Associates, *Design Firm*
Terry Heffernan, Mark Joseph,
Dennis Dooley, *Photographers*

Page 94
H.J. Heinz 1987
Bennett Robinson, *Designer*
Corporate Graphics,
Design Firm
Rodney Smith, *Photographer*

SEI Corporation 1986
George Tscherny, *Designer*
George Tscherny, Inc.,
Design Firm
James H. Karales, *Photographer*

Page 95
Pier 1 Imports 1989
Jim Strickland, *Designer*
Witherspoon, *Agency*
Leo Wesson, *Photographer*

Doyle Dane Bernbach 1984
Doyle Dane Bernbach
International Inc., *Agency*

Page 96
MICOM System 1986
Robert Miles Runyan &
Associates, *Design Firm*
Guy Billout, *Illustrator*

Page 97
**Lomas & Nettleton Financial
Corporation 1976**
Jack Summerford, *Designer*
Richards Brock Miller Mitchell &
Associates, *Design Firm*
Daniel Schwartz, *Illustrator*

Vallen Corporation 1983
Jerry Herring, *Designer*
Herring Design, *Design Firm*
Melissa Grimes, *Illustrator*

Page 98
**Lomas & Nettleton Housing
Corporation 1981**
Nancy Hoefig, *Designer*
Richards Brock Miller Mitchell &
Associates, *Design Firm*
Jack Unruh, *Illustrator*

Page 99
Intermedics 1984
Jerry Herring, *Designer*
Herring Design, *Design Firm*
Keith Kasnot, *Illustrator*
Ron Scott, *Photographer*

Page 100
Informix Corporation 1987
Linda Brandon, *Designer*
Lawrence Bender & Associates,
Design Firm
David Lesh, *Illustrator*

Metropolitan Life 1988
Bennett Robinson, *Designer*
Corporate Graphics,
Design Firm
Daniel Morper, *Painter*

Page 101
**Central and South West
Corporation 1988**
Jack Summerford, *Designer*
Summerford Design,
Design Firm
Jack Summerford, *Illustrator*

Reuters Holdings PLC 1988
Mervyn Kurlansky,
Penny Madden, *Designers*
Pentagram, *Design Firm*
George Hardie, *Illustrator*
Ian Berry, *Photographer*

Page 102
Champion International 1984
Richard Hess, *Designer*
Hess & Hess, *Design Firm*
R. O. Blechman, *Illustrator*
Ted Kawalerski, *Photographer*
Chester Gould, *Cartoonist*

H.J. Heinz 1984
Bennett Robinson, *Designer*
Corporate Graphics,
Design Firm
Bill Hayward, *Photographer*

Reliance Group Holdings 1987
Bennett Robinson, *Designer*
Corporate Graphics,
Design Firm
Bill Hayward, *Photographer*

Page 103
Times Mirror 1988
Jim Berté, *Designer*
Robert Miles Runyan &
Associates, *Design Firm*

Page 104
Dylex 1985
Robert Jakob, *Designer*
Arnold Saks Associates,
Design Firm
Jim Allen, *Photographer*

Pier 1 Imports 1984
Bill Johnson, *Designer*
Witherspoon, *Agency*
Rick Sales, *Illustrator*

Page 105
Union Texas Petroleum 1987
Jerry Herring, *Designer*
Herring Design, *Design Firm*
Tom McNeff, *Illustrator*

**New York Power
Authority 1985**
John Laughlin, *Designer*
Arnold Saks Associates,
Design Firm
Mark Godfrey, Gloria Baker,
Michele Singer, NYPA staff,
Photographers

Page 106
Alcoa 1986
John Laughlin, *Designer*
Arnold Saks Associates,
Design Firm

Intel Corporation 1988
Timothy Lau, *Designer*
Lawrence Bender & Associates,
Design Firm

Page 107
Galveston-Houston 1979
Jerry Herring, *Designer*
Herring Design, *Design Firm*

Potlatch 1981
Kit Hinrichs, *Designer*
Pentagram, *Design Firm*
Tom Tracy, *Photographer*
Will Nelson, *Illustrator*

Page 108
Allied-Signal 1988
Ingo Scharrenbroich, *Designer*
Arnold Saks Associates,
Design Firm
Chacma, Wayne Eastep,
Gary Gladstone, *Photographers*

Team, Inc. 1988
Jerry Herring, *Designer*
Herring Design, *Design Firm*

Page 109
Champion International 1984
Richard Hess, *Designer*
Hess & Hess, *Design Firm*
R. O. Blechman, *Illustrator*
Ted Kawalerski, *Photographer*
Chester Gould, *Cartoonist*

Pier 1 Imports 1989
Jim Strickland, *Designer*
Witherspoon, *Agency*
Leo Wesson, *Photographer*

Page 110
Centel Corporation 1985
Bart Crosby, *Designer*
Crosby Associates Inc.,
Design Firm
Bruce Davidson, *Photographer*

**American National
Corporation 1987**
Jacklin Pinsler, Bart Crosby,
Designers
Crosby Associates Inc.,
Design Firm
David Wagenaar, *Photographer*

Page 111
Intermedics 1984
Jerry Herring, *Designer*
Herring Design, *Design Firm*

W.R. Grace & Company 1984
George Tscherny, *Designer*
George Tscherny, Inc.,
Design Firm

Page 112
Domino's Pizza 1985
Ernie Perich, *Creative Director*
Carol Austin, Janine Thielk, Tom
Masters, *Designers*
Group 243 Incorporated,
Design Firm

Page 113
Panhandle Eastern 1988
Bob Erwin, *Designer*
Craig Stewart, *Photographer*

Page 114
Domino's Pizza 1986
Ernie Perich, *Creative Director*
Carol Austin, Carol Mooradian,
Tom Masters, *Designers*
Group 243 Incorporated,
Design Firm

Domino's Pizza 1983
Ernie Perich, *Creative Director*
Ernie Perich, Wayne Pedersen,
Jeanette Dyer, *Designers*
Group 243 Incorporated,
Design Firm

Page 115
Domino's Pizza 1982
Ernie Perich, *Creative Director*
Ernie Perich, Jeannette Dyer,
Designers
Group 243 Incorporated,
Design Firm

Domino's Pizza 1984
Ernie Perich, *Creative Director*
Ernie Perich, Carol Mooradian,
Jeanette Dyer, *Designers*
Group 243 Incorporated,
Design Firm

Page 116
Herman Miller 1982
Stephen Frykholm, *Designer*
Peter Kiar, *Photographer*

Herman Miller 1979
Stephen Frykholm, *Designer*
Earl Woods, John Boucher,
Photographers

Page 117
Southwest Airlines 1988
Croxson Design, *Design Firm*
GSD&M, *Agency*

US West 1986
Joe Duffy, Sharon Werner,
Charles S. Anderson, *Designers*
The Duffy Design Group,
Design Firm
Tom Berthiaume, Westlight
Photography, *Photographers*

US West 1987
Sharon Werner, Haley Johnson,
Designers
The Duffy Design Group,
Design Firm
Dan Weaks, Arthur Meyerson,
Photographers

Page 118
Herman Miller 1987
Stephen Frykholm, *Designer*
Nick Merrick, *Photographer*

Page 119
Chili's 1988
Brian Boyd, *Designer*
Richards Brock Miller Mitchell &
Associates, *Design Firm*
Regan Dunnick, *Illustrator*

Index